Homemade Esthetics

HOMEMADE ESTHETICS

Observations on Art and Taste

Clement Greenberg

New York Oxford
OXFORD UNIVERSITY PRESS
1999

Oxford University Press

Oxford New York

Athens Auckland Bangkok Bogotá Buenos Aires Calcutta
Cape Town Chennai Dar es Salaam Delhi Florence Hong Kong Istanbul
Karachi Kuala Lumpur Madrid Melbourne Mexico City Mumbai
Nairobi Paris São Paulo Singapore Taipei Tokyo Toronto Warsaw

and associated companies in
Berlin Ibadan

Published by Oxford University Press, Inc.
198 Madison Avenue, New York, New York 10016

Oxford is a registered trademark of Oxford University Press

Library of Congress Cataloging-in-Publication Data
Greenberg, Clement, 1909–
Homemade esthetics : observations on art and taste / Clement
Greenberg.
p. cm.
Includes bibliographical references and index.
ISBN 0-19-512433-2 (cloth : alk. paper)
1. Aesthetics. 2. Art—Philosophy. I. Title
BH39.G675 1999
111'.85—dc21 99-19396
 CIP

Page from Clement Greenberg's early draft of "The Experience of Value," reproduced on page 2.

1 3 5 7 9 8 6 4 2

Printed in the United States of America
on acid-free paper

CONTENTS

FOREWORD

- Axiology -

To offer some background on *Homemade Esthetics*: In 1970 Clement Greenberg was approached by Bennington College to give a series of seminars. He had given a seminar once before at the college, six talks in the fall of 1962, and had often remarked on how much he had gotten out of the tough give-and-take from the Bennington students and faculty. Since the publication in 1961 of his collection of essays, *Art and Culture*, he had been planning to write a book that he would call *Homemade Esthetics*. He thought the college would provide a lively forum for exploring his ideas.

On April 6, 1971, after an introduction by Sidney Tillim, he gave the first of nine seminars. He had prepared at length—four drafts of this talk, as well as a general sketch of where the remaining eight seminars might lead, purposely leaving the agenda open for the benefit of his audience as well as himself. The last seminar was delivered April 22.

Clem later expressed to friends his disappointment that this most recent experience at Bennington hadn't challenged him as much as he'd hoped. However, working from the seminars as a broad base, he took the next step in refining his views. Over the following seven years (1972–1979) he published in various art magazines eight essays that explored his deliberations on esthetics, using the titles, "Seminar One," "Seminar Two," and so on (except for the third piece which was published as "Can Taste Be Objective?"). These texts appear in Part I of this book. They were amended/corrected slightly by Clem after publication and I have incorporated those changes. I have also retitled the essays to more clearly differentiate the material in Part I from that in Part II. The ninth essay, as it appears here, is a late draft (though

probably not a final draft) of an essay of this series which has not been previously published.

Part II of this book presents the seminars themselves. All the seminars and the lengthy question-and-answer sessions that followed each of them were audiotaped and transcribed (roughly) soon after. In 1994 Peggy Schiffer Noland, for her master's thesis at the Institute of Fine Arts at New York University, undertook the task of re-transcribing the tapes, annotating them, and assembling a bibliography (see "Further Reading," which includes many of these sources). It is her invaluable work that provides the basis of Part II. Included are the nine talks, each followed by excerpts from the question-and-answer sessions that I selected for their particular relevance to each evening's topic. I have also edited these talks and excerpts, taking grammatical and editorial liberties for the sake of clarity and readability.[1]

In the late 1970s Clem began shaping his accumulated material into book form. Once again moving away from his most recent text (this time the published articles), he started on a first chapter (see the Appendix), completing two drafts. The process behind this never-completed book is clearly laid out in the file folders he worked from. (When he spoke of the book, he would usually refer to a projected twelve chapters; however, his folders do not extend past ten.) I had originally considered appending some of this material, which includes notes and drafts of the seminars; the texts he prepared to deliver (because he was never one to stick to the page, they differ from the transcripts of what he actually said); drafts of the articles for publication; drafts and notes of the first chapter of his planned book; and a bibliography of the various clippings he had collected and filed in their relevant folders. I decided, however, to keep this book true to his focus—esthetics—rather than have it become an in-depth study of his work process. In any event, comparisons between Parts I

1. The original audio tapes and transcript, and Noland's thesis, *Clement Greenberg: The Bennington Seminars*, which includes her full transcript with background and commentary, are at the Bennington College library in Vermont.

and II offer in themselves a substantial opportunity to explore that process.[2]

For their encouragement with this project and their suggestions, I want to thank Sarah Chalfant, Ingeborg Hoesterey, Karen Wilkin, Charles Millard, Ann and James Walsh, and Sarah Greenberg Morse and Matthew Morse. At Oxford University Press, my gratitude and thanks to Peter Ginna and Allison Arieff.

One final note: I have taken the liberty of using the title Clem had originally chosen in 1964. Although what follows here is obviously not the book he had envisioned, it contains the seeds of that project. And *Homemade Esthetics* (his preferred spelling), in its directness, is so apt, so expressive of who Clement Greenberg was.

September 1998 Janice Van Horne Greenberg

2. These additional materials, are among the Clement Greenberg papers held at The Getty Research Institute in Los Angeles.

ACKNOWLEDGMENTS

Eight of the nine essays in Part I of this volume were published individually in magazines as follows:

"Intuition and the Esthetic Experience" as "Seminar One." *Arts Magazine*. v. 42, no. 2. November 1973.
"Esthetic Judgment" as "Seminar Two." *Art International*. v. 18, no. 6. Summer 1974.
"Can Taste Be Objective?" *Art News*. v. 72, no. 2. February 1973.
"The Factor of Surprise" as "Seminar Four." *Art International*. v. 19, no. 1. January 1975.
"Judgment and the Esthetic Object" as "Seminar Five." *Studio International*. v. 189. May/June 1975.
"Convention and Innovation" as "Seminar Six." *Arts Magazine*. v. 50, no. 10. June 1976.
"The Experience of Value" as "Seminar Seven." *Arts Magazine*. v. 52, no. 10. June 1978.
"The Language of Esthetic Discourse" as "Seminar Eight." *Arts Magazine*. v. 53, no. 10. June 1979.

The Bennington Seminars, the basis of Part II, were sponsored by the Graham Foundation for Advanced Studies in the Fine Arts. The Graham Foundation also supported Peggy Schiffer Noland's transcription of the seminars, from which the text of Part II has been drawn.

INTRODUCTION:
THE JUDGMENT OF ART
Charles Harrison

Clement Greenberg was unquestionably the most influential critic of modern art writing in the English language during the mid-twentieth century.* To be more precise, it is Greenberg's work that most lucidly establishes the central concerns of Western art criticism from the mid 1930s, when the modern movement was established on an international basis, until the later 1960s, when the value of Modernism itself began to be widely questioned.

To define Greenberg's status in these terms is immediately to draw attention to the controversy that status is now bound to attract. It was certainly he rather than any other writer—indeed, to the effective exclusion of other writers—who furnished the terms in which Modernism came to be defined, both as a property of specific works of visual art and as a period in Western art's long-term development. Furthermore, at a time when other writers were looking to social and historical factors to explain significant changes in art, his consistent tendency was to start from the qualitative character of art and to extrapolate such social-historical conditions as were required to explain it. To talk of Modernism in art is thus not only to engage with an account of modern art—of its distinctive virtues and of the character of its development—for which Greenberg was primarily responsible. It is also to locate that account within a wider debate about the relative priorities of historical inquiry and esthetic judgment whenever the critical analysis of culture is concerned. This is true

*I would like to record my considerable gratitude for the advice and criticism offered on a previous draft of this essay by Michael Baldwin, Jason Gaiger, and Richard Shiff.

not only for those persuaded by Greenberg's view of Modernism, but also for those who would oppose it. In the urgent reassessment to which Modernism has been subject since the late 1960s, both as the designation for an historical period and as a system of values, Greenberg's work has provided a singular focus for critical and revisionary accounts.

In the journalism of the art world Greenberg often appears as one who enforced a form of critical doctrine through his power as a maker and breaker of movements and reputations, and through his influence upon acolytes and upon the market. Prevalent though this image has become, it is difficult to reconcile with the actual published writings, or to support with any but the most selective quotations from them. It was Greenberg's own often-expressed view that the only proper means through which a sense of art's value can be acquired is through a personal response on the occasion of a direct encounter. He was impatient of those who would neither contribute a sufficient measure of exertion to this encounter nor take responsibility for their own judgments. "Too many people simply refuse to make the effort of humility—as well as of patience—that is required to learn how to experience, or appreciate, art relevantly," he wrote in an essay on "The Identity of Art" in 1961. "Such people do not have the right to pronounce on any kind of art" If Greenberg claimed the right to pronounce, it was because he was prepared to take full responsibility for his own responses to art, and for the arguments he developed on the basis of his experience. Once the published writings are given their due attention, it is clear enough that his true authority as a critic derived not from any power with which the market may have invested him, but rather from the forthrightness with which he represented his responses, from the strength and provocativeness of his hypotheses, and from the clarity and cogency of his arguments.

The arguments in question are most clearly revealed in a series of major essays on the broader tendencies of art and culture, beginning with the seminal "Avant-Garde and Kitsch" of 1939 (echoes of which can be heard in "The Factor of Surprise"), but the quality of Greenberg's thought about the underlying problems of artistic practice and critical judgment shows in even the briefest and most occasional of the reviews he wrote over the

ensuing thirty years. It was not the main business of either the spoken or printed seminars to provide analysis of individual works of art, but in those passages that make specific reference to the art he admired—as in the virtual asides on the Impressionists, on Cézanne and on Kandinsky in "The Experience of Value" or in the discussion of Mondrian's *Fox Trot A* in "The Language of Esthetic Discourse"—he demonstrates that combination of thoughtful observation with incisive writing that distinguished him as a practicing critic. It is a matter deserving of some note that the deliberations on esthetics represented in *Homemade Esthetics* rest upon this substantial body of work. Surprising as it may seem, contributions to the field of esthetics are all too often untroubled either by thought about actual cultural tendencies and conflicts or by practical engagement in the criticism of art.

Since the late 1960s, interest in the revision of concepts of Modernism has been fueled by a general growth of studies in the history of modern art and of its accompanying criticism. The reconsideration of Greenberg's work has gathered momentum accordingly. In the process of that reconsideration, widespread attention has been given to three substantial and mutually reinforcing types of claim or premise upon which his characteristic arguments may be seen to depend. The materials assembled here provide further evidence of the crucial role that these claims play in the organization of his thought about art. One type of claim takes the form of universal statements concerning the psychology of esthetic judgments and the nature of taste. Greenberg saw taste as involuntary and intuitive in nature, and thus as incorrigible and objective. Much of his discussion in the essays is addressed not to what we contingently happen to do, but to what we cannot help but do. "You no more choose to like or not like a given item of art than you choose to see the sun as bright or the night as dark," he claimed in "Intuition and the Esthetic Experience" (p. 7). Though Greenberg saw judgments of taste as involuntary, he was not so consistent as to see them as incapable of revision or improvement. He conceived of taste as a faculty that could be "developed" or "cultivated" through increasing exposure to art—both through a broadening of the range of experience and through repeated encounters with the same works—

and through reflection upon what was seen (or heard, or read). In their very involuntariness, judgments of taste are thus revealing of the *degree* of "cultivation" of the individual's taste. It is for reasons of social insecurity, Greenberg implies, that the reporting of judgments of taste is often less than honest.

A second type of claim is contained in hypotheses concerning the nature of continuity in modern artistic traditions—hypotheses which have thus been of particular interest to art historians. Greenberg understood development in art as decided by processes of self-criticism in response to feedback from the medium in question—processes which lead to the elimination of dispensable norms and conventions. In "Modernist Painting," one of the most influential and most widely read of all his essays, he argued that "The essence of Modernism lies . . . in the use of the characteristic methods of a discipline to criticize the discipline itself—not in order to subvert it, but to entrench it more firmly in its area of competence. . . . " Under modern conditions, he continued, "It quickly emerged that the unique and proper area of competence of each art coincided with all that was unique to the nature of its medium . . . the enterprise of self-criticism in the arts became one of self-definition with a vengeance." In "Convention and Innovation," Greenberg dwells on the necessity of resistance from the conventions associated with specific artistic media if esthetic experience is to be communicated through "formalized art": "The record shows no case of significant innovation where the innovating artist didn't possess and grasp the convention or conventions that he changed or abandoned" (p. 53). To be avant-garde, according to his view, was never to perform a "radical break with the past," but always to transform the workings of a medium, as it were from within.

Claims of a third type take the form of evaluative judgments concerning recent and present works. Such claims often appear as specific applications of claims of the second type. This is to say that Greenberg's tendency was to establish the virtues of the work he admired by reference to a specifically "Modernist" tradition and to an inherited agenda of technical concerns and problems set by an existing canon of Modernist art—rather than, say, by reference to any topical concerns or socially critical values the work might be thought to express. It is first and foremost in

terms of artists' evident engagement with modern artistic conventions that the critical virtues of their work appear to have been established for Greenberg. Thus in seeking to define "American-Type Painting" in 1955, he characterized the work of Jackson Pollock as a form both of continuation and of criticism of earlier European developments: "Within a notion of shallow space generalized from the practice of Miró and Masson as well as Picasso, and with some guidance from the early Kandinsky, he devised a language of baroque shapes and calligraphy that twisted this space to its own measure and vehemence. Pollock remained close to Cubism until at least 1946, and the early greatness of his art can be taken as a fulfillment of things that Picasso had not brought beyond a state of promise in his 1932–40 period." In "Convention and Innovation" he writes in approval of Manet that he "knew from inside out the centuries-old convention of modeling-shading that he violated" (p. 52).The type of verdict made on this basis appears in its negative form in Night 4 in Greenberg's disparaging reference to Duchamp, who "misread Cubism when he saw Picasso's first collage constructions and thought this was a joke and came up with his bicycle wheel" (p. 122). The implication is that Duchamp failed to appreciate the significance of Cubism as a modern convention.

One has only to question a claim of one type to see how it is reinforced by the others. For example, asked for evidence that esthetic judgments are indeed involuntary and objective, rather than being governed by specific theories or individual preferences, Greenberg pointed to a "consensus [of taste] *over time*" (p. 26) which has settled on the defining high points of an artistic tradition. "In this durability [of taste]," he writes in "Can Taste Be Objective?", "lies the proof of its objectivity" (p. 26). If required to elaborate on a positive judgment made on the work of an individual artist, he would tend to describe the critical demands of a specific medium as these have borne down in practice: the ends to which "painting" or "drawing" would or would not permit itself to be put at any given moment, the types of illusion or reference or formal organization that could be sustained without loss of esthetic quality. In Greenberg's view it is through the evidence of feedback from the work in process that these demands are understood by the artist. The viewer who responds to

the end result with an esthetic judgment, and who goes on to inquire into the grounds of that judgment, must then in effect follow the self-critical procedures of the artist—who is for Greenberg the primordial critic of work in process. ("It is the taste of artists themselves that has kept high art going . . . ," he claimed on Night 6 [p. 145]. For the writer who proceeds to deliberate on a succession of such judgments, what may be uncovered is an apparent retrospective logic in the development of the given artistic medium—in other words, a view of the historical development of a tradition.

In Greenberg's scheme of things, then, artistic traditions are defined by connections which are first and foremost matters of relative esthetic merit—rather than, say, by utilitarian, or geographical, or even stylistic considerations. They are therefore most appropriately diagnosed and mapped in the light of intuitive esthetic judgments rather than socioeconomic or historical generalizations and theories, or through the findings of art-historical research or cultural studies. "Art has its history as a sheer phenomenon, and it also has its history as quality," he wrote in 1967 (in "Complaints of an Art Critic"); and again, in "The Factor of Surprise": "The life of a tradition of art is its quality" (p. 35).

If the clarity of Greenberg's descriptive writing and the unambiguous character of his views renders his work highly accessible to re-examination, it is also easy to see why the views should in themselves have proved so provocative to those—artists, critics, art historians, and advocates of cultural studies alike—for whom the prospect of intellectual progress seemed around 1970 to depend not upon the continuation of Modernist self-criticism but rather upon the critique of Modernism itself. The timing of the Bennington seminars in the spring of 1971 is a crucial factor in establishing their vividness as testimony. On the one hand they furnished a kind of public apogee to Greenberg's long and influential career as an observer of modern art, and as such they coincided with widespread interest in the Conceptual Art movement, which offers a strong case to be regarded as the first global manifestation of an artistic Postmodernism. On the other hand the seminars as delivered at Bennington initiated a long process

of summarization of Greenberg's theories about the indispensable role of esthetic judgment in cultural and art-historical generalization. Under this aspect they coincided with a sea change in the study of art history, the immediate effect of which was to place a virtual prohibition on expressions of esthetic interest. This change was itself part of a wider intellectual tendency of some significance at the time, in which the philosophical critique of originality and authorship and the social-historical critique of values gained a seeming priority over the celebration of individual artistic achievements and the formal analysis of esthetic effects. It is this moment of coincidence that gives a special interest to the body of material here gathered under the disingenuous title *Homemade Esthetics*, and that renders that material of topical interest to all concerned with the art and criticism of the modern period.

At a deep level, both the Conceptual Art movement and the revisionary art history of the early 1970s were responsive, often unwittingly, to historical currents working their way through in the aftermath of the major political conflicts of the first four decades of the twentieth century. These conflicts themselves had been principally European occasions, but their legacy gained new interest and relevance in the United States under the political conditions of the 1960s, and as academic careers in the humanities were opened up to previously excluded classes and constituencies. The currents in question bore within them memories of artistic practices and theoretical arguments by which the original conflicts had themselves been accompanied or which they had provoked—practices and arguments that had been implicitly marginalized in Greenberg's account of the modern tradition and by his concentration on painting and sculpture as the representative modern forms of what he termed "major art." Included among these marginalized materials were such artistic forms as readymades, photomontages, and agit-prop displays, and such intellectual resources as critiques of the class character of esthetic presuppositions. In the early 1970s avant-garde artists and academic art historians, each according to their different interests, sought to recover forgotten forms of significance from those earlier avant-garde episodes. And in doing so they were at times impelled

by a sense of radical virtue in face both of political conservatism and what looked like Modernist conservatism in art.

To each of the three types of claim outlined above, matching forms of counter-claim were beginning to be advanced or rediscovered during the period when Greenberg's seminars were held at Bennington. In fact, each of the three types of claim was subject to revaluation on the basis of a single crucial objection: that the notion of esthetic experience as involuntary and disinterested could not actually be justified. Reminders of the situated character of our response to works of art came to play an increasing part in the critique of Modernist theories in general. More radically, it was argued that the idea of esthetic experience is itself a misrepresentation, the effect of which is to add a spurious objectivity and universality to preferences which are based in the contingent interests of specific classes, or genders, or races. At their crudest, objections in this form were rooted in a vulgarization of the Marxist intellectual tradition that was to prove as congenial to barbarians of the right as of the left during the 1970s and '80s. It is of some ironic significance that the objectors were echoing in unwitting and distorted form those urgent debates on avant-gardism and realism that had preoccupied certain mostly expatriate writers on the European left during the 1930s— writers who were then working to articulate an opposition to Fascism which was yet free of the increasingly anti-Modernist tendencies of Stalinism. The irony resides in the fact that Greenberg's own "Avant-Garde and Kitsch" of 1939 was written as a contribution to those very debates—albeit from a distinctly American position.

Those who have taken serious issue with Greenberg's work since the early 1970s have in essence asked one or other of three types of question. The first is: How do we know that an effect described as esthetic has the specific work of art as a necessary condition of its occurrence, and that it is not, for instance, a mere manifestation of the psychological preoccupations and interests of the observer? The implication here is that the natural workings of human psychology cannot of themselves be used to justify separating out certain aspects of our experience—and certain causes of that experience—under the definition "esthetic,"

and that any such separation is therefore due some skeptical scrutiny as to its motivation.

The second question is: On what grounds are decisions made about what considerations are and are not relevant to the business of judging works of art? The criticism implied here is that it is mere idealism to claim that art can have meaning and value as "form," independently of what art is made of—including what it is made of economically, politically, morally, or psychologically. Greenberg writes disparagingly in "The Experience of Value" of "all the excavating . . . for meanings that have nothing to do with art as art" (p. 63). The criticism such statements attract is that the idea of "art as art" serves to insulate the artistic canon as Greenberg conceives it, and to exclude aspects and "meanings" damaging to his theoretical account. Were art to be regarded, say, as a mode of social production or as historical testimony, we might find ourselves making judgments on the basis of other evidence than mere form.

The third question is: By what kinds of argument are esthetic judgments connected to accounts of art-historical developements? The implied suspicion here is again that the apparent coherence of a retrospective account—such as the one Greenberg offered in "Modernist Painting"—may merely be a consequence of certain aspects and types of work having been eliminated from consideration in the first place, so that potential counter-examples are automatically rendered of no account. The thoroughly illusionistic work of Salvador Dali, for example, could not easily be said to support the notorious claim made in that essay that "Modernist painting oriented itself to flatness as it did to nothing else." Greenberg does not refer explicitly to Dali in this essay, but an appropriate response to the objection can be readily extrapolated from the larger body of his work: that the thesis of "Modernist Painting" is a thesis about "major art," that the work of Dali is no better than minor, and that it has therefore no relevant status as an exception; that, on the contrary, the esthetic response and the theory are mutually supportive, each corroborating the validity of the other. Admirers of Dali's work might want to object that the argument is circular; that the supposedly intuitive judgment on Dali's work was actually one that must

have been formulated post hoc according to the requirements of
the thesis, or that the thesis about "major art" was no more than
an attempt to ratify a set of personal preferences which can have
no real objective status. (Of course, the objection is a weak one
if all it amounts to is a positive judgment on Dali's work in place
of a negative one, and if it is unsupported by any compelling
alternative account of the relevant art-historical development.)

This, then is the wider context in which Greenberg's Semi-
nars need to be read—a context defined on the one hand by the
long accumulation and reiteration of theoretical tenets and crit-
ical judgments within his own work, on the other by a swelling
chorus of dissent both from these tenets and from many of his
specific judgments. The Seminars are the work of a writer de-
terminedly opposed to a tide of opinion. Greenberg's first explicit
foray into the field of esthetics gains greatly in significance from
the increasing skepticism to which the whole idea of esthetic
judgment was being subjected at the time. A great deal can be
seen to hang on the first of the claims cited above: that there is
a category of experience that can justifiably be singled out as
esthetic, and that the judgments that follow are indeed disinter-
ested. Responding to an interlocutor after the first of the Ben-
nington "Nights," Greenberg claims that "When we say 'art,' we
mean something we have experience of" (p. 84). His intention
here as elsewhere was to draw attention to the indispensable
function of the direct empirical encounter in all considerations
of value. But a listener of a skeptical persuasion might have fol-
lowed the implications of the statement into quite another logical
space and asked, "Who is it that counts as 'we'?" If it is "the
consensus of taste over time" that has established a canon of
"major works"; and if that consensus is not actually objective—
if it might rather be the reflection of some power, such as the
relative power vested in a class, a gender or an imperial nation—
then why should any special authority be allowed to the canon
by those who are not similarly empowered, or by those in sym-
pathy with the disempowered?

This is clearly a vexed and substantial question, and one of
which Greenberg himself was well enough aware. In the course
of discussion on Night 6 he referred with evident distaste to a
published thesis to the effect that "Pure art and autonomous art

[is] something that the ruling classes have put up to emphasize their difference from the masses" (p. 150). But it is significant that when an interlocutor on the third night at Bennington sought to distinguish between "time showing something to be objective" and "time making something objective," Greenberg responded to what was in fact a question about the role of power and authority in establishing cultural history as though it could be adequately answered by distinguishing between taste and opinion in judgments on art (pp. 108–9). And what would our unsympathetic listener have made of Greenberg's assertion, on the concluding night at Bennington, that "The great increase in numbers of the middle classes since the onset of industrialism has constituted a steady threat to high culture, and the avant-garde is part of high culture's answer to that threat" (p. 190)?

It should be clear that it is not only the principled basis of Greenberg's own criticism that is at issue here, but also the entire system of priorities sustaining the concept of "high" art in criticism and art history. As we might expect, that system rests on a set of connected assumptions to which the grounding claims of Greenberg's criticism are closely related. One assumption is that the value—indeed the very *existence*—of art resides in nothing so much as its esthetic merit. "When no esthetic value judgment, no verdict of taste, is there, then art isn't there either . . . " Greenberg asserts in "The Experience of Value" (p. 62). A second assumption is that for purposes of criticism and art history the decisive historical developments are those which link together works of the highest esthetic merit—what Greenberg refers to as "major art" (see especially the conclusion to "The Factor of Surprise"), and elsewhere as "the all-out try in the sense of high seriousness" (Night 6 [p. 144]). A third assumption is that where esthetic judgments are in conflict with judgments of moral or political virtue, it is the grounds of moral or political judgment that should be questioned first. The point for Greenberg was not that the values of art supervened over all others. "It is a subordinate value as against the weal and woe of human beings, as against the happiness and suffering of any single human being," he insisted on the opening night at Bennington (pp. 80–81). It was the involuntariness of intuition in esthetic response—and the commitment of the whole person in the giving of that response—

that gave the esthetic its singular validity. "Esthetic intuition commands the world as nothing else can," he asserted in "Intuition and the Esthetic Experience," adding the all-important rider, "—for human consciousness." And at the outset of "The Language of Esthetic Discourse," "The sole issue is value, quality" (p. 65). Around that one word "sole" a weight of controversy gathers. There can be no doubt as to Greenberg's awareness of this weight. The evidence of his own arguments is that that awareness outweighed all other factors in motivating the intellectual enterprise that *Homemade Esthetics* represents.

The particular forum in which Greenberg was invited to deliver his seminars was not one where the oppositional chorus was likely to be heard at its loudest. Bennington was something like home ground for him, and he was later to express his disappointment that the audience had not been more challenging in its responses. Nevertheless, the preoccupations of the oppositional chorus are clearly represented, both in the occasional concerns voiced in the ensuing discussions and, more tellingly, in Greenberg's own anticipation of those preoccupations and in his attempts to address them. Among the clearest examples of the latter are his acknowledgment, during the third night at Bennington, that "the question of being able to discriminate quality in art seems . . . improper to touch on in public nowadays" (p. 107), and his evident concern to redress the current standing of Duchamp, depending as this did on that artist's role as the author of such early avant-garde forms as the readymade, on his status as example to the avant-garde movements of the late 1960s and early '70s, and on his usefulness as a resource of demonstrations for emerging anti-Modernist forms of criticism and art history. It was Duchamp who had first effectively proposed that the status of art could be acquired by an object apparently devoid of intrinsic esthetic interest. It was thus crucial to Greenberg's position that Duchamp's reputation be explained in terms that would not also serve to validate his enterprise. The argument he offered was that the Dadaist's gesture was not a truly critical assault upon the authority vested in the esthetic but rather a "flight from taste," and as such the type of an avant-gard*ism*— an avant-gardism adopted as an attitude rather than a necessity— which he saw as now prevalent among those unwilling to

meet the stringent demands that "cultivated taste" represented (p. 170).

These clear signs of address to the immediate context of debate occur more frequently and are more extensive in the original Bennington seminars than in the subsequently published texts. The comparison is highly instructive. It is to a large extent this very difference of address that animates the relationship between spoken and printed versions. In the spoken seminars the presence of the art world and of its preoccupations is more readily felt than in the printed texts. The latter are more clearly addressed to the larger if less animated world of philosophical esthetics. In the conclusion to the printed "Can Taste Be Objective?" for instance, the agenda of theoretical issues raised by the work of Duchamp is dismissed with the remark that if art can do without taste, then we might as well do without art. (Though under the circumstances this could not be the last word on the artist that Greenberg had to offer in the essays. He returned in "Convention and Innovation" to the issue of Duchamp's "institutionally viable" but "raw" and "unformalized" art.)

In the very opening statement of the Bennington Seminars, Greenberg defined the context of debate from the perspective of his own values. Attention to the contemporary art of the past ten years was to reveal "certain truths about art that no philosopher of esthetics could have discovered before" (p. 79). The revelation that some of his audience might well have expected from recent art—if not from Greenberg—was that esthetic values were inescapably contingent. It is significant that an interlocutor on that first night protested that morality and esthetics were not to be separated "at a time when civilization itself is threatened" (p. 82). What Greenberg had in mind, however, was a quite different two-fold agenda: on the one hand to reassert what he saw as the indispensable and indissoluble link between art and the intuition of esthetic value; on the other to argue *against* the "far-out" art of the past ten years and the present and *for* what he saw as the still challenging art of an unbroken Modernist tradition.

Greenberg's assault on the "far-out" had already been rehearsed in lectures and in print. But the Bennington audience may have been surprised at the form his argument took on this

occasion. What he did was to associate the "far-out" art of the present with the academic art of the nineteenth century; to represent it as too safe, too easy, too immediately popular—just as he had argued over thirty years ago that kitsch effectively displaced the art of the avant-garde by rendering its difficulty consumable. And as to the recent abstract painting and sculpture to which he had already given public support, if there were any in his audience who shared the growing opinion that this work was too predictable—too readily accommodated to an established Modernist esthetic, too evidently dependent upon the expensive conditions of its display—they may have been taken aback by Greenberg's characterization of it as "malicious" (Night 9, pp. 184–85). A century and more previously, he suggested, the "best new art" had appeared malicious in confounding expectation and in exposing opinion. The malice of recent abstract art, he proposed, lay in its tendency "to mask itself as conservative" (p. 185). In other words, those he stigmatized as "the middle-brow followers of modernist art" (p. 184) had been caught out by a form of drastic reversal. This, then, was the promised lesson to be learned from the contemporary art of the past ten years—the lesson that Greenberg finally delivered on the ninth and last night at Bennington. The received wisdom about the history of modern art had been turned upside down: given that the academic had come to represent itself in the forms of the "far-out," the response of the truly avant-garde was to cloak itself in a seeming conservatism, and in doing so to demonstrate that the disruptions of the past hundred years of modern art "had never been more than apparent" (p. 184).

At the outset of Night 2 Greenberg had declared that "disagreements about art should never be taken personally," since, "when you can't help yourself, you can't be blamed" (p. 89). But of course to criticize a judgment of taste is inescapably to question another person's experience—its depth and its value. Indeed, if "taste means everything that is in you is in your eye," as Greenberg was to claim elsewhere (in a TV interview with T. J. Clark recorded by the Open University in 1981), what form of criticism could be more far-reaching? Given that Greenberg's esthetic theories were formed in the context of a critique of modern art and culture as a whole, it is reasonable to understand his "everything"

as referring to the sociological underpinnings of esthetic responses as much as to their psychological depth. The implications of judgments of taste could be said to go all the way down in both senses. In setting himself against what was to prove the prevailing taste of the age, Greenberg was thus making his own "everything" bear some considerable weight in a far-reaching debate on the question of where esthetic merit was now to be found.

The argument itself is of more interest than any single resolution is likely to be. What can perhaps be said already—less than thirty years since the Seminars were first delivered—is that if some of the artists Greenberg then supported seemed to suffer a considerable decline in the quality of their work through the 1970s and '80s (even according to criteria which he might have had to allow as relevant), as much—or as little—could be said about many of those who would fall into his category of "far-out" artists, and of course their overall number was greater. Beyond that point we can perhaps leave the relative merits of "conservative Modernism" and "far-out Conceptualism" to be decided, if not in the spirit of Greenberg's own admonitions, by the "consensus of taste over time," then at least in some appropriate process of discussion and edification.

There are two substantial conclusions that can be offered here, however. The first is that our beliefs regarding the status and possibility of esthetic judgments must powerfully affect the way we understand continuity and discontinuity in art and culture—and must thus in turn decide the historical significance we attach to human production at its most imaginative and its most intense. Do we come to understand art through history and the critique of history, and are our judgments about works of art corrigible in terms of what we may have to learn about the conditions of their production and about the conditions which they may somehow in turn reproduce? Or are our intuitive responses to art the means by which history is made most vividly present to us, guarding us against the sentimental self-images and spurious certainties of our politics and our morality, holding before our minds as no other documents can the irrefutable evidence of what we have been and are, both at our worst and at our best? Since the early 1970s controversy in art history and art criticism

has often been conducted as though these positions were mutually exclusive: as though art must either be judged *or* explained; as though we have to take sides in an argument in which it is either true that historical inquiry is properly inhibiting to esthetic judgment, or that esthetic judgment properly renders historical inquiry subordinate or even irrelevant.

By those arguing for the priority of historical inquiry, Greenberg has often been represented as speaking for an esthetics indifferent to the evidence of history. Yet the idea that the respective priorities are mutually exclusive is not one that emerges from a careful reading of his work. It is certainly true that he tended to concentrate his discussion of esthetic quality on the psychology of individual responses and on those factors by which such responses were liable to be compromised. He was very chary of the notion that what he called esthetic quality might be conceived as a property entirely inhering in some objects rather than others, and in that sense independent of the mind by which it was intuited. But if the test of objectivity in the findings of taste is that it settles in the end on the "best" art, there must surely be some implicit assumption that that "best" is not merely a property attributed to the works in question, but is somehow a consequence of how they were produced—and thus of their status as testimony to the experienced conditions of their time. Otherwise how could the repeated recognition of that relative merit be any kind of test of objectivity? Greenberg comes close to making this assumption explicit at the very end of the Bennington Seminars, when he suggests that in "what keeps avant-garde art going ... there's ... some kind of immanent logic—autonomous logic, or autonomous dynamism—at work" (p. 191). Ten years later, in speaking of the paintings of Mondrian, he was to suggest that "when they work there's a world of experience in them," adding "And it's not by accident either" (interview with T. J. Clark, 1981). The implication seems to be that we should conceive of esthetic intuition—indeed, of taste itself—as response to the realistic evidence of human history, and thus as itself an answering kind of realism. If this implication is indeed justified, then it might validly be argued that developed taste is a sounder basis upon which critically to assess human potential and human failings—more reliable because less sentimental—than those

forms of historical and sociological critique which would identify taste merely with preference and interest, however well such critiques might seem to comport with the moral or political convictions according to which we attempt to regulate our lives. It is the possibility that this argument might be sustained that justifies the central and in the end most provocative assertion of Greenberg's *Homemade Esthetics*: the assertion that "The sole issue is value, quality."

The second conclusion is that while no individual can claim infallibility for their acts of discrimination, there can be no question but that discrimination is the first and indispensable responsibility of the critic. Whether or not the passage of time supports Greenberg's judgments on "the contemporary art of the past ten years," he is surely deserving of support in his belief that "when no verdict of taste is there . . . then art isn't there either." Without the exercise of a critical and self-critical taste on the part of the artist there is no art worth the imaginative exertion. It is art's indispensable function to stimulate such exertion, both in the lives of individuals and in the critique of culture as a whole.

In insisting on this truth, Greenberg's work avails us of an important safeguard against wishful thinking in other areas. We are nowadays often encouraged to believe that a broad consensus of values is the necessary condition of a stable civil life. Given the difficulty of reconciling developed taste with consensus, we may be persuaded that the exercise of discrimination is somehow undemocratic. If it is, however, so—for better or worse—is art. Greenberg's harshest judgment against the art he called "far-out" was that it was driven by the desire to make "qualititative inferiority beside the point" (p. 159). It can certainly be said that he was unjust to much of the art and to many of the artists that this condemnation was intended to include. Yet it can also be said that there is indeed some art which has that desire as a significant motivation. And of this art it can with justice be said that it is at one with all that has proved most thoroughly deserving of condemnation in the political and economic culture that the 1970s were to usher in, however assiduously that culture might seek to clothe itself in the garb of "values," "excellence," and "quality."

True pluralism has its virtues, nevertheless. For all his insistence on the need for openness in the approach to art, Greenberg was certainly no pluralist. Yet the example of his discrimination remains indispensable. The era in which we find ourselves is one that has seen a massive increase in the amount and variety of published writing on art. But this era has still to produce a critic who does not appear indecisive and inarticulate in comparison with Clement Greenberg.

Part I
The Essays

music criticism

SEMINAR SEVEN : *Use of Esthetics*

Results are all that count in art qua art. ~~Art as edification, instruction, document is not art qua art.~~

Results here mean verdicts of taste, judgments of esthetic

value. These constitute, ~~a~~ & are constituted by, the in-
tuitive experience of ~~art~~ (See "Seminar). *as art -- that in intuitive experience in the* *esthetic* *mode* ~~The~~ ~~Where the~~ ~~,a~~ insofar as it's art,)
discussion of art as art, has to start ~~from results.~~ *It's w. this kind of results that the*

~~has to return to results. And nothing else. And~~ *eventually to return* ~~it ought to and there too~~ ~~The results of intuition~~ *they that Art can be , x-* ~~in the esthetic mode. This isn't to prohibit the discussion~~ *talked about)* *in terms of other than esthetic results,* ~~of any~~ under other aspects, but it is to insist that when
-- as edification or instruction, as doc-- art is discussed under other aspects, it's being discussed
, for the responsible art critic, as something other than art. And ~~it's also to insist that/~~
And be approached) ~~art as art, as art in the first place, whatever else it may~~ ~~be or~~ ~~be in the second or third.~~ *metaphor)* *to use a temporarily useful*
~~The "crunch" (as must be said nowadays)~~ *For aesthetics)* comes in criticism *Theory* *Fechner, quote*

For esthetics, ~~the~~ esthetic theory, the "crunch"
(to use a temporarily useful metaphor) comes
in criticism ~~The art critic is the only and~~
appreciation

INTUITION AND THE ESTHETIC EXPERIENCE

Here are some definitions of the word "intuition." "The direct and immediate apprehension by knowing a subject of itself, of its conscious states, of other minds, of an external world, of universals, of values or of rational truths" (Ledger Wood in *The Dictionary of Philosophy*, Philosophical Library, c. 1950). "Direct or immediate insight" (*Oxford English Dictionary*). "The immediate apprehension of an object by the mind without the intervention of any reasoning process . . . " (ibid.). Also: "In receiving Intuitions, the mind exerts no conscious activity" (Francis Bowen in *A Treatise on Logic*, 1870, as quoted in the *OED*).

Intuition is perceptive: it is seeing, hearing, touching, smelling, tasting; it is also registering what goes on inside your own consciousness. No one can teach or show you how to intuit. If you can't tell for yourself what heat or cold is like, or the color blue, or the sound of thunder, or remembering—if you don't know these things by yourself and for yourself, nobody else can tell you.

As Croce says in his *History of Aesthetics*, existence, experience, knowledge are unthinkable without intuition. So is esthetic experience as such, art as such. But there is a crucial difference between the way ordinary or primary intuition—which is necessary to existence, experience, knowledge—makes itself felt and the way esthetic intuition, which is not necessary to anything at all, does. Ordinary intuition informs, apprises, orients you, and in doing that always points to other things than itself, to other things than the act of intuition itself. Ordinary intuition does this even when furnishing data for pure knowledge, for knowledge valued for its own sheer sake; even here the act points to something other than itself: that is, to data.

The moment, however, that an act of intuition stops with

itself and ceases to inform or point it changes from an ordinary intuition into an esthetic one. An esthetic intuition is dwelled on, hung up on, relished—or dys-relished—for its own sole sake and nothing else. The intuition that gives you the color of the sky turns into an esthetic intuition when it stops telling you what the weather is like and becomes purely an experience of the color. The same conversion takes place when the intuition of the taste or smell of wine is received for its own sake as a taste or smell instead of for what it means in the way of allaying thirst. The same happens with the recognition that two different things cannot be one and the same when the intuition involved here is savored for itself and doesn't lead to thought or action. (This last is a far-fetched example, but it's not an impossible one.) In short, esthetic intuition is never a means, but always an end in itself, contains its value in itself, and rests in itself.

The difference between ordinary and esthetic intuition is not blurred by the fact that the former is a necessary condition of the latter. Of course you have to have the use of at least some of your senses in the ordinary way, and have to be able to be aware in the ordinary way of at least the surface of your consciousness, in order to have any esthetic experience at all. Yet the difference between registering an intuition as a means and registering it as an end in itself remains, as I've said, a crucial one despite everything that might seem tenuous about it.

It's implicit in what I have said above that anything that can be intuited in the primary mode can also be intuited in the esthetic mode. This, to me, seems a fact of experience. But I'd go even further, with the support of experience, and say that things not intuited in the primary mode, things remaining beyond the reach of intuition in that mode, can likewise be intuited esthetically. I mean entities like inferences, chains of reasoning, deduced knowledge. Unlike primary or ordinary intuition, the esthetic kind has no limits set to it. Which means that anything that's experienceable at all, anything at all that enters awareness, can be intuited and experienced esthetically. In other words, esthetic intuition commands the world as nothing else can—for human consciousness. (But of this, more later.)

The turn from ordinary to esthetic intuition is accomplished by a certain mental or psychic shift. This involves a kind of dis-

tancing from everything that actually happens, either to yourself or to anyone else. Consciously or non-consciously, a mind-set ensues whereby that which enters awareness is perceived and accepted for its own immediate sake; not at all for what it might signify in terms of anything other than itself as an intuition in the present; not at all for its consequences; not at all for what it might mean to you in your particular self or to anyone else in his or her particular self; not at all for the bearing it might have on your interests or anyone else's interests. You become relieved of, distanced from, your cares and concerns as a particular individual coping with your particular existence.

If anything and everything can be intuited esthetically, then anything and everything can be intuited and experienced *artistically*. What we agree to call art cannot be definitively or decisively separated from esthetic experience at large. (That this began to be seen only lately—thanks to Marcel Duchamp for the most part—doesn't make it any the less so.) The notion of art, put to the test of experience, proves to depend ultimately, not on skillful making (as the ancients held), but on that act of distancing to which I've just called attention. Art, coinciding with esthetic experience in general, means simply, and yet not so simply, a twist of attitude toward your own awareness and its objects.

If this is so, then there turns out to be such a thing as art at large: art that is, or can be, realized anywhere and at any time and by anybody. In greatest part (to put it weakly), art at large is realized inadvertently and solipsistically, as art that cannot be communicated adequately by the person who realizes or "creates" it. The esthetic intuition of a landscape when you don't convey it through a medium like language, drawing, music, dance, mime, painting, sculpture, or photography belongs to yourself alone; nevertheless, the fact that you don't communicate your intuition through a viable medium doesn't deprive it of its "status" as art. (Croce had a glimmering of this.) The difference between art at large and what the world has so far agreed to call art is between the uncommunicated and the communicated. But I don't find it a difference that holds.

Everything that enters awareness can be communicated in one way or another, even if only partly. The crucial difference is not between the communicated and the uncommunicated, but

between art that is presented in forms that are conventionally recognized as artistic and art that is not fixed in such forms. On the one side there is unformalized, fleeting, "raw" art, and on the other there is art that is put on record, as it were, through a medium that is generally acknowledged as artistic. Yet even this difference is a tenuous one: a difference of degree, not of experienced essence or of demonstrable "status." You can't point to, much less define, the things or the place where formalized art stops and unformalized art begins. (Thus flower-arranging and landscape architecture can be said to belong to either, though I myself would claim that they both belong very definitely to formalized art. There are other such cases. It's the great theoretical service of the kind of recent art that strives to be advanced that it has made us begin to be aware of how uncertain these differences are: the difference between art and non-art as well as that between formalized and unformalized art.)

As I've already said, esthetic intuition gets experienced as an end in itself, which means as an ultimate, intrinsic value (or, as the case may be, a dys-value). Moral value can be experienced that way too. And some philosophers hold that moral value, insofar as it is final and intrinsic, is likewise accessible only to intuition (and intuition of a kind, moreover, that's hard to differentiate from esthetic intuition). However, there is also a kind of moral value that is not intrinsic, but instrumental and which can be arrived at through reasoning, not through intuition. (Every human being is a final, ultimate, intrinsic value; this can't be proven or reasoned out; it can only be intuited. But the means by which human life is maintained can be reasoned out and reasoned about, and are relative, instrumental.) Esthetic value is never instrumental or relative. It identifies itself by being altogether intrinsic, final—and utterly and immediately *present*. By affording value of this kind, esthetic experience constitutes itself as what it uniquely, irreplaceably, is.

Esthetic intuition is entirely a matter of value and valuing— nothing else but that. With the same immediacy as that with which ordinary intuition registers the *properties* of things (to borrow G. E. Moore's distinction), to wit, their descriptive, identifying attributes, so esthetic intuition registers value and values. Which means that you don't, and can't, experience art or the

esthetic, *as* art or the esthetic, without judging, evaluating, appraising. To the extent that something is intuited or experienced esthetically, to that same extent is its esthetic value appraised, evaluated, judged (whether consciously or non-consciously). There's simply no separating esthetic intuition from evaluation; it can't be imagined or thought of without that.

Esthetic evaluating means, much more often than not, making distinctions of extent or degree, of more or less. Relatively seldom does it mean a flat either-or, a yes or no, a guilty or not guilty. Esthetic judging tends to mean shading and grading, even measuring—though not with quantitative precision, but rather in the sense of comparing (and there's no refining of esthetic sensibility without exercises in comparing). Esthetic evaluating is more on the order of appraising and weighing than on that of verdict-delivering—even though it so often has to sound like a verdict, pure and simple, when expressed in words.

The intuition of esthetic value is an act of liking more and less, or an act of not liking more and less. What is liked or not liked is an affect or a group of affects. Esthetic value or quality *is* affect; it moves, touches, stirs you. But affect here is not to be equated with anything so "simple" as emotion; esthetic affect comprehends and transcends emotion; it does that in being of value and in compelling you to like it more or less. Value doesn't provoke emotion. Esthetic value, esthetic quality can be said to elicit satisfaction, or dys-satisfaction, but this is not the same thing as emotion. Satisfaction or dys-satisfaction is a "verdict of taste."

From everything I've said so far it ought to emerge that esthetic judgment is not voluntary. This should hardly need stating. All intuition, whether ordinary or esthetic, is involuntary in content or outcome. Your esthetic judgment, being an intuition and nothing else, is received, not taken. You no more choose to like or not like a given item of art than you choose to see the sun as bright or the night as dark. (What is chosen or willed is the placing of your attention, but that placing, as such, has little to do directly with your intuition as such.) To put it in other words: esthetic evaluation is reflexive, automatic, immediate, not arrived at in the least through willing or deliberation or reasoning. (If

this were kept better in mind, there might be less rancor in disputes about art. But it would not, I'm afraid, induce people to report their esthetic judgments more honestly.)

Immanuel Kant (who had more insights into the nature of esthetic experience than anyone else I'm aware of) held that the "judgment of taste" always "precedes" the "pleasure" gained from the esthetic "object." It's not necessary here to go into the reasons he gave for saying this. I'd rather go into the reasons my own experience offers for agreeing with him. I would say that the very involuntariness of the intuition that is the esthetic judgment does not so much precede the "pleasure" as enable you to commit yourself to it. That the judgment is received instead of taken makes it felt as a necessary one, and its necessity frees and surrenders you to the commitment. A judgment taken deliberately would lack such necessity; the "pleasure" would be infected with possible qualifications and doubts. (It would be the same way if the "object" gave you dys-pleasure instead of pleasure.) In short: If the judgment of taste precedes the pleasure, it's in order to *give* the pleasure. And the pleasure re-gives the judgment.

Whether Kant's separation of the judgment from the pleasure is meant in a temporal or logical sense, I'm not expert enough to tell. My reading, along with my experience, insists on the latter sense. I find it impossible to separate the "moment" of judging from the "moment" of pleasure in any but a metaphorically logical way. The judging and pleasure mean one another and are therefore synchronous. The pleasure—or dys-pleasure—is *in* the judging; the judging gives the pleasure, and the pleasure gives the judging.

In his *Critique of Aesthetic Judgment* Kant also speaks of esthetic pleasure as consisting in the "free play" and "harmony" of the "cognitive faculties"; in their "harmonious activity"; and in the "easier play of both mental powers—imagination and reason—animated by their mutual harmony." All this is occasioned by the esthetic object, which is itself a "given representation" such as is "generally suitable for cognition." This, despite there being no cognition as such, no addition to knowledge involved in esthetic experience as such. (Which doesn't mean that some sort of addition to knowledge can't be a corollary of esthetic experience, even if it's only the knowledge of having had the experience.)

I don't have to accept Kant's particular designation of the mental faculties in order to find that the gist of what he says about the role of cognitive activity in esthetic experience is confirmed by my own experience. As I sense it, as I introspect it, the affect or pleasure of art (when it does give pleasure) consists in a "sensation" of exalted cognitiveness—exalted because it transcends cognition as such. It's as though for the time being, or for the instant, I were in command, by dint of transcendent knowing, of everything that could possibly affect my consciousness, or even my existence. I *know*, and yet without having anything specific to know. Definiteness in this respect would extinguish the sensation. For it is a question of "ness"-ness, not of what-ness; of a state of consciousness, not of a gain to consciousness. The more "general" the affect, the more embracing or comprehensive is the state of cognitiveness—and also the more challenging. A certain picture, a certain passage of verse, a certain piece of music can make you feel unequal to the exaltation of cognitiveness with which it floods you; those are the supreme works.

What is ordinarily meant by emotion is swallowed up in esthetic experience (when the latter is "pure" enough). It's as though the affect or state of cognitiveness contained emotion, along with everything else—sensory experience and intellection and knowledge—and, in containing what it did, transcended it. Emotion, sense perception, logic, knowledge, even morality become known, felt, sensed from outside themselves, from a vantage point that controls and manipulates them for the sheer sake of consciousness. ("Distancing" enters in again.) The pleasure of esthetic experience is the pleasure of consciousness: the pleasure that it takes in itself. To the extent that esthetic experience satisfies, consciousness revels in the sense of itself (as God revels in the sense of himself, according to some theologians).

This state of exalted cognitiveness or consciousness *is* esthetic value or quality. Inferior art, inferior esthetic experience shows itself in failing to induce this state sufficiently. But all art, all esthetic experience, good and bad, promises or intimates a promise of it. And it's only esthetic intuition—taste—that can tell to what extent the promise is kept.

ESTHETIC JUDGMENT

Certain axiomatic truths about art have to be harped on. If they are not kept in mind somewhere, there's the constant danger of being beside the point when talking about art, about any kind of art.

I don't think it's appreciated enough that esthetic judgments, verdicts of taste, can't be proven or demonstrated in the way it can be that two plus two equal four, that water is composed of what is called oxygen and what is called hydrogen, that the earth is round, that a person named George Washington was our first president, and so on. In other words, that esthetic judgments fall outside the scope of what is ordinarily considered to be objective evidence.

Kant was the first one I know of to state (in his *Critique of Aesthetic Judgment*) that judgments of esthetic value are not susceptible of proof or demonstration, and no one has been able to refute this, either in practice or in argument. Yet there are ever so many people who should know better who continue to believe that esthetic judgments can be proven in more or less the same way that statements of facts can be. Why, anyone in his right mind—they'll say—can be shown in a hard-and-fast way that Beethoven is better than Irving Berlin or the Beatles, or that Raphael is better than Norman Rockwell or Peter Max, that Shakespeare is better than Eddie Guest or Bob Dylan, that Tolstoy is better than Harold Robbins. But a great many people who are in their right minds do prefer the Beatles to Beethoven, Peter Max to Raphael, Bob Dylan to Shakespeare, and Harold Robbins to Tolstoy; they may not all say this, but they show it in what they choose to listen to, look at, hear, or read. Is this just because nobody has taken the trouble to prove to them that

they are wrong? If so, why hasn't anyone taken the trouble—
which shouldn't be all that much trouble if esthetic judgments
actually can be proven in anything like the way in which factual,
logical, and scientific propositions can be?

I've been talking about comparative esthetic judgments. But
it's the same with absolute ones. The fact is that no one has yet
been able to prove that Beethoven, Raphael, and Shakespeare are
any good at all, that any art is any good at all—or, for that
matter, that most art is no good or hardly any good at all.

To try to show in some detail just how impossible it is to
prove an esthetic judgment, I've chosen a case from literature
(verbal art is the easiest to deal with on paper). Here are two
passages of verse, both about the month of April (both can be
found in Stevenson's *Home Book of Quotations*). The first is by
Sir William Watson (1858–1935), who was knighted for his poetry
and just missed becoming a poet laureate of England:

> April, April
> Laugh thy girlish laughter;
> Then, the moment after,
> Weep thy girlish tears!

The second one is by T. S. Eliot from *The Waste Land*:

> April is the cruelest month, breeding
> Lilacs out of the dead land, mixing
> Memory and desire, stirring
> Dull roots with spring rain.

There's no question for me but that the four Eliot lines are far
better as art. But try to prove, in the compelling way that belongs
to proof, that this is true, that everybody in his or her right mind
has to agree with me in accepting it as true that Eliot's four lines
are better art than Watson's.

Both are in trochaic meter, with the stress on the first syllable
of each foot (as though both poets took their key from the tro-
chee of "April" itself). Is Eliot's passage better than Watson's
because it is unrhymed, and Watson's isn't? How can this
be *proven*, without starting from the secure assumption that

unrhymed is *always* better than rhymed verse? Or is the Eliot better because it's slower paced and because it contains more long vowels? Is slower paced *always* better than faster paced verse? Do long vowels *always* make for better verse? Of course not.

But may not the fundamental reason why the Eliot passage is better than the Watson be that taking a grim view of April is *always* better artistically than taking a fond and gently sexual one? How can we found this assumption, get universal agreement to it, so that it can be safely used as the major premise of an irrefutable syllogism? This sort of syllogism is what is required to demonstrate esthetic judgments, absolute as well as comparative ones. If we could be sure that every grim view of April worked better artistically than a less than grim one, then we'd be able to show in a clinching way that Shakespeare's "Proud-pied April dressed in all his trim/Hath put a spirit of youth in every thing" suffered artistically because of the cheerful view it takes. We would be able to compel agreement with this verdict in the same way that we can compel everybody to agree that Socrates was mortal because he was a man, and all men are mortal.

But esthetic judgments are (as I've said) absolute as well as comparative. If they could be proven at all, then they would have to be proven in isolation too. It would have to be proven just how good the Eliot "quatrain" is all by itself, and not just by comparison with Watson's. And it would also have to be proven just how bad the Watson quatrain is all by itself, and not just by comparison with Eliot's. (It may be that all esthetic judgments are somehow comparative in the end. I don't happen to think so, even though I do believe that taste is developed only through the making of comparative judgments.) To prove just how independently, intrinsically, or absolutely good the Eliot passage is would require more than a statistical registering of the frequency with which members of artistically favorable classes of properties occur in it. What would also be required is that these classes themselves be ranked hierarchically in order of their artistic weight. Is the grimness of Eliot's view of April more decisive than the rhythms and cadences, or the word choices or word order, or syntax, that body forth that view? How much do the

long vowels count for, or the absence of rhyme, or the irregular number of syllables from line to line? All these questions would have to be settled in order to prove just how good as poetry Eliot's four lines were all by themselves. (And there would also be the question of how well they functioned artistically as part of the much longer poem of which they are the beginning. And of how much weight was to be given to that functioning as against everything else in those four lines.)

In my experience, Eliot's grim view of April is fused inextricably with the rhythms, the word choices, the long vowels, and all the rest. If this is so, then *fusion* becomes another class of artistically favorable properties that has to be isolated and defined so that it could afford a major premise from which the merit of Eliot's four lines could be deduced. But isn't a property like fusion a matter of degree or intensity rather than frequency? And how is degree of fusion to be made measurable? For it would have to be made that in order to provide a basis for proof, whether of absolute or relative artistic quality. I happen to find the Watson passage "fused" too, with its view of April borne out in the jauntiness of its rhythm, in its word choices and word order, in its varying of the syllable count from line to line, and so forth. But just how *much* fused is it? And if that could be measured, and it were found that there was fusion to the highest possible degree, how much would that decide as to the quatrain's absolute or relative artistic value?*

And so, in order to fix the invariably favorable properties of the art of versification or poetry so that they can be classi-

* The fact is that Watson was a *skilled* versifier. How is the factor of skill, too, to be isolated so that it can be quantified, and then weighed, in an esthetic judgment? I have my doubts as to how skilled a versifier Eliot was—beyond a certain point. Also, my taste can pick faults in his four April lines that have nothing to do with skill in versifying: as effectively as the spondees in the fourth line come in where they do, "dull" in that same line is redundant after "dead" in the second line; "spring" is even more redundant after "April" in the first line; while "Memory and desire" in the third line are a little too blankly evocative. To what extent can it be proved that these are really, objectively, faults? It can't be proved to me, even though I do want to be assured that they are faults on Eliot's part and not on that of my taste.

fied and the resultant classes made the major premises of syllogisms that could then be used to prove esthetic judgments—in trying to do this, we find ourselves turning in spirals that go nowhere.

There are still other spirals, or rather circles. If reliable ways of proving esthetic judgment were actually found, these could be used to arrive at, not just prove, esthetic judgments. Then we would be able to judge works of art on the basis solely of transmitted information, and not have to come in direct contact with them. Having been told that a certain work contained so may instances of "class-A" properties, so many instances of "class-B" properties, and so forth, and also one or more instances of "class-Z" properties (like "fusion") to such-and-such degree, we'd be able to infer from all this just how much or how little esthetic value the work in question had. We wouldn't have to read, listen to, or look at the work. Nor would we even have to feel it necessary to prove the judgment that we had arrived at, since the very information on which it was founded would already contain the proof of it; the act of judging and the act of proving would be one and the same. In effect, we'd be able to experience all the art that has ever been made public simply by reading or hearing reports.

Nor would that be all. Did we know specifically what classes of properties and what degrees of such properties always made for superior art, we'd be able not only to prove and infer esthetic judgments, but also to know in *advance* what kinds of properties superior art would always have, and have to have. From this it would follow that anyone who informed himself enough would be able to create superior art at will, deliberately; and he would also be able to decide beforehand just how superior to make it. The making, like the appreciating, of art would be reduced to a matter of codified selective procedures that were as learnable as those of accountancy. This is what would have to follow if esthetic judgments could really be proven. And it would follow further that a deaf person could be "shown" just how good Haydn, Mozart, Beethoven, and Schubert were, and then proceed, if he got the statistics right, to compose music just as good, if not better, than theirs. And a blind man would be able to do the same thing with painting, and someone ignorant of Italian

would be able—again, if he got his statistics right—to create poetry in Italian that was as good as, if not better, than Dante's.

Some people will find the point I'm making so obvious as to not need making at all. Some others will still refuse to accept it. So I'll labor the point further, this time with an example taken from the art of painting.

Suppose your admiration for Raphael and for Ingres led you to conclude that smooth-surfaced, brushstroke-obliterating, and vividly linear handling always conferred superior value on a painting, so that any picture that exhibited this kind of handling was invariably better by that much than a picture that did not. This would mean that any later Rembrandt, any late Titian, almost any Rubens or Delacroix was under a qualitative handicap. (No less a judge than William Blake actually did maintain that "brushy" painting was inherently inferior to the "hard-edged" kind.) Suppose that all other aspects of painting were as identifiable as that of handling, and could be classified according to their invariable capacity to add or detract from pictorial quality, and that the resulting classification held for anyone in his right mind. If so, then the evaluation of a picture would demand no more than the entering of pluses and minuses (with their quantified "powers") in a pair of columns.

A Frenchman, Roger de Piles, tried to assess the relative merits of the Old Masters in roughly this sort of way. That was in the seventeenth century, and his results remain interesting only because de Piles had an eye. He had arrived at his esthetic judgments before he set out to tabulate them. Which is just the point. The evidence needed to prove an esthetic judgment can be furnished only by esthetic judgment itself. To try to prove that a good deal of Shakespeare's verse is effective poetry to someone who hasn't already arrived at that judgment by himself and for himself is like trying to make a color-blind man acquainted with the redness of red. The color-blind man may take you on faith, for practical reasons, as to the redness of what he sees as a neutral brown, and the Shakespeare-blind person may, for a different sort of reason, take you on faith about Shakespeare's poetry, but that won't alter the case: You still won't have proven or demonstrated anything at all about redness or the merits of Shakespeare's verse.

Esthetic judgment—esthetic intuition—closets you with itself and with yourself. That it's arrived at in a theater, a concert hall, or a crowded art gallery changes nothing in this respect. Nor does it change anything in this respect that you discuss your judgment with others and compare it with the judgments of others, or that your *attention* is swayed by what others say or write. You're still left to make the judgment—have the intuition—all by yourself. And you're left to make it—receive it, rather—in complete freedom. (This freedom, which is so complete because it doesn't depend on volition, is not affected by the fact that you may not always feel free to report your judgment honestly—say, when you find yourself getting more from a calendar picture than from a much praised Rembrandt and are ashamed to say so, even to yourself. In this case you're able to decide not to tell the truth, but in the case of your esthetic judgment as such and all by itself, there's no room for anything but the truth.)

Since esthetic judgments can't be proven, demonstrated, shown, or really even argued (though they can be argued *about*), efficiently conducted discussions of such judgments are confined to pointing or quoting. You point to what you do or don't like in a work of art and you ask for agreement. And the only way in which the person you're talking to can genuinely agree with you is by looking at, or reading—or if it comes to that, remembering vividly and exactly enough—what it is you're pointing to and finding that his own intuitive and spontaneous esthetic reaction is the same more or less as yours. An esthetic judgment can be changed, or confirmed, only under renewed contact with the work of art in question, not through reflection or under the pressure of argument. This is not as simple as it might sound. When someone, in maintaining his judgment of an art work, points out aspects of it that he likes or doesn't like, he is trying (whether or not he knows it) to influence your attention. (Attention is of the essence for the experience of art, yet does not actually enter into that experience as an integral rather than conditioning or preliminary factor.) And your *influenced* attention can expose your intuition or taste to aspects of a work of art that it might not otherwise have directed itself to, or been directed to, at that particular time. And in being so directed, your intuition or taste can be compelled to a judgment it might otherwise

not have produced, or to the revision of a judgment previously produced.

The main, and maybe the only, reason why many cultivated people resist the idea that esthetic judgment can't be proven is their feeling somehow that these are not ultimately subjective or private, not just "matters of personal taste," but that they do have, or strive to have (as Kant said), their own kind of objective and universal validity.

No sane human being lives shut off from esthetic experience of some kind. But not all sane human beings develop taste beyond a certain point—taste in any art or medium. The impediments here are mostly social, but often they are temperamental or owed to circumstances of upbringing that have nothing to do with social or economic factors. Yet, whatever their origin, these impediments do tend to make themselves felt as natively personal (like many other things actually owed to circumstance). They settle in as an aspect of your very individual, private self, and thus as part of your "subjectivity." Now it's precisely the subjective that, more than anything else immediate, gets in the way of the distancing that is essential to esthetic experience. The "subjective" means whatever particularizes you as a self with practical, psychological, interested, isolating concerns. In esthetic experience you more or less distance yourself from that self. You become as "objective" as you do when reasoning, which likewise requires distancing from the private self. And in both cases the degree of objectivity depends on the extent of the distancing. The greater—or "purer"—the distancing, the stricter, which is to say the more accurate, your taste or your reasoning becomes.

To become more objective in the sense just given means to become more impersonal. But the pejorative associations of "impersonal" are excluded here. Here, in becoming more impersonal, you become more like other human beings—at least in principle—and therefore more of a representative human being, one who can more adequately represent the species. This is what the seemingly polar opposites of the esthetic and the rational can both contribute to when consorted with in their "purity." (This doesn't mean that either the esthetic or rational, or both together, suffice to full human-ness. Another, and far more decisive, kind of selflessness has to come in, one that makes you put yourself

in the place of other persons. And for that matter, it would be hard to argue, from the record, that a developed taste or a developed intellect has usually made for a developed human being. The contrary has been the case all too often. Yet I will say that taste or intellect that continues to develop into middle age and beyond has to be backed by character, or human-ness, that does the same.)

In short, esthetic experience requires for its ampleness and its intensity that you become a distanced, therefore objective receptor, and become that increasingly. (Here "receptor" does not necessarily connote passivity.) The transmitter—the artist, writer, composer, performer—has to objectify himself too, but in a more roundabout way. He needs to be subjective in order as it were to get started; he needs a good many things that are singular and peculiar to him: his temperament, his autobiography, the privateness of his self—even the most "classical" of artists needs these, even a Sophocles or an Old Kingdom Egyptian sculptor. But more than these, and more than sheer talent, are needed to make *successful* art. For that the discipline and pressure of a medium are required. In coping with these the superior artist objectifies his subjectivity, transcends it without leaving it behind. This, whether he's a Gothic stone-carver or Keats, a Paleolithic painter or Gustav Mahler. Dante wrote poetry out of personal rancor, among other things, but along with the other things this became for him means to the means of art, and there has never been a more "objective" work of art than the *Divine Comedy*. Ultimately, the successful artist separates himself from, overcomes, transcends his private self as much as the "successful" art lover does.

The successful artist needs taste too, and needs to objectify himself in his taste in order to objectify himself in his art. The discipline of his medium is there like a resistant, as well as objective, presence. He must orient himself to and in that presence if he is to force it to accommodate his subjectivity, his unique vision or inspiration. (He can't choose to evade that presence, not if he's authentically serious.) And the only means he has of so orienting himself is his taste. This he has to develop in the same way, more or less, as the non-practitioner or contemplator does. Just as the latter can't experience art amply without partic-

ipating somehow, so the artist can't proceed successfully without contemplating—and not somehow: He, too, has to contemplate as a receptor. Not that every good artist is a good connoisseur or critic. A very good connoisseur or critic is very catholic in his taste—has to be. There have been great artists who shut themselves off from certain kinds of great or good art in order to serve their own creative interests—and maybe had to do that. But this notwithstanding, I can't imagine any artist, good or bad (at least in an urban society), whose crucial decisions in starting out did not somehow involve decisions of taste. And usually, the better the artist, writer, composer, or choreographer, the more accurate (or "objective") most of those initial decisions were.

In transcending the privately personal, art and taste don't separate themselves thereby from "life," from the rest of experience, that is non-esthetic experience. To keep on expanding and refining your taste, in no matter what direction, does ask—as it seems to me—that you keep on expanding and refining your sense of life in general. There are what look like ever so many contradictions of this thesis: geniuses at a loss in the day-to-day, persons of precocious sensibility in this or that art who lack anything resembling wisdom, esthetes in general, and so on. Yes. But my emphasis here is on *continuing*, on not coming to a stop in the development of your taste. Just as the challenges and satisfactions of life are inexhaustible, so are those of art—at least high art. A good, a large part of the satisfaction to be gotten from art over the course of time consists in overcoming newer and newer challenges to your taste, whether in art of the present or art of the past. To keep on doing this you have also—my experience says—to keep on learning from life apart from art.

I find it hard to give evidence for what I've just asserted. How ripeness of general experience can be shown to expand and refine your experience of music, of the dance, or the visual arts—and at the same time actually "purify" that experience—is beyond me. But this doesn't deter me from believing it. There are many things about art (like hard-and-fast evidence for an esthetic judgment) that can't be exhibited in words or discourse, but that hold nevertheless. Moreover, I do think that in the more "transparent" arts like drama, prose fiction, the movies, and even still photography, it's possible to make an approximation at showing how

experience accumulated away from an art can decisively inform an esthetic judgment. A good deal of Shakespeare comes through to you as being, besides great poetry, great drama only—as I've discovered for myself—when you have enough years behind you, or have made enough of however few years you do have behind you. I see Henry James, when most at sea in some of his later novels, practically imploring you as reader to filter the abundance of his words through your own acquaintance with what life is like.

James's *Golden Bowl* is a good case in point. If you come away from that novel feeling that Maggie Verver is its redeemed heroine, I would say that you had failed to get from it all there was to get, in terms sheerly of esthetic experience. You would have been more moved by the novel, I say, as only art can move you, had you recognized the money-empowered wickedness of Maggie, and her father too. And had you also recognized how the intimacy between the two affected their relations with their respective spouses. In the context, the adulterous intimacy of the latter two is the less immoral one: it doesn't necessarily exclude intimacy with other people; and it isn't *used* against other people. If you miss this when you read *The Golden Bowl*, I would say it was because your own experience hadn't yet taught you to see through the false clues that are strewn through the novel as though it were a detective story; and missing this, you would have missed part of the art.

A lived sense of life might also help you discover that in the first scene of *King Lear* the gullibility of the old king isn't his crucial fault. Gullibility is no more than an intellectual fault. Shakespeare needed a moral fault to "justify" what happens to Lear afterward, so that the sense conveyed of the frequent sense-lessness of things wouldn't be altogether senseless itself. Lear's mistake consists much less in his credulousness with respect to his two older daughters than in his brushing aside what Cordelia means when she says:

> . . . Why have my sisters husbands, if they say
> They love you all? Haply, when I shall wed,
> That lord whose hand must take my plight shall carry
> Half my love with him, half my care and duty.

Sure I shall never marry like my sisters,
To love my father all.

It's Lear's folly to want to hold on to and possess his offspring.
Cordelia's view of marriage is almost diametrically opposed to
what turns out to be Maggie Verver's. And just as I think that
you won't get the point of *The Golden Bowl* in a way that satisfies
you esthetically enough unless you recognize Maggie's persistent
wrongness, so I think you won't savor all the art there is in *Lear*
(and to "savor" that art means to be deeply moved by it) unless
you detect the old king's real, and crucial error.

There are people, of real taste, who will ask, still, what all
this has to do with literature as art. Isn't it something like won-
dering about how many children Lady Macbeth had? No. The
number of Lady Macbeth's children doesn't matter in the play
called *Macbeth*. But Maggie's alliance with her father and their
use of that alliance and of the power of money, along with the
conventions of marriage, to control their respective spouses be-
long to the very form of *The Golden Bowl*, belong to its form as
much as do its words, the rhythms of its prose, the pacing of its
plot, the ordering of its chapters. Cordelia's home truth about
marriage, coming just where it does, is as inherent to the form
of *Lear* as its blank verse and the grammatical shape of its sen-
tences are, as inherent to that form as the quickening pace of
the exchange between Cordelia and her father, in which sti-
chomythy so tellingly alternates with longer speeches.

All the same, the wisdom got from digested experience
doesn't suffice by itself when it comes to art. Of course not. You
may have learned much about the ways of life, and really possess
what you've learned, but still remain immature in the realm of
art. Told *about* Maggie, Lear, and Cordelia, you would know
what to make of them, but you might not know what to make
of them if you met them at first hand in the novel or play. You
might not be able to recognize them for what they are when
presented with them solely by the artistic, "formal" means to
which they owe their original and only existence. James's staging
and prose might bewilder you, so might Shakespeare's staging
and verse. To realize and recognize Maggie or Lear at first hand,
you need a certain quantum of taste along with your wisdom—

taste, which unlocks art. Taste comes first "logically"; wisdom informs and extends it.

That the converse doesn't apply, that taste doesn't inform or extend wisdom, doesn't gainsay what I've just said. It has yet to be shown that anyone has ever learned anything at all about anything other than art from art *as* art, from esthetic experience *as* esthetic experience. Gibbon's *Decline and Fall of the Roman Empire* is (off and on) a great work of art that also happens to afford a great deal of interesting information; but the experiencing as *art* of the *Decline and Fall* does not include the receiving of information *as* information. You can come away from a reading of Gibbon's book without possessing an item of it as knowledge but still having had, and knowing that you've had, a tremendous esthetic experience. That's the way it is with esthetic experience: All you need with respect to it is to have it, nothing more; it's only there to be had, not to be profited by (except in the interest of improving your taste).

Once again: The esthetic or artistic is an ultimate, intrinsic value, an end-value, one that leads to nothing beyond itself. When you enjoy knowledge for its own sake you are experiencing it, maybe, esthetically. The same with wisdom. Knowledge and wisdom can funnel into, can serve, the esthetic, but the esthetic—like the ethical or moral in the end—can't serve anything but itself. (And for this reason some philosophers have held that in the showdown the moral has to be assimilated to the esthetic: i.e., that anything relished and cherished for its own sole sake, including any person you genuinely love, is experienced esthetically.)

CAN TASTE BE OBJECTIVE?

The word "taste" (*gusto* in both Italian and Spanish) entered the discussions of art in the seventeenth century. In the eighteenth it became the hard-and-fast word for the faculty of esthetic judgment. It's as though this term, in isolating this faculty, also isolated and brought into focus most of the problems connected with that faculty: problems that were, as far as the understanding was concerned, the crucial ones involved in the experiencing of art.

I've used the word "problem" in the plural; maybe I should use it in the singular. For the crucial problems involved in the experiencing of art are "problems" of taste. And yet the problems of taste do seem to boil down to one in the end: namely, whether the verdicts of taste are subjective or objective. This is the problem that haunted Kant in his *Critique of Aesthetic Judgment*, and he stated it better than anyone I know of has done since. He acknowledges its importance, returns to it again and again, and in exhibiting the difficulties of the problem faces up to them as, again, no one I know of has since him.

He doesn't solve the problem satisfactorily. He posits a solution without proving it, without adducing evidence for it. He deduces his solution from the principles of his "transcendental psychology," and it's a wonderful deduction, but it doesn't really advance the argument that the verdicts of taste can be, and should be, objective. Kant believed in the objectivity of taste as a principle or potential, and he postulated his belief on what he called a *sensus communis*, a sense or faculty that all human beings exercised similarly in esthetic experience. What he failed to show was how this universal faculty could be invoked to settle disagreements of taste. And it's these disagreements that make

it so difficult to assert the potential or principled objectivity of taste.

Kant's failure in this direction—as well as his success in driving it home that esthetic judgments can't be demonstrated or proven—may have had a good deal to do with what looks like the general abandonment of the problem of taste or esthetic judgment on the part of philosophers of art for a while after his time. The last two hundred of the six hundred pages of Gilbert and Kuhn's meritorious *A History of Aesthetics* contain only three fleeting mentions of the word "taste," and none at all of "esthetic judgment." But I think that the Romantic exaltation of art may have had even more to do with this. That art could be and was subjected to judgment and evaluation came to be felt as unseemly; or at least the open acknowledging of this came to be felt as that. And it still is, to some extent. The word "taste" itself acquired prosaic and pejorative connotations and became increasingly compromised by association with manners, clothes, furniture. It became too mundane a notion to be connected with anything so spiritual and exalted as the Romantic conception of art.

Not that taste didn't, and doesn't nonetheless, remain as essential in the appreciation, and in the creation too, of art as it ever was. Not that any term usefully replaced it. Not that questions of taste didn't, and don't, enter, even more than in the past, into informal talk about art and the arts; or that assertions deriving from the operations of taste, however indirectly, didn't, and don't, come up everywhere in the formal talk and in the writing about art. And not that very much of that talk and writing would, in fact, be possible without presupposing verdicts of taste. All the same, the reluctance to bring the question of taste out into the open again, the coyness about dealing with it, persists.

As I've said, the Romantic change in attitude toward art is at the bottom of much of this. But I return to Kant. After his time the question of the objectivity of taste, of esthetic judgment, came to seem more insoluble than ever, with or without Romantic attitudes toward art. There seemed to be less than ever a way of settling disagreements of judgment or appreciation. None of the philosophers who addressed themselves to esthetics after Kant was quite ready to admit that taste was a subjective matter, but none of them was ready, either, to try to show that it wasn't.

As far as I know, they avoided the question or else only pretended to tackle it. Some had the courage to dismiss it explicitly. Grant Allen, a not unknown inquirer into esthetics of the later nineteenth century, held that it was an advantage from the scientific point of view to be without strong preferences in art (he may not have been wrong in some of the reasons he gave). But even Croce—the philosopher of esthetics I've found more in than anyone since Kant—escaped into what I make out as double-talk when it came to the objectivity of taste. Santayana simply evaded the question, and Susanne Langer only grazes it, if she even does that. Harold Osborne doesn't evade or graze, but somehow still fails to meet it head-on.

The question continues to be suppressed, evaded, or merely grazed. I wouldn't claim that the failure to deal conclusively with the issue of taste and its objectivity is alone or even mainly responsible for some of the startling features of recent art and of recent discussion of art. But I think it partly responsible—at a distance as it were; the shunting away of the whole question does make certain things more permitted than they would otherwise be. There are artists now who confidently dismiss taste as irrelevant. And art critics who say out loud that judgments of value are beneath them, being the affair of "reviewers," not of critics proper. It certainly has been taken for granted for a while now that art critics—and literary critics too, for that matter—can maintain themselves more than respectably without having to tell, or being able to tell, the difference between good and bad. At the same time, words like "connoisseur" and "connoisseurship" have come to sound old-fashioned and even pejorative. Add to this the business about "elitism": which is, in effect, the argument that taste should no longer be decisive because the art it elevates has so little to do with life as lived by the common man. It used to be that only philistines said this sort of thing, but now it's said by people, including artists, who don't otherwise talk or act like philistines.

And yet taste continues to be decisive, and maybe more obviously so than ever before (at least in the West)—that is, if you look at what actually happens to, with, and in art, and pay less attention to what's proclaimed about up-to-date persons in up-to-date situations. Art that used to be valued for all sorts of

non-esthetics reasons (religious, political, national, moral) has lost its hold on the cultivated public almost entirely, or else its non-esthetic significance has been more and more discounted in favor of its purely esthetic value, whatever that might be. (It could be Fra Angelico's or it could be Maxfield Parrish's.) And as this happens differences of taste fade into one another; the agreements become more important and conspicuous than the disagreements. Actually, this is what has been happening all along, in one way or another. As far back as we can see into the past, agreement has been overcoming disagreement. The solution of the question of the objectivity of taste stares you in the face. It's there in the record, as well as in all the implicit assumptions on which the making and the experiencing of art have proceeded since time immemorial.

In effect—to good and solid effect—the objectivity of taste is probatively demonstrated in and through the presence of a consensus *over time*. That consensus makes itself evident in judgments of esthetic value that stand up under the ever-renewed testing of experience. Certain works are singled out in their time or later as excelling, and these works continue to excel: That is, they continue to compel those of us who in time after look, listen, or read hard enough. And there's no explaining this durability—the durability that creates a consensus—except by the fact that taste is ultimately objective. The best taste, that is; that taste which makes itself known by the durability of its verdicts; and in this durability lies the proof of its objectivity. (My reasoning here is no more circular than experience itself.) It remains that the people who look, listen, or read hard enough come to agree largely about art over the course of time—and not only within a given cultural tradition but also across differences of cultural tradition (as the experience of the last hundred years teaches us).

The consensus of taste confirms and reconfirms itself in the durable reputations of Homer and Dante, Balzac and Tolstoy, Shakespeare and Goethe, Leonardo and Titian, Rembrandt and Cézanne, Donatello and Maillol, Palestrina and Bach, Mozart and Beethoven and Schubert. Each succeeding generation finds that previous ones were right in exalting certain creators—finds them right on the basis of its own experience, its own exercise

of taste. We in the West also find that the ancient Egyptians were right about Old Kingdom sculpture, and the Chinese about T'ang art, and the Indians about Chola bronzes, and the Japanese about Heian sculpture. About these bodies of art, *practiced* taste— the taste of those who pay enough attention, of those who immerse themselves enough, of those who try hardest with art— speaks as if with one voice. How else account for the unanimity, if not by the ultimate objectivity of taste?

It's the record, the history of taste that confirms its objectivity and it's this objectivity that in turn explains its history. The latter includes mistakes, distortions, lapses, omissions, but it also includes the correcting and repairing of these. Taste goes on making mistakes, and it also goes on correcting them, now as before—now maybe even more than before. Amid it all, a core consensus persists, forming and re-forming itself—and growing. The disagreements show mainly on the margins and fringes of the consensus, and have to do usually with contemporary or recent art. Time irons these disagreements out, progressively. Within the core, certain disagreements will continue, but only about ranking: Is Titian or Michelangelo the better painter? Is Mozart or Beethoven the better composer?

Disagreements of this kind assume fundamental agreement about the names concerned—that they are among the supreme ones. The implicitness of this fundamental agreement is borne out at every turn. You may find Raphael too uneven or Velazquez too cold, but if you can't see how utterly good they are when they are good, you disqualify yourself as a judge of painting. In other words, there are objective tests of taste; but they are utterly empirical and can't be applied with the help of rules or principles.

It's the best taste that, as I've already indicated, forms the consensus of taste. The best taste develops under the pressure of the best art and is the taste most subject to that pressure. And the best art, in turn, emerges under the pressure of the best taste. The best taste and the best art are indissoluble. Well, how do you in your own time identify the bearers of the best taste? It's not all that necessary. In time past the best taste could have been diffused through a whole social class, or a whole tribe. In later times it may or may not have been the possession of a coterie—

like the *cognoscenti* in and around the Vatican in the early 1500s, or the circles in which Baudelaire mixed in the mid-nineteenth century. But it would be wrong on the whole to try to pin the best taste of a given period to specific individuals. I would say it works more like an atmosphere, circulating and making itself felt in the subtle, untraceable ways that belong to an atmosphere. At least that's the way it seems, in the absence of closer investigation. The most that is safely known is that the best taste, cultivated taste, is not something within the reach of the ordinary poor or of people without a certain minimum of comfortable leisure. (Which happens to be true of the highest fruits in general of civilization, and it doesn't change the nature of those fruits, however much the human cost of them may be deplored or however clearly it is recognized that art and culture are not supreme values.)

Anyhow, we know the best taste well enough by its effects, whether or not we can identify those who exercise it. And through those effects the consensus of taste makes itself a fact, and makes the objectivity of taste a fact—an enduring fact. The presence of this fact is what's primary, not so much the names of the particular individuals who, as exponents of the best taste, continue to create the fact.

The philosophers of art must have been aware from the first of something like a consensus of taste, however dimly. What I wonder about is why they didn't become more definitively aware of it and take it more into account, with its implications. Had they done so they would, as I think, have had no choice but to exclude once and for all the possibility that taste is ultimately subjective. (As if Homer's standing, or Titian's, or Bach's could have been the outcome of what would have had to be the accidental convergence of a multitude of strictly private, solipsistic experiences.)

It is Kant's case, I believe, that may offer the best clue as to why the consensus of taste hasn't been taken seriously enough; it was solely a matter of record, too simply an historical product. To found the objectivity of taste on such a product would be proceeding too empirically, and therefore too unphilosophically. Philosophical conclusions were supposed to catch hold in advance of all experience; they were supposed to be arrived at

through insulated reasoning, to be deduced from premises given *a priori*. This isn't my own view of philosophy, nor is it the view of many philosophers themselves, including Hume, Kant's predecessor. But, as it seems to me, it's a view that has infected the investigation of esthetics even among empirical philosophers. They too have tended to start from the inside of the mind and try to establish esthetics on the basis of first mental or psychological principles. It was well and good for Kant to postulate a *sensus communis* on the basis of experience—empirically, that is. (And who knows but that experimental psychology may not bear his postulate out in some scientific detail in some unforeseeable future?) But his deductions from the postulate didn't advance his case much; what they showed mostly is that we want to agree in our esthetic judgments and may be justified in so wanting. He could have clinched his case for the time being—and for some time to come too—by remaining content to point to the record, the empirical record, with the consensus of taste that it showed. And he could have also pointed to how that consensus of taste showed that most important disputes of taste did get settled in the shorter or longer run. But he would have had to recognize then, I think, that they got settled through experience *alone*—as far as anybody could tell. And with this recognition, that experience alone demonstrates and vouches for the objectivity of taste, he would have had to leave the question.

I realize that I take my life in my hands when I dare to say that I've seen something better than Kant did—Kant, who, among so many other things he did, came closer to describing what went on in the mind when experiencing art than anyone before or anyone after him. I can plead in justification of my brashness only what close to two hundred years of art since his time have expanded and clarified.

Closer to our own time, psychologists have been trying by experimental methods to discover constants in esthetic appreciation that would enable them, presumably, to predict, if not describe, the operations of taste. Some habits of esthetic perception or reflex have been ascertained. It has been discovered that most people, across most cultural divisions, prefer blue to other colors; and that certain relations of sound tend, at least in the West, to be preferred by most people—and so on. But nothing has been

ascertained so far that bears usefully on the way that practiced taste works, or that says anything really useful about the objectivity of taste.

In the meantime I keep on wondering, again, why the consensus of taste, with all it says for the objectivity of taste, goes so unmentioned in the recorded controversies about esthetical questions that have been carried on outside formal philosophy. All the reputations that have come down to us form a kind of pantheon. There the masters are, and they are there by virtue of what has to be a consensus of taste, and nothing else. The fact of that consensus should loom in the awareness of anyone seriously interested in art or music or literature or dance or architecture. Yet somehow it remains unregistered at the same time that it remains implicit and necessary. It's not referred to all the while that it's proceeded upon; all the while that the activity of art and around art, as we know it, would be unthinkable without the presence of the consensus. When I say "unregistered" I mean without being brought to clear consciousness and without being invoked as a given on which an argument can be built. And so the common, objective validity of esthetic judgments continues to be disputed—and not just as a demonstrable fact, but even as a possibility.

Art can do without taste—I hear voices from as far back as 1913 saying this. What they mean, without knowing it, is that art can do without art; that is, art can do without offering the satisfactions that art alone can offer. That's what art doing without taste really means. Well, if the satisfactions exclusive to art are dispensable, why bother with art at all? We can go on to something else. (And there are, after all, things more valuable than art, as I myself would always insist.) But meanwhile we're talking about art.

THE FACTOR OF SURPRISE

Esthetic experience depends, in a crucial way, on the interplay of expectation and satisfaction (or dys-satisfaction). Esthetic expectation is of a kind all its own. It has nothing to do with desire or fear, wishing or unwishing. (Because it deals too much in wish-fulfillment, daydreaming provides little genuine esthetic experience.) Esthetic expectation is "unpractical," disinterested, and it is that because it's created solely within esthetic experience and by nothing outside it. You may come to art with the expectation, the desire, the wish for esthetic experience, but this has nothing to do intrinsically with esthetic experience itself; it comes from outside it. The kind of expectation that is properly esthetic is aroused only by, and in, esthetic experience in itself, by the work of art in and of itself.

It's much easier, of course, to point to the interplay of expectation and satisfaction (or dys-satisfaction) in the arts that unroll in time than it is to point to it in the visual arts. All the same, there's no question but that the interplay takes place importantly in these too. It does so not only in sculpture in the round and architecture, but also in pictorial art whose full effect can be gotten—and has to be gotten—from a split-second glance. (Actually, the experience of sculpture in the round and of architecture, insofar as it's purely visual, depends on a succession of such glances.) Here the interplay is compressed into microscopic time—and who knows but that it may violate the dimension of time, or rather our consciousness of the dimension of time.

In visual art, as it seems to me, satisfaction (and maybe dys-satisfaction too) can generate expectation retroactively, or, if not that, coincide with it in the same apparent instant. I'm not sure but that this doesn't happen in the temporal arts too: that is,

that at some place in a piece of music or work of literature or movie or dance performance you sense a certain expectation only in the moment or moments that it gets satisfied (or frustrated). Thus the interplay of expectation and satisfaction can be understood to work in a circular and reciprocal way as well as in a temporally linear one. And in any case, esthetic expectation and its satisfaction don't work so simply in superior art as they might do in a detective story or a melodrama; there can be clusters or sets of expectations crisscrossing and clusters or sets of satisfactions that likewise crisscross and interact, both with one another and with the expectations. (And at the same time, as Kant was the first to hint, cause and effect don't operate in esthetic experience so self-evidently.)

That esthetic experience consists in, among other things, the interplay of expectation and satisfaction has been said many times before. It's also been said often enough that an element of surprise is necessary to esthetic satisfaction. In eminently successful art the element of surprise is perdurable, repeatable, renewable. Even things you know by heart can retain their capacity to surprise. Of course you can wear anything out, temporarily, by seeing, hearing, reading, or repeating it too often within too short a span of time; but this has to do with the human condition in general and not just with esthetic experience.

What amounts to somewhat—but only somewhat—the same thing as saying that esthetic experience involves expectation and satisfaction is to say that it involves tension and the relief or resolution of tension. This too has been said many times. And it can often help to talk about esthetic experience in these terms, especially when dealing with the factor of surprise. Tension and resolution can provide better framing terms within which to emphasize the fact that art or esthetic experience can't afford too much surprise in delivering satisfaction. The satisfaction has to be *of* a certain expectation, the resolution has to be *of* a certain tension: the expectation and the tension created within and by the experience of the work of art itself, and not by anything outside it. When the factor of surprise is too great, too unanticipated, it fails to connect with the given expectation or tension and to satisfy or resolve it; then it comes from outside as it were, or resolves a tension that comes from outside, and which, for

that reason, the spectator, listener, or reader hasn't been introduced to, hasn't felt. In other words, esthetic resolution or satisfaction, however obligated to surprise in order to be effective, has still to provide its surprise within reach of the terms of the expectation or tension that "precedes" it. Art fails not only when surprise is over-anticipated but also when it's under-anticipated. (The objections made in the past to *deus-ex-machina* resolutions of drama or fiction were not just pedantic ones; they also came from real dissatisfaction, experienced dys-satisfaction.)

There is what I'd call a secondary interplay of expectation and satisfaction that takes place *between* and *among* different works of art, or esthetic experiences. The expectation here cannot be called esthetic properly; it's created not by art or esthetic experience in and within itself, but by the accumulation of past esthetic experience. Here the notion of tension and its relief or resolution isn't serviceable; we don't go from one work of art to another with tension that needs relieving or resolving; tension, esthetic tension, comes about only inside works of art or inside esthetic experience—as I can't emphasize enough. It's not created by the relation between different works or experiences, not in its esthetic "mode." Yet despite this, the factor of surprise—surprise from the outside—does enter here, sometimes even more conspicuously than inside a work of art or a given esthetic experience, and I'd hesitate to say it wasn't truly esthetic surprise, and I'd hesitate to say that the kind of expectation—expectation before and outside esthetic experience itself—wasn't truly esthetic expectation. But I'd also hesitate to say it was.

The expectations with which we go from one work to another in art of the past are different in "feel" from those with which we go to works of contemporary art. With art of the past the internal expectations created in and by the given work are to a large enough extent expected expectations. We are already set to "read" the works of the past more or less as they ask to be. But with contemporary art that's significantly new we are often not set to "read"; the internal expectations created are too unexpected, too surprising in themselves, so that at first approach the whole aspect of a work offers surprise, and when that happens the work becomes inaccessible esthetically and strikes you more as a sheer phenomenon, and an arbitrary one, than as something that

has to do with art. Repeated exposure to the work in question can, however, teach you to "read" the internal expectations it creates; that is, eliminate the factor of surprise from these and shift and confine it to where it belongs, to that which satisfies these expectations. And just as the surprise-in-satisfaction inside a work has to be limited and connect with previous surprise, so the surprise-in-expectation created in and by a work has to be limited and to connect with previous expectation. If there's too much newness, too much surprise, in the expectations no amount of repeated exposure will make them "readable." In other words, the newness of and in a work of art as a whole has to maintain a degree of continuity with previous art, just as surprise-in-satisfaction inside a work has to maintain continuity with the expectations that same work arouses and can't be totally unanticipated.

The problem of (seemingly) excessive newness or surprise in going from one work of current art to another has come up only recently. But the difficulty for art lovers of newness, originality, innovation as such has been here since the middle of the last century. Until then surprise and newness used not to take cultivated people so much aback. Before then, innovation and originality used not to make themselves so startling and upsetting. The factors of continuity used to be, if not more present, steadier, and more obvious—more framingly obvious: like the illusion of the third dimension in painting and of corporeal likeness in sculpture, like the tonal conventions in music, and common-sense logic and metrical rules in literature. These aren't by any means the only reasons why old-time innovation in art was so readily accepted; there were also social and general-cultural reasons, some of which we all know about, many of which we don't know about, or at least can't grasp in their living concreteness.

All the same, the differences between past and present should not be exaggerated (that's one of the maladies of the journalistic present). The best, the "elite" taste of the recorded past appears to have developed itself in much the same way as it does right now. That best taste was that which, having assimilated the satisfactions and surprises of previous art up to its own moment, received new art in the expectation of receiving somewhat new expectations and somewhat newly surprising satisfaction of these. This best taste had—and has—its expectations *of* art and *in* art

constantly and continually expanded and revised by fullness of new experience. After Dante or Masaccio, after Palestrina or Cervantes, after Milton or Watteau, after Victor Hugo or Wagner, after Dickens or the Impressionists the best taste wanted, in each case, something from art that it hadn't wanted before, and at the same time no longer wanted as much as something that it had wanted or expected before. This is how art, in a given tradition, is made to keep moving and living. It moves and lives by changing, by innovating. When expectations *of* art stop changing—which means in effect when surprise is no longer wanted from art or in art—then a tradition sickens and begins to die or become paralyzed. For it's only through continued newness, continued originality and surprise that esthetic quality gets maintained—and the life of a tradition of art is its quality.

Of course, I've made all this too neat and schematic. There are exceptions to anything that it's possible to say about art (maybe). But the schematic can illuminate as long as it's not taken too literally. Nor do I want to be understood as saying or implying that art progresses, or that quality in art progresses. Sometimes it does and sometimes it doesn't *within* a given tradition. But there's no such thing as general progress in art or esthetic quality. Nor is there such a thing as a general *evolution*. A specific tradition of art will evolve, but not art as a whole. (Please remember that "evolution" doesn't mean the same as "progress.") Art was as full-fledgedly art, for all we know, among the Neanderthals—even though they've left hardly anything behind to show that they made art—as among the Athenians of the fifth century B.C. When it comes to art as such the question of progress or evolution should be treated with extreme circumspection. It may be a different matter when it comes to art history and esthetic theory and esthetic psychology, but these do not belong to art as such.

If in some large enough part high art in the West is still quite alive and moving, as I think it is, there is one very important, maybe all-important reason. Western tradition and Western society have produced something historically unique: the avant-garde. Why it was produced in the West alone has to be explained in a variety of ways, only one of which I'll attempt. In its emergence in Paris one hundred-odd years ago the avant-garde was a

writers' and artists' effort in a sense in which I can discern no other artistic or cultural tendency to have been (not even in China or Japan). I won't say that the avant-garde was originally an enterprise of practitioners to the total exclusion of critics, theorists, learned men, and even connoisseurs, but it was close to being that. And in some respects it has remained nearly that. Back in the middle of the last century a few poets, novelists, and painters (not sculptors or architects) saw, in a surprisingly decided way, the need to maintain high expectations in and of art as they were no longer being maintained by cultivated art lovers at large. And it's been these practitioners who have exhibited as never before just how high art is kept alive and moving whenever and wherever it does stay alive and moving. It's as though they undertook to do this as in a laboratory, spelling out everything the way it's supposed to be done in a laboratory (though nothing could have been further from their conscious minds).

The most conspicuous feature of avant-garde art was that its surprises, both in creating expectation and satisfying it, seemed excessive by comparison with the surprises of past art. They also seemed more deliberate. It was as though the avant-garde set out to emphasize as never before how indispensable surprise was to high esthetic satisfaction, and to show that high art could thrive only amid high expectations of surprise, and that these expectations had to be expanded or redirected from point to point more radically than before if they were to be kept high.

What the avant-garde also seemed to be intent on emphasizing (again unconsciously) was how much the truly ambitious artist, writer, or composer had to do in the line of assimilating the best new art that was immediately, and not so immediately, previous to himself. He had to digest the newest expectations and the newest surprises. He had also to reject more deliberately those directions of art in his own time that did not press him toward newness and innovation. Which means that he had to exert his taste more strenuously, or more consciously, than artists before him in his own tradition had had to do, usually. And with more catholicity. (El Greco appears to have had reservations about Michelangelo's Sistine frescoes because he felt they were not painting as painting ought to be; they were too Florentine and "linear," and El Greco was a partisan of Venetian, that is,

painterly painting. I say a "partisan," just as Delacroix was of painterly painting, and Ingres on the other hand of the linear, "hard-edged" kind. But when Manet complained about the "soups and gravies" he saw all around him in the painting of the 1850s—meaning dull browns, grays, and neutral colors in general—he was not being a partisan at all; he was applying his taste with the impartiality of an ideal critic or connoisseur. That's what it took to bring the avant-garde into being and keep it there: to be neither for Florence nor Venice, but simply for better art, wherever it was or came from.) Yet all along, the course of better, superior art had run in the way that the avant-garde emphasized; what made the avant-garde what it was, and still is, is that it did emphasize and did make explicit ever so much that had been implicit before, that had been taken for granted before, but no longer could be. The past could know more easily from what direction the surprise was coming: Michelangelo, Leonardo, Beethoven; avant-garde did not let you know that so easily.

Phenomena of art do get neatened up, and thereby traduced, in being examined and described. The chain of expectation and satisfaction-through-surprise doesn't work as tidily as I've made it look. Or again, at least not in terms of the temporal dimension. In the course of art, just as within given works of art, satisfaction sometimes "precedes" or coincides with expectation. The last great efflorescence of monolithic sculpture—coming with Degas, Rodin, Maillol, Brancusi, Lachaise, and with Despiau, Kolbe, Marcks, and Wotruba too—created its own expectations; after the fact as it were—and after Picasso's collage-constructions had given birth to a kind of new and un-monolithic tradition of sculpture. Over the past fifty years, the less than very best, less than major painting (which less-than-best is still precious) has been mostly of a kind deriving from nothing later than Fauvism. It has not followed advanced painting very closely as a rule, or has done so only sporadically. The major art of our time has been preponderantly abstract, but just below that level the best art has been preponderantly representational—and, as it looks to me, still is. (Maybe there has never been any art quite as banal as inferior abstract art, and most abstract art—for reasons I'd rather go into elsewhere—does happen to be inferior.)

Yet despite what I've just said, styles (if not movements) do

seem for the most part to follow one another in a logical and orderly way. Hindsight sees that best, but it doesn't take hindsight alone to see it. Continuity imposes itself inexorably. David reacts against Fragonard but at the same time learns much from him; Géricault and Delacroix react against Ingres but don't break with him, and their polemical differences, as seen in their art itself, fade increasingly (as Matisse noticed). This same continuity and order are discernible in pottery and furniture and interior decoration and even in utensils and machinery.

It's a continuity that has overridden all the innovations of the avant-garde, and still does so. There have been no breaks or discontinuities in the course of avant-garde art, just as there were none in Western art before it. The continuity of sensibility—in this case the continuity of Western sensibility—has seen to that, if nothing else. *That* continuity happens to be the most inexorable one of all. You can no more escape from it than you can from yourself. (I say this in the face of the plausibility with which some artists brought up in China or Japan have created Western-style art.) Lately there have been attempts made at what I would call discontinuity, especially in visual art. Such attempts could succeed only by revealing a newness of sensibility that bewildered you at first. But what I, for one, am struck by is the actual stodginess, the actual conventionality of sensibility that pervades and undermines all these works, phenomena, events, acts, situations, and projects. In the end continuity is too well served. (This is one among the many ironies that infect, instead of energizing, almost all the self-proclaimedly advanced art of the past dozen years.)

The continuity and long-term orderliness of the course of art so far embolden me to say that certain probabilities do seem to govern the immediate future of the best art. Just as it was highly improbable that major art could still be produced in the Byzantine manner in fourteenth- or fifteenth-century Italy, so it seems highly improbable today that the very best new painting or sculpture of tomorrow will not be more or less abstract. Or that ornament or decoration will be used successfully in original architecture. (If there's anything I'm certain of at this moment, it's that ornament and decoration have become dead arts in the West.) But this still doesn't mean that you can predict the course of art, that you can deduce from what art is at one moment what

it will be in the next. The best new art will always surprise you somehow; if it didn't, it would not be new and it would not be the best. No conscious conclusions drawn from experience will enable you to anticipate or even recognize the best new art. For the latter you will have to rely on your taste alone, but for the former even your taste won't help. To be sure, taste forms itself through experience, but it does not foresee new experience any more than it controls present experience. (I leave aside here the kind of surprise you may get *at first sight* from art of the past. But even here prediction is very limited if not altogether excluded. One Gothic sculpture may enable you to anticipate the general aspect of another one, but it won't enable you to anticipate the particular, very specific esthetic experience you'll get from it.)

It's one thing to admit and allow for the force of probability; it's another to be in favor of that force. I am not. On the contrary: I'd like to see probability violated; I'd enjoy that. I'd enjoy seeing the continuity of art disrupted insofar as the succession of styles was involved. I'd prefer seeing the next great art coming from literally realistic painting and sculpture, or else from Conceptualism, or from the likes of Robert Morris or Joseph Beuys. I'd be intrigued and challenged by a sensibility that really broke with the past without diminishing itself in the process. But this *cri de coeur* has a proviso: namely, that however disorderly and discontinuous the course of art becomes, major art, major esthetic experience continue. By "major" I mean art or esthetic experience that exhilarates me as much, or nearly as much, as does that which I know as the very best art of the past and the present. This has to be insisted on—without prejudice to minor art, which anyhow won't thrive in the longer run in the absence of ongoing major art.

JUDGMENT AND THE ESTHETIC OBJECT

I have said previously that no firm distinction could be made between the esthetic and the artistic; that all esthetic experience had to be considered art. But I had to allow for the difference between esthetic experience in the rough and at large—which I called "raw" art—and the kind of esthetic experience that is commonly recognized as art—which I called "formalized" or "formal" art. I went on to say that esthetic experience wasn't subject to volition. That judgments of taste, which are of the substance of esthetic experience, are intuited, therefore received passively (as far as consciousness can tell) in a way similar to that in which sensory and introspective perceptions are. Further, I implied that the making of art and the appreciating of it belonged to the same order of experience and could be assimilated to one another. Croce had already said this seventy years ago (in his *Aesthetic*), and some of the reasons he gave for saying this were good ones. But I'd rather not repeat them here; I'd rather start from my own experience and see whether that has sufficed to bring me to the same conclusion.

On the face of it the idea that the appreciating and the creating of art can be assimilated to one another seems far-fetched. It could be granted that appreciation is passive, but how can it be maintained that the making of formal art is passive too? Doesn't formal art, unlike the "raw" kind, require willing, deliberating, and deciding? I also asserted that any and everything can be experienced esthetically, which would mean passively. It would follow from this that any decision involved in the making of art could be experienced esthetically, therefore passively. But

it would also follow that any kind of decision whatsoever, practical and moral as well as esthetic, could be experienced esthetically, and therefore passively. So what difference could there be between the esthetic and passive experience of an esthetic decision and the esthetic and passive experience of a non-esthetic decision? It doesn't serve my argument to hold that acts of volition in general can be experienced passively. There has to be something more intrinsically passive in the decisions that go into the making of formal art if they are to answer in kind the decisions that go into its appreciation.

That any and everything can be experienced esthetically amounts to saying that experience in general, presumably all experience, can double back on itself. Esthetic experience is the experiencing of experience. (Hence "esthetic distance," which should mean removing yourself by "doubling" from any possible consequence of experience.) But there's one kind of experience that can't double back on itself, and that's esthetic experience itself. If it could that would mean receiving esthetic judgments of esthetic judgments, which can't be done. You can esthetically experience the circumstances attending on an esthetic experience (like visiting an art exhibition or sitting in a concert hall or feeling chilly and sleepy while watching the sun rise), but this isn't the same thing as experiencing the esthetic experience itself, as doubling back on it and experiencing it at a remove. You don't then experience esthetically the judgment or judgments integral to the esthetic experience itself. An esthetic judgment as such happens to be inseparable from its object. You would have to separate a judgment from its object or occasion in order to experience the judgment esthetically, the judgment all by itself; if you couldn't effect this separation you would simply be *duplicating* or trying to duplicate the original experience of that judgment.

Suppose you tried to experience all by itself your original judgment of a line of verse—say, Wordsworth's "Our birth is but a sleep and a forgetting?" How could you experience, or reimagine, that judgment without at the same time experiencing or imagining the very words of that line? How could you ever detach your judgment from those words and the superbly varied

rhythm of the line as a whole? A moral judgment can be separated from its object: a judgment that says it's wrong to make fellow-creatures suffer has for its object fellow-creatures in general, and where the object is a general or collective one it can be detached from any judgment made of it. The same with practical judgments: That too great an accumulation of ice will damage the roof of a house is a judgment that has for its object roofs, ice, and damage in general; the judgment here too can be separated from its occasion and experienced esthetically as a judgment. What makes esthetic judgments different is that their objects or occasions are unique—one-time things at any given time. This is why it's impossible to detach or abstract esthetic judgments from their objects, which in turn is why it's impossible to gain esthetic distance—the distance essential to esthetic experience—from esthetic experience itself. (It's also why rules and maxims don't hold in the making or appreciating of art, whereas they can and do in morality and practical life.)

As I've already said, esthetic experience is judging, is making judgments of taste, is liking or not liking, getting or not getting satisfaction in different degrees; an esthetic intuition doesn't just coincide with, isn't just consubstantial with, a verdict of taste: It means a verdict of taste. Do the decisions that go into the making of art belong then to esthetic experience? Of course they do—when they're genuinely esthetic decisions. We can't exclude such decisions from esthetic experience, and since esthetic experience is essentially judging, then these decisions must consist in judging, just as appreciation does. And because they consist in judging, these decisions are of a special kind in their very character as decisions. Just as an esthetic judgment can't be separated from its object, so an esthetic decision can't be separated from its result: One is the other, without any gap between them. When the artist makes an esthetic decision he experiences its result in the decision itself, and at the same time. And it makes no difference whether that decision stays locked in his mind or whether it gets precipitated in an object, an act, or a symbolized meaning. (In the context of my argument it makes no difference. But this isn't to say that many of the most fruitful decisions do not come as feedback in the course of making an actual object or arriving at an act or symbolized meaning. The artist receives

judgment-decisions—inspiration, if you like—from his medium as he works in it; one judgment-decision, as the artist himself sees, hears, or reads it, gives rise to another or reacts on a previous one or cancels it out or cancels itself out.)

The artist, writer, composer, choreographer, director, performer invites the beholder to accept the judgment-decisions he has accepted for himself. He asks that these be intuited by others as positively, with as much satisfaction, as he himself has originally intuited them. He counts on the beholder's, auditor's, reader's taste as he counts on his own. In effect, he asks others to arrive with himself at that final stage when he, the artist, has resigned himself as it were to saying yes to everything that the finished work conveys. It's at this final stage that symmetry between artist and beholder is established. The former *receives* the outcome of his applied taste, the latter the outcome of his own applied taste. That the outcomes won't always agree doesn't affect the symmetry, which doesn't depend on agreement; it depends rather on the maintaining of "esthetic distance" on both sides: that is, letting esthetic intuition alone decide everything.

Yet not every decision received in the course of making formal art has to be an esthetic intuition or a judgment-decision. There are decisions motivated by extra-esthetic factors having to do with religion, politics, or social considerations. Such decisions are not judgments of taste, not in themselves; they don't contain their results in themselves. But they can become judgments of taste, judgment-decisions, and usually do, for better or for worse. For better in the case of much religious art of the past and even in the case of some didactic and some political art. It's a rare work of art anyhow in which all of the decisions start out as judgment-decisions, as esthetic intuitions.

Some other decisions going into the creation of formal art may be arrived at by what looks like reasoning and not intuition. But usually what seems a reasoned decision starts from intuitive judgment and aims at one. The artist has seen, read, or heard something from which he got a positive judgment of taste, and he infers—and hopes—that by imitating or adapting that something (whether a device, a convention, a scheme, or a nuance) he will make it produce an equally positive judgment in his own work. The same happens more or less when the artist's seemingly

reasoned decision is based on faith in a theory or a formula (like the Golden Section). The faith usually starts off from a positive esthetic intuition here too, and from what the artist thinks, rightly or wrongly, is responsible for it. He sees the Golden Section at work in those paintings of Raphael that he admires and he adopts the Golden Section for himself. Or he deems that a fixed system underlies certain works of music that move him very much. The rarer case is that of the artist who stakes himself on a theory or system that doesn't ostensibly derive from his esthetic experience, but which he believes is grounded in some extra-esthetic factor like God or ultimate reality or the harmony of the spheres. Yet even here positive esthetic judgments lie usually somewhere under the artist's faith, whether he's aware of that or not (and crank though he may be).

What the artist is consciously aware of doesn't matter so much in any event; it doesn't matter any more than what the beholder is consciously aware of as he has his esthetic experience. That, at least, is what experience shows. Experience also reveals that there is no such thing as *intellectual* art. For a work of art to be properly intellectual would require its proceeding from a universally accepted datum by as strictly logical a chain of inferences as that by which a truth of knowledge is arrived at. I have never seen, heard, or read of any work of art that does that.

The case of the cynical artist is the really special, and also the most illuminating, one. The ideally cynical artist does what he does in order to ingratiate his art at the cost of his own judgment-decisions. He rejects his own judgment-decisions and chooses deliberately those that he anticipates will be accepted by a kind of taste that he himself regards as inferior to his own. In this kind of art-making, volition and calculation do play the crucial role, and not spontaneous and involuntary intuition. Insofar as he lets this happen the cynical artist makes his relation with the beholder asymmetrical; he tries to manipulate the latter's esthetic experience while keeping himself apart from it. He separates himself both from his own art and from its audience. But the case of the cynical artist is a largely hypothetical one, and I offer it here only because it helps make my point the way the negation of a truth can serve to throw that truth into greater

relief. I have never heard of, much less come in contact with, a truly cynical, integrally cynical artist, and I doubt whether complete cynicism is possible in art-making except as a *tour de force* to show that it might be possible.

This isn't to deny, on the other hand, that it would be difficult to draw a hard-and-fast line in all instances of art-making between willed and calculated decisions and honestly intuited judgment-decisions. Probably no sophisticated artist, however alert, has managed to keep entirely away from calculated decisions, decisions that he doesn't test enough by sheerly intuitive means: decisions that he takes because, whether or not they please himself, he knows—consciously or unconsciously—that they have already pleased in other art than his own. An English poet in the eighteenth century might not have accepted, left alone with his taste, the way the rhymed couplet worked for himself, but he would adopt it not only because it had already worked so well—as his taste told him—for Dryden and Pope, but also because in using it those two had won so much approval. And who was he to break with that precedent, even if aspects of it went against his own intuitive leanings?

Seemingly cynical art, art that could be construed as cynical, is usually frightened art. The artist is too frightened to rest with his own judgment-decisions because they diverge too much, at least at first glance, from what he sees as, or is reputed to be, the best art of the past or even of the present. In effect, the frightened artist decides un-esthetically, un-intuitively—that is, *practically*—to be frightened. All sophisticated artists are frightened this way to some extent (as are most unsophisticated artists too, only their fright is more unfocused and more abject). The original artist, the genuinely original one, stays with enough of his own judgment-decisions in the face of precedents he is conversant with, but how and why he decides to do so is part of the greater mystery that is art itself (as far as discursive reason is concerned). And it's as much of a mystery in Giotto's and Leonardo's case, whose originality was quickly hailed, as in Baudelaire's and Manet's, whose originality was resisted at first. And why and how the connoisseur, the rare one, is not put off by originality and welcomes its expansion of his taste is equally a mystery (to discursive reason).

Postscript

It will be pointed out, I'm sure, that attention to an esthetic object or occasion requires a willed decision. Yes and no, I would have to answer. There is, of course, the conscious decision to attend to the experiencing or making of art. But there are times when this decision is felt as involuntary. Something esthetic catches your attention without your having made any sort of decision; you can find yourself creating art without having set out to do so. And anyhow, specifying the difference between voluntary and involuntary attention seems beyond our powers of self-observation. (Harold Osborne has remarked on the difficulties for investigation that the problem of "attention" continues to offer.)

CONVENTION AND INNOVATION

> Minds in which there is nothing original turn with arrogance against every talent that does not please them at the first glance.
>
> W. B. Yeats

Experience says that formalized art, the kind that most people agree to call art, offers greater satisfactions by and large than any other kind of esthetic experience. Formalizing art means making esthetic experience communicable: objectifying it—making it real—making it public, instead of keeping it private or solipsistic as happens with most esthetic experience. For esthetic experience to be communicated it has to be submitted to conventions—or "forms" if you like—just as a language does if it's to be understood by more than one person.

Conventions put resistances, obstacles, controls in the way of communication at the same time that they make it possible and guide it. The particular satisfactions we get from formalized art are due, in some essential part, to the sense gotten of resistances coped with by dint of choices or decisions (*intuited* decisions or what I call *judgment-decisions*). Quality, the very success or goodness, of formal art derives, formally, from these decisions, from their intensity or density.*

* Because we sense these decisions as coming from human beings alone, they somehow speak for all of us, for the whole species. True, we are given these decisions as results, but that's how the art-maker himself experiences them in the showdown: the intuitive decisions that go into the final version of a work of art are simultaneously results. . . . But what about those young chimpanzees and gorillas who painted plausible and sometimes even agreeable abstract pictures? Did they speak for our species? Well, yes. All the plausible or agreeable

The density or intensity of decision that goes into the making of communicable art has nothing to do with quantity or multiplicity. But it's impossible not to resort to quantitative terms in discussing the matter: thus as when I affirm that as "much" density of decision can, in principle, go into the shaping of a box as into the carving or modeling of a representation of the human figure. The size, proportions, material, and color of a box can bear as great a weight of intuited decision as the sculpture that fills a pediment. The fact that this has proved unlikely so far (despite some of the achievements of one or two Minimal artists) doesn't make it any the less possible.

To say it over again: Under a certain aspect, and a very real one, quality in art appears to be directly proportionate to the density or weight of decision that's gone into its making. And a good part of that density is generated under the pressure of the resistance offered by the conventions of a medium of communication. This pressure can also act to guide and evoke and inspire; it can be an enabling as well as a resistant pressure; and it guides and enables and evokes and inspires precisely by virtue of its resistance. Measure in verse and in music, patterns in ballet, ordered necessities of progression in drama, prose or verse fiction, and movies: These have empowered creation at the same time as they have constrained it—and because they have constrained it.

The conventions of art, of any art, are not immutable, of course. They get born and they die; they fade and then change out of all recognition; they get turned inside out. And there are the different historical and geographic traditions of convention.

pictures were done on sheets of paper, and they all betray the fact that the young apes who painted them respected the quadrilateral limits of the paper support and were even guided by these. Other young apes botched their pictures because they didn't distinguish between the paper surface and the surface of the table or board on which the paper lay; they painted on both indiscriminately; that is, they didn't submit to the convention, the human convention, that had been presented to them. The apes that did do so joined the human species for the time being, for the nonce, insofar as by recognizing or accepting or discovering that a pictorial surface had to be delimited, they intuited an esthetic decision in a particularly human way, that is, a formal way. (Whether we who found their pictures plausible or even agreeable did, by that fact, join a simian species for the nonce is another question.)

But wherever formalized art exists, conventions as such don't disappear, however much they get transformed or replaced. This goes for "low" art and for folk art and for tribal, pre-urban art as much as it does for high urban art.

Most of what I've just said is not new. But the emphasis I've put on decision or choice may be. If so, that would be thanks to what's happened in art itself in recent years. It's the boringness, the vacuousness of so much of the purportedly advanced art of the past decade and more that has brought home—at least to me—how essential the awareness of decision is to satisfying experience of formal art. For the vacuousness of "advanced" art in this time is more like that of "raw," unformalized art or esthetic experience, which vacuousness derives precisely from the absence of enough conventions and the want of decisions made or received under the pressure of conventions.

"Convention," "conventional" became pejorative words during the last century. But another of the theoretical services done by recent "advanced" art is to begin to rehabilitate them, to make us more careful in using them, just as we've also become more careful in using "academic" in a pejorative way. Now when we object to art that's found to be too imitative or tame or routine, we have to say "*too* conventional" or "*too* academic" and not "academic" or "conventional" *tout court*. Now when we say "academic" we begin to feel that we have to specify *which* academy and allow at the same time that not all academies were bad. (This, however, isn't just because of the lessons learned from the latest bad art; it has also to do with the irrefragable fact that taste keeps becoming more catholic, in which respect—and it's the only respect—progress is being made in art or in the context of art.)

Bad, inferior art is not necessarily boring or vacuous. What is relatively new about the badness of recent "advanced" art—new, that is, in the context of formal art—is that it *is* so boring and vacuous. This, because of the large absence of decisions that could be felt as "meant," as intuited and pressured, and not just taken by default. That's just it: that so many of the decisions that go into the supposedly newest art go by default, become automatic, and by the same token arbitrary, decisions. It used to be that the tutored artist failed through wrong or incomplete de-

cisions; but the wrongness or the incompleteness came under the pressure of conventions, which made them "meant" decisions. Which is why even the failed results could be interesting, at least up to a point. You could get intrigued by what went wrong, receive intellectual if not esthetic pleasure from seeing how it went wrong (even though the possibility of your getting that kind of intellectual pleasure depended upon having enough *taste* to see that something went wrong). The real newness of "advanced" art in this time consists mostly in the uninterestingness of its failures, their desolateness.

I flatter myself with thinking that I can put myself into the state of mind of the "far-out" artist. I think that I can do this because the idea of innovation, of newness in art, has been so epidemic since the mid-1960s, and the mind-set that goes with it has consequently become so familiar. Don't we all, in the art world, know now what it feels like to decide to innovate? To go far out? So you start by discarding every, or almost every, convention you can recognize as a convention. You leave easel-painting and "sculptural" sculpture behind; that is, you "free" yourself from the conventions that these arts have, as you suppose, been controlled and guided by. You next alight on an "idea," "conception," or category: serialization, objecthood, literalness, process, "conditions of perception," or simply the far-fetched and startling. This becomes the decisive moment of creation; all following decisions are left to the care of this moment. You don't intuit your way any further; you don't, if you can help it, make any further decisions or choices; in principle you let that first moment carry you, logically or mechanically, all the way through execution.

No one can say that superior art can't possibly come about this way. Superior art can come about in any way, conceivable or inconceivable; there's no legislating or prescribing, or proscribing either, when it comes to art. There are only, at a given time, greater and lesser probabilities—neither of which are to be *believed* in. But I'm talking here about art that has already come about in the way just outlined. (Art that is already there is the only art that can be talked about.) That art happens to be almost entirely what I've said it was: uninterestingly bad. And I presume to think I can account for this badness, at least in scheme. This

art has been made too largely in freedom from pertinent esthetic pressures (if not from physical, economic, or social ones). The decisions that have gone into it have been too largely tangential in the esthetic context, however much governed by other terms (such as those, say, of serial repetition, or mathematical permutation, or those of the physical or mental environment, etc., etc.).

Esthetic pressure can come from only two directions. There is the pressure of what the artist has to say, make, express. Facing that is the pressure of the conventions of his medium, which is also the pressure of taste—for in the end it's taste and nothing else that empowers or disempowers convention. (But of that more later.) Convention isn't "form"; rather it's a limiting and enforcing condition that functions in the interests of the communication of esthetic experience. This alone: whether it acts as measure in music; or perspective, shading, design, the "integrity" of the picture plane in painting; or the notion of compactness or else that of light and shade in sculpture, or else that of a circumscribed ground plane; or as meter in verse; or as the obligation to go from beginning through middle to end in fiction. There are many, many less evident, less specifiable artistic conventions than the like of these "old-fashioned" ones I've just listed. We have to go along with the notion of convention, for the most part, as with the notion of art: as something recognizable but not adequately definable. That belongs to what makes art what it essentially is, just as it makes intuitive experience in general what it essentially is.

I've already said: The conventions of art are neither permanent nor immutable. But no matter how feeble they may become, they don't—as the record shows—get finished off by fiat, by wishing and willing. At least not fruitfully, profitably, effectively, not in the interests of good art. Conventions will fade and they will die out, but not because anybody has simply resolved to have it that way. And how conventions have decayed and lapsed with the decline and extinction of a whole artistic tradition, say the Greco-Roman, is one thing; and how they have done so within a tradition that stays alive and moves beyond them is another. But in either case it happened because the conventions in question prevented certain artists from saying new things that they

had to say—or else prevented them even from finding out that they had new things to say.

A tradition of art keeps itself alive by more or less constant innovation. We all know that. What we may have to know better is that some element of innovation or originality goes into all good, not to say superior, art. All good art innovates, however modestly or furtively. It innovates because any maker of better art has, aside from his competence, something to say that no one else has said or could say. Each time, certain conventions or aspects of convention have to be altered in order to accommodate the better artist's uniqueness, no matter how small that may be. This truism holds for Luini as it does for Leonardo, for Lépine as it does for Corot, for Samain as it does for Baudelaire. It holds for all the many relatively obscure artists who, in every tradition, inserted enough of their own particular selves or own particular inspiration in what they sometimes did to make it worth looking at, listening to, or reading. Innovation can't be separated from any dimension of real success in art, allowance made for the fact that by far the most innovation is not striking enough to make itself known as that.

It used, maybe, to be better recognized—even if only implicitly—that in order to break with a convention you had to possess it or, if not that, at least see its point and appreciate that point. Blake, and Whitman too, had enough metric verse in them to be able to go over more or less effectively, or at least interestingly, into "free" verse. Joyce had to own the literary past in order to do what he did do to so many hallowed conventions of narration. Schönberg had to have classic tonality in his bones before he could depart from it as he did. Manet knew from inside out the centuries-old convention of modeling-shading that he so radically dismantled. Pollock was practiced well enough in all the precedents of composition and handling that he violated. Picasso was fully conversant with the Western tradition of monolithic sculpture when he broke away from it as he did in his collage-constructions.

I don't mean to insist that all signal innovators were, or had to be, learned in the full sense, the accepted sense. (And anyhow, artistic learning, the learning that an artist needs, is not a matter so much of knowledge as of taste, of consciousness developed in

a certain direction. Shakespeare didn't have, apparently, as much book learning as Ben Jonson, but he was more artistically learned—i.e., his taste was wider and deeper.) All I mean is that the record shows no case of significant innovation where the innovating artist didn't possess and grasp the convention or conventions that he changed or abandoned. Which is to say that he subjected his art to the pressure of these conventions in the course of changing or shedding them. Nor did he have to cast around for new conventions to replace those he had shed; his new conventions would emerge from the old ones simply by dint of his struggle with the old ones. And these old ones, no matter how abruptly discarded, would somehow keep being there, like ghosts, and give ghostly guidance. The monolith haunts Picasso's first collage-constructions (the most radical and "revolutionary" of all twentieth-century innovations in art) as it does his later direct-metal sculpture, to give them their compass bearing as it were.

Even a rather cursory review of the past of art (of any art and of any tradition of any art) shows that artistic conventions have hardly ever—and maybe never—been overturned or revised *easily*, not by even the greatest of innovative geniuses. A more than cursory review of the past of art, at least of the recent past, shows, however, that conventions have been, and can be, tampered with or abandoned prematurely. Premature innovation afflicts some of the best art of the nineteenth century and some of the just less than best of the twentieth. The frequent ungainliness of Blake's and Whitman's free verse is due to a certain thinness of decision that's due in turn to a departure from measured verse that isn't *lingering* enough; suggesting why they didn't influence or direct succeeding poets except at long and indirect range. Seurat is usually better, in oil, when he stays closest to Impressionism (as in his beachscapes) than when outrightly Pointillist. Both Gauguin and van Gogh are at their best too when closest to "conservative" Impressionism. That the importance for the future of painting of all three of these artists stems from their least Impressionist works doesn't change the case as far as sheer quality is concerned (which is part of what could be called the "problematics" of art in general after 1860). The Impressionists themselves were more consistently successful when they were, as in

the late 1860s and earlier 1870s, less than completely Impression-
ist, when they still hadn't worked themselves free of light-and-
dark painting. It was because Cézanne never stopped regretting
the light and dark of illusionist tradition, because he kept on
trying to rescue the conventions that his Impressionist vision
compelled him to undermine—it was in some very important
part because of this, the back-drag of the quality of the past—
that Cézanne's art steadied itself as it did, for all its ups and
downs, on an extraordinarily high level. It was almost precisely
because of his greater reluctance to "sacrifice" to innovation that
Cézanne's newness turned out to be more lasting and also more
radical than that of the other post-Impressionists. Matisse and
Picasso and Braque and Léger and even Mondrian and certainly
Klee were likewise reluctant innovators, cherishing the very con-
ventions they felt themselves forced to go against—and by their
time it had become a little harder to do that kind of cherishing.
It was still harder for Pollock, who from first to last kept yearning
for the sculptural shading-modeling that his taste, involved with
his own art in its own time and oriented by the best art of the
time just before, would not let him return to.

How reluctant such artists as Kandinsky, Kupka, and Mal-
evich were as innovators is hard to tell, but all three of them
were premature innovators on the evidence of their art—and er-
ratic because of their prematureness. This at the cost of quality.
While shedding certain conventions all three stayed stuck in cer-
tain others whose revision was more fundamental to what they
were trying to bring about. (That it takes hindsight to see this
doesn't matter.) Something similar happened with Gauguin, and
with Walt Whitman too (who stayed with certain conventions
of rhetoric and diction that often deprived his poetry of a needed
tautness). Kandinsky's is almost the exemplary case. His first ab-
stractness, in the pictures he did from 1910 to 1918, fails to as-
similate to itself, that is, modify enough, the traditional and con-
ventional illusion of the third dimension, so that in too many of
these pictures the abstract configurations get lost in the space
that contains them: They wobble and float and sink (though it
can't be denied that in certain rare moments this is just what
brings a painting off; such being the wonderful inconsistency of
quality in art). But it's Kandinsky's outrightly flat pictures, which

come afterward, that offer the more obvious case of premature innovation. Here Kandinsky renounces stereometric illusion *in toto*, but the resulting flatness still doesn't stay flat enough because the configurations that he introduces, and still more the placing of these configurations, disrupt that flatness (violates the integrity, rather, of the picture plane, of which the flatness is just an agent); in the showdown there's more integral "flatness" in a good Ruisdael than in this kind of Kandinsky. The point is that Kandinsky went over into his all too literal flatness by a leap, so to speak, without having coped with, worked his way out of the conventions of spatial illusion that he was so abruptly discarding.

Duchamp after 1912 is a different kind of example of premature innovation. But in the paintings he made before 1913 his case was, as a case, much like Kandinsky's in scheme. That these paintings are quasi-Futurist and pseudo-Cubist doesn't necessarily hurt them: that is, that they put on a look of newness while retaining a conventional enough "infra-structure." But they don't really dispose of the conventions they seem to be shedding (they depend on a traditional illusion of depth more than Kandinsky's first abstract works do), which keeps them a little thin, even a little papery. They also tell us that Duchamp had hardly grasped what real Cubism was about. The first "recovered objects" that he mounted, the *Bicycle Wheel* and the *Bottle Rack* of 1913, tell us that he didn't know, either, what Picasso's first collage-constructions were about. It was one thing to have your fun with long settled-in conventions (though even that was not so easy when it came to the essential conventions of illusion); it was another thing to "play" with more recently established ones, like the shuffled planes of Cubism. Duchamp doesn't seem to have had enough taste to cope here. He seems to have thought that Cubism was too much a "physical" way of art, and at the same time that it was theoretical enough to have required, as he said late in life, to be "detheorized"!

I can't help thinking, and imputing, that it was out of frustration that Duchamp became so "revolutionary" after 1912; and that it was out of despair of being new and advanced in his own art that he came to set himself against formal art in general. That he wasn't consistent in this direction; that he kept on making some things that took a proper place as formal art, even rather

good formal art (the painting *Network of Stoppages*, the *Glasses* large and small, and still other works)—this doesn't affect my argument. (Duchamp was like most other human beings in not being able to control and program himself beyond a certain point. And formalization, and inspiration with it, can insinuate themselves without being summoned. Also, some artists make superior art only when they give up trying to make it, when they give up conscious awareness and self-awareness. Besides which, I think that Duchamp's unconscious absorbed more of Cubism, and of other excelling art in his time, than his rather mechanical conscious mind let him notice.)

All the same, Duchamp did by intention set himself against formal and formalized art. He did, in effect, try to make free-floating, "raw" esthetic experience—which is inferior esthetic experience by and large—institutionally viable (showable in art galleries and museums, discussable in print and by art-interested people). His "raw" art turned out, however, to be less than raw insofar as it had its own orientation to conventions; only these weren't esthetic ones, but the largely un-esthetic conventions of social propriety, decorum. The point became to violate these. So a urinal was shown in an art gallery; the spread and unclothed lower limbs and the hairless vulva of the effigy of a recumbent young female were put on view through a peephole in a rather staid museum. The point was made. But there was a still further point: to defy and deny esthetic judgment, taste, the satisfactions of art as art. This remained the main point for Duchamp (even though he couldn't always adhere to it: the painted background of his Philadelphia Museum peepshow is beautiful in a small way). And it remains the main point for the sub-tradition that he founded. With the necessity or inevitability of esthetic judgment pushed aside, the making of art and of esthetic decisions, whether by artist or beholder, was freed of real pressure. You could create, act, move, gesticulate, talk in a kind of vacuum—the vacuum itself being more "interesting," or at least counting for more, than anything that happened inside it. The gist of consorting with art was to be intrigued, taken aback, given something to talk about, and so forth.

Yet Duchamp and his sub-tradition have demonstrated, as

nothing did before, how omnipresent art can be, all the things it can be without ceasing to be art. And what an unexceptional, unhonorific status art as such—that is, esthetic experience—really has. For this demonstration we can be grateful. But that doesn't make the demonstration in itself any the less boring. That's the way it is with demonstrations: once they've demonstrated what they had to demonstrate they become repetitious, like showing all over again how two plus two equals four. That's not the way it is with more substantial art, good and bad: that kind of art you have to experience over and over again in order to keep on *knowing* it.

To come back to conventions, and then to decisions. Grasping a convention, digesting and assimilating it—certainly doing so enough to be able to change, expand, shrink, or discard it in the interests of art—that means appreciating those works in which the convention is enabling and dys-appreciating those in which it's disabling. That requires taste, that penetrating taste I've already referred to. A convention is disabling when the artist or beholder lets himself be controlled in the wrong places by that convention. It takes taste, as well as inspiration, to get that convention out of the way; inspiration alone (of which the beholder has his need too) won't usually suffice.

One of the ironies that haunt ostensibly avant-garde art in this time lies in the persistence of "older" conventions that taste fails to notice—I mean the taste of the practitioners of ostensibly avant-garde art. The persistence of these older conventions, *older* because they persist unrevised, betrays itself in conventionality of sensibility. No amount of "far-outness," no degree of "literalness," no quantity of lucubration about what art is and how it relates to language or society and so forth, has been able to hide this. Conventionality shows through all the many gaps in the apparatus of innovation. Undetected, therefore uncoped-with conventions remain the controlling ones. They control artist and viewer alike by permitting and inducing routine esthetic decisions, expected and expectable ones, unpressured decisions. This is the kind that artists who are called academic in the pejorative sense have always made. (Duchamp's sub-tradition has only contributed to all the expectability. What's unexpected in a social or

abstractly cultural context, no matter how titillating or shocking, usually turns out to have been long rehearsed in an esthetic context. Duchamp's *tableau "mort"* in the Philadelphia Museum is a perfect case in point.)

But what artists in the pejoratively academic sense rarely did before was try to escape in their decisions from the pressure, as such, of convention. And as I've suggested, the usual outcome for all too many would-be innovative artists in this time has been that, while shedding the obvious conventions, they get trapped in the unobvious ones. Or else, having succeeded in placing themselves in a situation that seems to shut out every conceivable convention, they fall into "raw," unformalized, usually random art. Here, where it should be beside the point if ever, sensibility manages all the same to sneak back in—and it is invariably, or has been so far, conventional sensibility despite all appearances to the contrary. All that's happened is that esthetic decisions become unbelievably weightless and esthetic results unprecedently empty—at least within the context of formalized art. And meanwhile conventions hang on, paltry ones like those that guide the decisions that go into scattering flower petals over water in a basin.

And yet once again: Something has been demonstrated that was worth demonstrating. Art like Duchamp's has shown, as nothing before has, how wide open the category of even formalized esthetic experience can be. This has been true all along, but it had to be demonstrated in order to be realized as true. The discipline of esthetics has received new light. In this respect it doesn't matter that the body of art that has thrown this new light is possibly the worst and certainly the most boring formalized art known to recorded experience. Art as such has lost the honorific status it never deserved as such; and esthetics will never be again what it used to be.

In the meantime genuinely innovative art, major art—the relatively small amount of it there is—goes on in this time much as before. Only now it proceeds underground so to speak, working away at the less apparent conventions and parameters of convention: coping, that is, with what hamstrings and defeats the "far-out" multitude.

THE EXPERIENCE OF VALUE

Nothing can be experienced esthetically without a value judgment, nothing can be experienced esthetically except through a value judgment. Esthetic experience is constituted by evaluation, by the perception of qualities that have value insofar as they induce that state of more or less heightened cognitiveness-without-cognition that is esthetic experience. It's the valuing inherent to esthetic perception that sends it "beyond" primary perception, beyond the perception of phenomena (whether physical or mental) as sheerly phenomenal. The experience of value is the experience—how could it not be?—of judgment; the presence of value requires the presence of judgment; neither is there without the other.

This holds true just as much in the case of unformalized, solipsistic, or autistic esthetic experience as in that of formalized esthetic experience, the experience of art "proper." And it doesn't matter that the value judgment is made more often than not without coming into conscious awareness, especially in the context of the unformalized. The judgment is there nevertheless, and usually only a little introspection will be enough to make it conscious after the fact. (It's arguable that all esthetic experience, all esthetic judgment becomes *conscious* only after the fact: that is, reflects itself, as the Germans would say, only after the fact.)

In the light of the above I seem to see still better what Kant meant when he deduced that the verdict of taste always "preceded" the pleasure taken in its object (or dys-pleasure—he should have added that). It's the judgment of value, quality, that opens art, makes esthetic experience accessible, actual, makes art live and give what it alone has to give. (Granted that Kant's

"precedes" is a little misleading: It's not to be understood in a temporal sense—esthetic judgment coincides with, is, esthetic experience; brings it into attention and at the same time is "consubstantial" with it.) All this holds, once again, for unformalized, "raw" esthetic experience too: for sunsets and sunrises (which latter I myself happen to prefer), for birdsong and the rustling of leaves, for pleasant and unpleasant sounds or noises, odors or smells, for sensations of touch and for those of cold or warm, for moods and notions and ideas and memories (all of which can be experienced esthetically, just like anything whatever except esthetic experience itself).

It is value judgment that also confers "form," whether in formalized or unformalized art. Esthetic distance cooperates here. But esthetic distance and esthetic valuing can't be separated either; in actual experience they coincide too, one means the other. There's no valuing without the distance, no distance without the valuing, the judging. By dint of being esthetically distanced, which means at the same time being esthetically judged, an object or an occurrence receives form. As well as through the judgment-decisions of an artist, this forming can come about through judgments that are not *decisions* on the part of any one. This, whether in the context of formalized or unformalized art. There are, to be sure, the conventionalized, relatively stabilized forms of formalized art, but there are also the unconventionalized, unstable, "unformed" forms—yet forms nevertheless—that waft themselves into unformalized, "raw" art. They waft themselves into formalized art too, as many versions of formalized art in the West have shown lately and not so lately: easel-painting, certainly sculpture, fiction, verse, certainly music, certainly dance, photography, movies, "events," and what not.

An esthetic value judgment means an experience that's liked or not liked, satisfying or not satisfying, pleasured or not pleasured in, positive or negative in varying degrees, in infinitely divisible degrees. There can be, however, experience in an esthetic context that puzzles you to such an extent that it doesn't become esthetic experience at all. You find yourself registering a purported work of art as something sheerly phenomenal, so that you don't either like or dislike it; you're merely perceiving it in the

"primary" mode. What baffles you is not the brute fact of your experience but the further fact that the object or event or performance is presented in an esthetic context and yet you're unable to react to it esthetically: that is, judge it. Of course, you will tend then, often, to express a negative esthetic judgment, but it will be an illegitimate one or rather not an esthetic judgment at all. It will simply express your failure to receive an esthetic experience or judgment and your irritation by that fact. It will be your irritation or bewilderment that you don't like, not the entity itself to which your attention has been drawn by the promise of esthetic experience. (Being puzzled out of, deprived of an esthetic response in a context that asks for one has become a much more common thing than before. A certain large irony has attended on this. Now there are art lovers who'll express a positive "esthetic" judgment precisely because they are at a loss for any judgment at all. The more "unreadable" they find a work of art, the better they assume it to be. Or still worse: They may be really and truly bored because the art at hand is really and truly boring; they may be having a valid esthetic reaction, even if a negative one, but they'll deny it and express a positive judgment because they've gotten used to associating boringness with "advancedness" and "advancedness" with quality. Of course it's not easy to register the difference between puzzlement and boredom. But in that lies the challenge of "advanced-advanced" art, literature, music in this time.)

The question of negative esthetic value, of failed art, of unsatisfying, or boring, or bothersome esthetic experience is one that philosophers of esthetics have tended to shy away from (as they have from the question of the objectivity of esthetic judgment). Sometimes, like Croce, they'll refuse to call bad art art at all. But there it is, all the same, bad unformalized as well as bad formalized art, and if it's not art or esthetic experience, then what is it? I have to say that it still has to be accounted esthetic experience—therefore art—as long as it's experienced at esthetic "distance," in the esthetic "mode," in a context of esthetic attention. What good would it do to call it anything else?

If the experience of art is essentially the experience of value, and if value requires judging in order to be perceived, then it follows that when we talk about art as art, or esthetic experience

as esthetic, we are talking about moments of judgment or evaluation—this in the first place. It has to be understood, however, that judging doesn't mean sitting in judgment. Esthetic judging is spontaneous, involuntary, is at the mercy of its object as all intuition is; it doesn't involve deliberation or reflection. (Assessment, appraisal—if it is to be distinguished from judgment—can come only after the fact, and depends on the reviewing of judgments that have already happened: thus when we try to decide where to rank the total achievement of an artist.) Once again, esthetic experience consists in intuited, not weighed, judgments of value. Works of art themselves consist ultimately of and in value judgments *insofar* as they are art, esthetic experience, and nothing else. This is so not only in the experience of the beholder or listener or reader. The acts by which works of art are created are value judgments too, judgment-decisions (as again, I've pointed out elsewhere). Coleridge says: "The judgment of Shakespeare is commensurate with his genius."

Of course art, in order to exist, has to be something besides art as such, besides esthetic experience. It has to be a material phenomenon "before" it's art. In the case of literature it has to be a mental phenomenon as well; "after" the sounds we hear or the marks we read come meanings that are sheerly meanings. And just as anything (except esthetic experience itself) can be experienced esthetically, so anything, including art, can be experienced un-esthetically—even Mozart, even Dante, even a Fouquet miniature, even a Chola bronze. These can be experienced as sheer or mere phenomena, as intrinsically valueless items, as information or as things whose value lies in the materials they're made of. There's nothing reprehensible in this. No categorical imperative says that what are intended to be esthetic entities have to be experienced esthetically, any more than sunrises or breezes have to be. What I do say is that we shouldn't assume we're talking about art or the esthetic when we're actually talking about something else for which the art at hand is just a pretext.

It remains: that when no esthetic value judgment, no verdict of taste, is there, then art isn't there either, then esthetic experience of any kind isn't there. It's as simple as that. (In *idea*. The trouble is that art has rather little to do with ideas.)

To repeat: In the esthetic context judging means liking or not liking (or you can say being moved or not, stirred, exhilarated, or not, or not enough, along a scale of degrees that's as infinitely divisible as any total continuum). If, as I've said more or less, the essence of the experience of art as art consists in degrees of liking and not liking, then what has to be pointed to in the first place when talking about art are those degrees. It's there that the interest and excitement of talking about art is, or at least starts from. Moments of taste. That interest and that excitement fade and become something else when the talk turns to what's read off from art and read into it, to what's interpreted out of and into it. Then it's no longer art as rock-bottom experience, as its own reality, that's being dealt with.

I don't mean that art shouldn't ever be discussed in terms other than those of value or quality. Of course not. What I plead for is a more abiding awareness of the substance of art as value, and nothing but value, amid all the excavating of it for meanings that have nothing to do with art as art. But, again, I have to say that there's nothing reprehensible in itself in disregarding art as value. Historical, stylistic, scientific, sociological, psychological curiosity have the right to feed on art as well as on many other things, and more power to them in their feeding. Only let it not be thought—as it's all too much thought—that these kinds of curiosity, as valuable as they may be in themselves, have as yet discovered anything fundamentally important about the experience of art as art.

That art *qua* art, that all esthetic experience insofar as it is esthetic, "dissolves" into value judgments takes no more away from it than is taken away from the world of human affairs by its own "dissolving" into questions of value, of moral value ultimately. And it can be said, and is said, that values converge in the long run. That hardheaded and wonderful philosopher, Charles Sanders Peirce, says: "Ethics, or the science of right and wrong, must appeal to esthetics for aid in determining the *summum bonum.*"

But I don't want to suggest for a moment that esthetic value, before it leaves the realm of formalized art and ascends to the *summum bonum*, is to be put on the same plane as moral value. Going that way is going toward barbarism, as Thomas Mann

said of Nietzsche's estheticism. Not all the art ever made, not all the esthetic experience ever relished, is worth the life of a single human being. I would deplore anyone's risking his or her life in order to save the contents of the Louvre. A real categorical imperative operates here.

I don't want to be misunderstood. I don't mean at all that moral value should take precedence over esthetic value when art as art is being dealt with all by itself. When art is under scrutiny as art and nothing but art, then the question of the relation of art to life, of esthetic to moral value, is beside the point. Just as the question of the relation of the value of knowledge to morality is beside the point when knowledge as knowledge, knowledge for its own sake and not as something to be used, is under discussion. Then the question of the *summum bonum*, the supreme good, has to wait—as it usually does anyhow.

THE LANGUAGE OF ESTHETIC DISCOURSE

"Whats" turn into "Hows"—but not the converse.

Art, the esthetic, is maybe the most pragmatically oriented of all areas of experience—art *qua* art, art as such, art as nothing else but art, as nothing else but esthetic. Because results are all that count in or for art (whether formalized or unformalized). Results here mean value judgments alone, nothing else: the intuitive registering of the esthetically good, bad, middling. This registering decides everything in art as art. All other questions about art in itself, about esthetic experience in itself, cede to it. The sole issue is value, quality. Does the result work, does it succeed, and to what extent? To what extent does it promote that state of heightened cognitiveness-without-cognition in which (as I think) esthetic value consists? However interesting or even important other questions may be, they're beside the point as far as art as such, as far as the esthetic as such, is concerned.

(Though I haven't said anything so very new here, I'm sure to be misunderstood. Once again: There are more important things than art or the esthetic. Art is autonomous; it's there for its own human sake, sufficient to its own human self, but this doesn't seal it off from society or history. What its autonomy does mean is that it serves humanity on its own terms, i.e., by providing esthetic value or quality. Art may provide other things as well, but if it does so at the cost of esthetic value, it deprives humanity of what is uniquely art's to give. Art that does this is not forgiven in the end, and the refusal to forgive asserts and confirms the autonomy of art—or, as it's time to say, the autonomy of esthetic value.)

Results are not only all that matter in art *qua* art, they are

also all there is to art insofar as it's art. The tissue, substance, essence of esthetic experience are results that are value judgments. When art is given to experience as or for anything else it's no longer or not yet art, and the experience of it is no longer or not yet esthetic.

It could be said that everything discernible and specifiable in art is at once cause and effect or result, means and end, both in one. But the identification is one-sided (if an identification can be that). Effect or result comes first, and also last: It swallows up cause or means. Among the causes of results in Shakespeare are diction, syntax, meter, plot. But in having effect as causes, these have at the same time effect as results by eliciting value judgments in their own right. The same goes for the fresco'd-ness and the brushstrokes, the lights and darks of the Sistine ceiling; for the devices of a Mozart composition and the intricacies of its performance; and for that matter, for the physique of a dancer and the physiognomy of an actor. All these means and causes become results, get judged (however unconscious the judgment), and enter into larger, more embracing value judgments. Context too, as established by the work or experience itself, acts as a result at the same time that it causes results (through the relations and connections it brings about). In effect, everything in art, in esthetic experience in general, circles back upon itself, that is, as far as discursive reason can tell: Causes seem to cause themselves, results seem to result from themselves.

Where causes always turn into results it's no use looking for causes of causes; what you get then is what logicians call an "infinite regress." Every cause, turning into a result, requires a still further cause, *ad infinitum*. This makes infinite trouble for reasoning about art. It turns out—and it has always turned out—that art, that esthetic experience can't be fruitfully reasoned about, at least not beyond a point that lies close to the beginning of reasoning.

An esthetic value judgment, as well as being a result without a cause, is also (it can be said) an answer without a question. It swallows up its question just as, in being a result, it swallows up its cause. It's no use asking why a work of art succeeds in spite of this and that fault, in spite of lacking this or that; or why it fails in spite of having this and that. There the brute fact of the

esthetic judgment *is*, and there's no thinking or arguing around or past it. It swallows every question that questions it.

Given, say, a painting by Mondrian: his *Fox Trot A* of 1930, say, in the Yale University Art Gallery: a diamond-shaped picture with ruled black bands that stay close to the framing edges, leaving the whole middle to the white that's the only other color on the canvas. It's as empty a picture as could be imagined short of a completely monochromatic one. Yet it works, it succeeds, and does so on the highest level; it can hold its own with anything else I know of in pictorial art. That's what my eye, my taste, says. It might be asked how I could be moved so much by a work that had so little in it. But the "little" happens to be only material and phenomenal, not esthetic. My response to the painting, my spontaneous value judgment, says that it has everything it needs to succeed, and to succeed highly. But what about "content," what about "human interest" and "relevance"? What about 1930? My value judgment gives the same answer: The picture has everything it needs in order to succeed as art. By virtue solely of that judgment it demonstrates that to me. And so does every other work of art or esthetic experience that I've found satisfying. How could art that's proven itself satisfying, that's elicited a positive value judgment, fail to have "content," "relevance," "human interest," and so on? Esthetic value judgments, and nothing else, not interpretation, not explication, not argument, answer that kind of question.

That the content or "meaning" of the Mondrian can't be put into words is not something that should give pause. The content of the *Divine Comedy* can't be put into words either, nor the content of any Shakespearean play, nor that of a Schubert song. As Susanne Langer says, the content or meaning of a work of art—and I'd say of any esthetic experience—is "ineffable." The subject, the references of a work are not the same thing as its content. Nor is its mood or emotional tone. And that people keep on trying to pin down content in art shouldn't deceive us. Notice only how little agreement in the long run their efforts, their interpretations get. There's far less agreement about these than about value judgments—again in the long run. Unexamined habits of mind and speech lay traps here (as they do almost everywhere else in the discussion of art). What a work of art is

"about"—subject, theme, "ideas," emotions—is, again, not equiv-
alent to its content or meaning. About-ness doesn't isolate the
affect of a work, either in part or in whole; it doesn't specify the
substance of an esthetic experience. But it's only in that affect
and substance that content or meaning dwells—and dwells there
inextricably, not to be grasped by language.

And anyhow the words "content" and "meaning" themselves
can't be defined at all satisfactorily in the context of the esthetic.
That's what it all comes down to. What they may be intended
to mean can't even be pointed to—of course not, since their
intended meaning is something that's ineffable. And what can't
be pointed to, what can't be indicated even indirectly, had better
be left out of any discussion of art, not only of art as art but of
art as anything else.

I want to return to the Mondrian to try to drive my point
home. Someone else, whose response to it is less favorable than
mine, may say that the picture lacks content. If so, I would ask
him what he meant by "content." He might answer: the depiction
of recognizable objects. But he might also say: feelings made
manifest, as—supposedly—in the paintings of the American Ab-
stract Expressionists. Then I'd ask him whether he thought that
content in either of these senses made a difference in quality; in
view of his objection to the Mondrian, he'd have to say: yes.
Well, I'd ask: As between two pictures both endowed with con-
tent but which he didn't like equally, how would he account for
the difference in his response? Suppose it was Tintoretto's *Cru-
cifixion* in Venice that he preferred to a painting of the same
subject of Bouguereau (there is one)? My interlocutor could say
that Tintoretto deepens and enlarges his subject-*cum*-content as
Bouguereau doesn't, that he illustrates it more affectingly, and
so forth. I would grant him this. Nor would I ask him to be
more specific and explain what he meant by "deepens," "en-
larges," or "illustrates more affectingly." Instead, I would show
him a Fantin-Latour still life that I thought highly of—say the
one in Washington—and suppose, as well he might, he preferred
that, too, to the Bouguereau. He'd have to twist and turn, then,
in trying to explain this preference on the basis alone of what he
called content. Pushed to it, he might say that there was actually
more feeling, therefore content, in Fantin's color and drawing

and touch than in the subject itself of the Bouguereau. Well, I'd say at this point: You're not talking in terms of what you call content any more, you're talking in terms of what's called "form." He'd also have to talk in terms of "form" when he tried to account for his preferring one Abstract-Expressionist painting to another. At this stage of our dialogue I would bring my imaginary interlocutor back to the Mondrian and say that I saw at least as much feeling in it, feeling of a high order, as he saw in the handling of the Fantin-Latour. But where would we have gotten when we both had to point to "feeling" as the decisive factor in esthetic quality? "Feeling" says no more than "content" does in this context. (Yes, there are different kinds of feeling. But no given kind, nor ostensible quantity either, is a decisive factor when it comes to esthetic quality.) The Mondrian has feeling; it has content simply because it works, because it succeeds—as I said more or less to start with. "Content," "feeling": both words amount here to a *"je ne sais quoi."*

I've had my imaginary interlocutor bring "content" in, and then "feeling," as *criteria*, and this is as good a place as any to get rid of the question of criteria of esthetic value. I've shown, I hope, that what is ordinarily meant by content can't serve as a criterion. By becoming a matter of "feeling," "content" drifts over into a matter of form, but "form" in depending on "feeling" drifts back into content, thereby becoming equally impossible to separate and identify, and therefore just as useless as a criterion. This isn't to say that there are no such things as esthetic criteria. There are. Esthetic experience, consisting as it does in valuing or dys-valuing, would be impossible without them. Only they can't be articulated, can't be put into words or concepts, can't be communicated (like so much else in esthetic experience). Criteria are there all right, just as standards are there, but hidden from consciousness, unobservable, known only through their affect—like the criteria of truth brought to bear in non-esthetic intuitive experience, those that enable us to tell black from white, loud from soft, smooth from rough. Esthetic criteria can no more be deliberately or consciously applied than the criteria by which we distinguish colors or sounds. Once attention gets esthetically involved, they come into application of their own accord, automatically and unsummoned.

Criteria derive from immediate, personal experience, and nothing else. Standards amount to the same thing as esthetic criteria. You acquire standards in the same way. But the differentiation of terms is useless. "Taste," which has managed to survive all the tendencies to discredit it since the eighteenth century, can serve for both. In spite of everything, "taste" is less misleading than "criteria" or "standards" because it doesn't ask so much to be defined, nor does it let itself get so easily detached from the individual.

To return once more to Mondrian's *Fox Trot A* and my imaginary interlocutor. He no longer tries to account for his dissatisfaction with the picture by saying that it lacks content. Nor does he say even that it's too simple, too empty, too wanting in visual interest. All he says now is that he doesn't like it and he leaves it at that. I'm faced with a "pure" value judgment, one that really can't be argued against or about. All I can do, and all my interlocutor can do, is urge one another to look again and see whether one of us doesn't change his judgment.

As it happens, an esthetic value judgment can't be legitimately changed, displaced, or tested except by another esthetic value judgment on the part of the same person who had the first one. No other person's value judgment can change or displace yours because—to say it still again—the experiencing of an esthetic value judgment can't be communicated or transferred from one person to another. This is, or should be, a truism. You can't see or hear through someone else's eyes or ears. The most another person's value judgment can do is send you back to an art work with attention sharpened or refocused. This is what criticism at its best does: points, quotes, and reminds too (at least in the cases of music and literature, which can be kept in memory and re-experienced there as visual art ordinarily can't be).

To say it still again: Art lives in the experiencing of it. And yet again: That experiencing consists in valuing, esthetic valuing. And the valuing comes out like results and answers that have swallowed their causes and questions. By a similar circularity, content and form disappear into one another. Esthetic experience turns out to be all content and all form. It's as though the one remains immanent in the other, to become manifest in and as that other the moment discursive thinking tries to pin that other

down. If that diamond-shaped Mondrian at Yale didn't excel by its content, its form would have availed it nothing; if it didn't excel by its form, its content would have availed it nothing. Thus they disappear—no, they change—into one another: the content and the form.

OBSERVATIONS ON ESTHETIC DISTANCE

To repeat: Esthetic experience *is* value judgment, is constituted by value judgment. I wrote also that an esthetic value judgment can be thought of only as a result that swallows its cause or causes, or as an answer that swallows its question or questions; that everything specifiable as esthetic in esthetic experience, in being a value judgment, can—nay, has to—be considered a result or answer, and that going from one aspect or part to another of an art work, or an esthetic experience, means going from results to results of results—or from answers to answers of answers—and so on. Whatever might be seen at first as a cause, or a question, turns out under scrutiny to be a result or answer; and if there seem to be still further causes or questions behind it, these too, when looked at closely, turn out to be results or answers.

This is what happens when the discursive mind probes a work of art or an esthetic experience in order to account for its specifically esthetic quality or qualities. It comes up always against the value judgment as a brute fact—"brute" because an act of intuition can't be taken apart by reason.

All this has to do with esthetic experience as seen from the inside, as it were. Backed away from and seen from the outside, esthetic experience arranges itself somewhat differently from thought. Now we see it *becoming* as it were, rather than *being*. Where before there was nothing but results now everything becomes sheerly means (but still *not* causes); means to esthetic results—but to be seen as, thought of, discussed as means only as long as it's not yet esthetic result, as long as it keeps something

of its extra-esthetic status, its status "outside," and is thus not fully integrated in the esthetic experience. Canvas and paint as sheerly material, sounds or the timbre of sounds when considered separately, the dancer's body seen as nothing but body, words and their meanings isolated in their dictionary or cognitive definitions: in the context of the esthetic, these when thought of this way remain or become means because they exist before art and independently of art, as "ordinary" phenomena, whether physical or mental. But this distinction applies to much, much more than the physical or purely cognitive aspects of the various mediums. It also applies to whatever gets incorporated in or conveyed by the mediums, whatever gets depicted, represented, manipulated, referred to, alluded to, implied, or hinted at by or through them. This distinction applies, moreover, to whatever kind of experience feeds unformalized art—that is, solipsistic esthetic experience—where sense impressions alone act as the medium (as in visual, auditory, olfactory, gustatory, or tactile esthetic experience of nature).

The distinction between the esthetic and the extra-esthetic is installed by what has come to be called "esthetic distance." "Distance" here means detachment from practical reality, the reality we live in ordinarily, reality at large, the reality that's shot through with behavior and consequences and information. Anything that reaches the stage of being, rather than just becoming a means to an esthetic result—that is, gets swallowed in the result—does so by being deprived more or less of its "weight," its practical or theoretical specific gravity, in reality at large. (The "more or less" is important here and I shall come back to that later.) It becomes frozen, so to speak, with respect to its impact on that reality. Esthetic distance lets you watch, behold, experience anything whatsoever without relating it to yourself as a particular human being with your particular hopes and fears, interests and concerns. You detach yourself from yourself (Schopenhauer). Esthetic distance permits you to experience everything at a remove, even your own feelings, your own joys and your own suffering. Admittedly, experiencing your own suffering esthetically is unlikely, but the possibility can't be excluded in principle (that there are other ways than esthetic distance of

achieving self-detachment—resignation, etc., etc.—would in truth only bear this out).*

Although esthetic distance is the prime condition of esthetic experience, it's not a condition that makes itself known in advance of such experience. It's realized only, it's there only, when esthetic experience itself is there. An esthetic occasion has to be there, an occasion that makes itself esthetic in a circular way by dint of being experienced esthetically. Esthetic distance and esthetic experience arrive together. The distance, as a condition of the possibility of esthetic experience, "precedes" the latter only in that same atemporal "logical" sense in which Kant said that valuing "precedes" the pleasure or dys-pleasure gotten from art. (Here again, discourse turns in a circle as it tries to come to grips with what actually happens in esthetic experience.)

But the identification of esthetic distance with esthetic experience itself isn't a complete one. You can decide, choose, in advance to have esthetic distance, put yourself in a frame of mind that's ready to have it. You can prepare yourself to have it as you enter a concert hall, theater, or art gallery, or when you go out into Nature. The artist chooses in advance to have esthetic distance when he goes to work—or he should. Yet this doesn't mean that you already have esthetic distance by mere virtue of your decision; you've only readied yourself to have it. Esthetic distance, and esthetic experience along with it, can also come unsummoned, without your being at all in readiness for it. Like esthetic experience itself and the valuing that constitutes it, esthetic distance—esthetic attention, focusing—can be involuntary

* Kant pointed in effect to esthetic distance when he said that the "judgment of taste is . . . indifferent as regards the being of an object"; also when he said, "Taste is the faculty of judging of an object, or a method of representing it, by an entirely disinterested satisfaction or dissatisfaction." What could be called the classic essay on esthetic distance is "Psychical Distance" (1913) by the English psychologist Edward Bullough. The American philosopher John Hospers takes issue with some aspects of Bullough's presentation of his thesis in another important essay, "The Aesthetic Attitude" (1967). Both essays—which I take issue with at some points—are reprinted in *A Modern Book of Esthetics*, edited by Melvin Rader. See also Chapter 8 in Harold Osborne's *The Art of Appreciation*.

or inadvertent, imposing itself when you're least in mind of anything esthetic. In this case it's as though the esthetic occasion, the moment of it, came first, and only then the distance that made it possible. Some appearance, some sound—or some touch, taste, or smell, for that matter—comes into your ken and instantaneously, without your having any say, enjoins the distance, the "esthetic attitude." This happens all the time. As I've said in another place, the esthetic lurks everywhere and—contrary to a common notion—you don't have to be particularly attuned in order to have esthetic experience on some level or another.*

In our culture, if not in others, it's formalized art, and anything resembling it, that elicits esthetic distance and attitude most noticeably.

* There's ever so much here that introspection still hasn't noticed in a responsible way. In some directions other cultures may have been ahead of ours in reflecting on esthetic experience. The trouble is that the Indians, the Chinese, and the Japanese haven't generalized or systematized in quite the logically consistent way that Western philosophy and esthetics have. So it seems to me, they haven't made their insights as viable as Kant, say, made his. Under the pressure of the same Greek-derived logic that made Western science truly scientific, Western thought has worked at least to develop guidelines for what's sayable in an explicit way about esthetic experience.

Part II
The Bennington College Seminars,
April 6–22, 1971

NIGHT ONE
April 6, 1971

GREENBERG: It's always a pleasure to be back at Bennington. These seminars are a real challenge to me. And I think it's altogether an untried venture because I feel that art and esthetics have not been discussed properly over the last hundred and fifty years. I don't propose that we will cast a new and blinding light on the question, but I do think we're at this moment in a particularly advantageous position to do something a bit new because of what we've learned from contemporary art over the last ten years. I happen to feel it has made clear certain general truths about art that no philosopher of esthetics could have discovered before.

It's quality that I'm interested in, and the so-called "far-out" art of the last ten years has put the question of quality on the table as never before and, as I think, shown or revealed amazing things about how quality in art makes itself felt. Now, I don't want to sound fashionably Wittgensteinian. I know Wittgenstein is a very okay name today, and I'm not competent to criticize him, but as I see it he had hold of one part of the truth— probably more—when he said, let's find out how we talk about things and maybe we'll find out what we really think of things— how we act on what we think rather than what we think we ought to think.

Now, making clear the limits of what you can say about art has more than theoretical usefulness. It is useful not only to the art lover and the art critic, it is useful—it could be useful—to the artist himself: the clearing away of irrelevancies—fetishes, dogmas, highfalutinness, irresponsible rhetoric, inflated language, melodrama—all the verbal excrescences that come to accompany

modernist art in particular, though not just modernist art. I think that pertinent thinking and talking about art are much simpler or should be much simpler, more direct, than they usually are. And even the talking and thinking about esthetics—the discipline known as esthetics—which may not be that simple to start with, needn't be that top-heavy or highfalutin.

I said limits. One of the things we have to do in approaching art is appreciate the fact that art is something recognizable but not satisfactorily definable or even describable. What we say and think and write are approximations, they are stabs, circumlocutions that have to do with the effect of art but hardly graze what goes on in the actual creation of art or in its actual appreciation. Unlike things that have meanings that can be put into words, works of art are intuited or experienced or perceived in a way like that in which sense qualities—colors, sounds, touching, smells, and tastes—are. These primary things—these primary perceptions—are inexplicable and indescribable. You can talk about wavelengths of light and wavelengths of sound, you may talk about other forms of measurement. You may be able to tell—prescribe—how sounds, colors, a certain quality, are to be produced, but you can't describe or define their *affect*, their feeling. In this respect, it's analogous with art. Works of art are describable and even measurable in many ways, but not as art *qua* art, not in their action or affect strictly as art.

Indefinability—indescribability—belongs to all things that contain their own purpose, things that are ends in themselves and not necessarily means to, or indicators of, something else. And this applies to human beings. It applies to love and moral behavior, ends in themselves like happiness, it even applies to play. Like these, art is an ultimate value. That is, the experience of art is an ultimate value. Something we go to for the sake of the experience alone, and of which we ask nothing more than that so-called "non-referential" experience. It is not an experience to be figured out or unraveled. Art is there for its own sake.

Now, "art for art's sake" is a notion that has been in bad odor lately, but it holds all the same. It is there, and it holds fast. All we have to do is remember that while art, insofar as it's inherently valuable, is an ultimate value in itself, it is not a supreme value. It is a subordinate value as against the weal and woe of human

beings, as against the happiness and suffering of any single human being. But all the same, this doesn't mean that when we occupy ourselves with art, art isn't valuable, doesn't remain valuable in and for itself and not for something else. Trying to justify art by assigning it a purpose outside or beyond itself is one of the main causes—though far from being the only one—of the art obfuscation, of all the misleading and irrelevant talk and activity about art.

In our Western culture it is very hard to put up with the notion of things valuable entirely in themselves, even though we may act on that notion much more than we realize. To a greater extent than any other civilization, Western civilization, for all that's wrong with it, happens to treat human beings—in theory anyhow—as ultimate ends. The esthetic—a thing valuable as an end in itself—seems to be much more familiar, much more taken for granted, among Chinese, Japanese, Greeks, or Romans, and other exotic peoples, who seem also—and this is seeming—to have granted less absolute ultimate value to the human person and personality. But it makes no difference. If we're talking about art, we're talking about art as an end in itself—if we're dealing with art, it's an end in itself. There is simply no getting around that.

There is a kind of convergence here. The inscrutability of something like primary perception—perception of colors, sounds, tastes, smells, touches—and the inscrutability of ultimate ends like art and like the human personality, these different inscrutabilities come together to compound the difficulty of talking about art in a discursive, analytic, ratiocinative way. And the fact is we are not able to describe or discriminate about, with anywhere near satisfactory precision or useful precision, what goes on inside the human mind when art is being made, or what goes on inside the human mind when art is being experienced. We certainly do not have discursive reasoning to help us. All we have is something I can only call "insight"—direct insight and insights of such a nature that they can't be visibly expressed.

We can know pretty well—we can know usefully enough—what goes on when we add two and two, and we know it is going to come out as four. And we know pretty well what we're about when we infer from the fact that all men are mortal, and

that Socrates was a man, that Socrates is mortal. And we know what we're about when we infer from the fact that there are clouds in the sky that there is a pretty good chance of its raining or snowing, and we know that the clouds have something to do with the rain or snow. It is in some part because we can't make safe inferences of this kind about art as art, about art as quality, that the talk and the writing about art amount at their best to guesses, stabs, approximations, and surmises and not to conclusive or factual statements. It is also because of that, that the talk and the writing about art reach their best when they show and exhibit something of this tentativeness. The exception is with respect to one aspect of art—the relative value, worth, quality of particular works or items of art. That is, when it comes to value judgments—esthetic verdicts—we need not be that tentative. More often than not we can tell when we like, and we can tell when we don't like, a work of art. The main point is to be able to report this truthfully not only to other people but to yourself.

Now, I don't want to anticipate too much where I hope to lead the seminar tomorrow, and I think I've said enough to provoke questions and even opposition from many of you. Let me say that you can't make a fool of yourself asking questions in this area. Too many people have already made fools of themselves for there to be any novelty in this respect. . . .

QUESTION: You talk about art for art's sake, and I would challenge that to this degree: I don't think that morality and esthetics can be separated at a time when civilization itself is threatened, and that implicit in art for art's sake is the denial of the responsibility of the artist to civilization itself when civilization is being threatened by militarization—a cultural and esthetic fact and a destructive esthetic fact.

GREENBERG: I have an embarrassing answer to that. Just as we don't ask the shoemaker to put himself in touch with the most burning issues of the day in making shoes, we don't ask an artist in making art to put himself in relation with the most important issues of the day. And as I said, this doesn't mean that art is just as important as what human beings do to one another. I'd only repeat that when you're at art—when you're making art—it's art

you're making as an end in itself, and it's art you're dealing with as an end in itself. It's rather simple, and I think St. Thomas Aquinas was the first to say something like it. The shoemaker making his shoe—of course a shoe is a means to something else—but the shoemaker has to make a good shoe first of all if he is a good shoemaker, and if he is to, let's say, fulfill the demands, the justified demands, that society makes on it. And it is, I think, as simple as that. Which doesn't mean that the artist, as a human being away from his art, has to turn his back on politics or morality. It doesn't follow at all from art for art's sake. What did happen to the slogan "art for art's sake" in the nineteenth century was it shifted over into the assertion that art was more important than anything else, which I feel is a very illegitimate, immoral assertion, actually.

QUESTION: Isn't the future of art dependent on the future of civilization?

GREENBERG: Most certainly. Well, let the artist when he is away from his art show his solicitude about civilization. . . .

QUESTION: I don't take exception to art for art's sake, but I wondered whether you might define it a bit more in relation to what happened before the late nineteenth century. In reference to Renaissance and . . .

GREENBERG: You mean before it became a slogan and before it became something conscious. Yes. Art was in the service of the church, it was in the service of the state, it was even in the service of politics. But we notice that the best art of the past was somehow made with the intention of making good art, primarily. That the religious theme, ceremonial theme, doctrinal theme, political theme, the glorification of a ruler or powerful person, all this became pretext. And we already notice, even before Vasari, that artists are not ever praised for their religious feeling, they're praised for the excellence of their art and hardly anything else. We have it right there in the discourse about art. And we also say the artist's conscious intention doesn't consciously operate for the most part. Giotto painted to celebrate the life of Jesus. We

can see from the results that he painted just as much to produce good pictures even though we might feel we are projecting our own experience of his pictures back into his motives. If we knew more about what went on in human consciousness when art was being made, we could answer your question with less surmise. . . .

QUESTION: There's confusion that we could clear up very easily, and that is the distinction between saying that art is valued for its own sake, as you said, and what you have also implied, that it is not valued for its own sake but for the sake of something else, very particularly, the spectator's experience. . . . If that's so, then couldn't we consider such questions as whether those valued affects you mentioned are of a unique kind or are they comparable to or shared by other experiences that we have, for example, the experience of games?

GREENBERG: Friedrich Schiller was the first to try to define art as a form of play or relate art to play, and he had trouble with that. My own answer is I happen to think play is a form of art and I would agree with Schiller in a way that would surprise and shock him. But I would think it is a very low-grade form of art for the most part. Now the question of valuing art for its own sake or for the experience it affords, that's what I call a "scholastic" distinction. All we know about art is the experience we have of it. When we say "art," we mean something we have experience of.

QUESTION: Not exactly, because I think you yourself would probably make a distinction between the experience of a work of art—for example, painting, as a piece of canvas with spots of paint and . . .

GREENBERG: That's not experience *qua* art. When I say "art," I imply *qua* art. I'm not talking about objects. Or when I talk about music I'm not talking about a succession of noises, I'm talking about an ordered succession of sounds that is music and unintelligible, we'll say, as anything but music. These other distinctions are scholastic . . .

QUESTION: It's not scholastic, because if you could make that distinction which you yourself have just made or deemed exists, then you can consider the relations between those two. That is, the relation between the art object described as such—for example, a physical object with dimensions—and the experience you have of it as an art work. And that then becomes an interesting question.

GREENBERG: Yes, it is an interesting question and here I'm brought up against my own incompetence. I'm not a philosopher—not a language philosopher. Incidentally, let me say there have been attempts to explain or explicate the relation between the art object as an object, or as an indifferent sense experience, and art as the experience of art. Someone like Susanne Langer says that all works of art create a kind of illusion. The painted cloth creates a pictorial illusion, dance creates the illusion of dance, and so on. I agree with her just as I agree with Sartre that works of art are imaginative entities—not imagined, imaginative entities. That's his answer to the same question. As far as I'm concerned, I think the difficulty is largely a verbal one and largely an answer designed to check the new-fashioned cant— "new-fashioned," it's fifty years old!—about reducing painting or reducing sculpture to their physical substances, and words like "non-referential" have come in lately—all the words of journalists. The artist emphasizes the physical qualities of painting instead of trying to conceal the fact that it's paint on canvas or that the canvas is on a stretcher, or whatever. You call attention to these facts explicitly. In calling attention to these facts in an artistic way, even though it may be in a bad artistic way, you're getting no nearer their self-identity—the self-identity of the canvas or the paint, natural pigment—than you are when you paint a *trompe l'oeil* cup on it. Again, the work of art eludes you the way a pellet of mercury does, and Sartre is right and Dr. Langer is right. Art is by way of being an illusion or an entity that belongs to the imagination. I happen to think this is important, what you have brought up, only in dealing with so much contemporary journalism about art. There are artists who claim, as the Minimal artists and others have, that art—and this claim, of course, has been made periodically for the past, either as a claim,

or as a charge or accusation—that art from now on is going to be entirely different from what it has been up to now. And now art is no longer—so you can read in art magazines—is no longer going to be this shabby thing called "illusion." It's going to be the "real thing"—the real piece of steel and the real piece of wood, and the real piece of plastic, and the real piece of string, and so on.

QUESTION: What do you mean when you talk about taste in that context?

GREENBERG: Well, I'll be getting to all that, but taste is the capacity to appreciate—which in turn means the capacity to experience more fully—works of art, good and bad.

QUESTION: Is there a certain standard applied?

GREENBERG: Yes, but we can't put it into words.

QUESTION: You have used—and specifically in the case of Pop Art—the phrase, "It is merely an episode of taste." You used the concept there pejoratively, and you have just established taste as something far more discriminating.

GREENBERG: That's right, far more essential, I mean. Well, I use "taste" as a metaphor—one of those loaded metaphors—and it teaches me something about how really tidy you should be in using language. There is the taste of the art public, and there is art at the same time—and I make this provisional division between them. The best art of our time, as it happens and as it has happened over the last hundred years or more, has proceeded largely separate—in the short term, each phase of art—from the taste of the larger public for art. The demonstration of that is, let's say, Eugène Carrière, who is a pretty good painter, and who was far, far more famous in 1900 than Cézanne was, and really more famous than any of the Impressionists, except possibly Monet. And we've got so many examples of that in painting since the time of Corot on, and we have it in literature too, and we have it in music. We can say the art public that admired Carrière

participated in the history of taste rather than the history of art, that's what I mean. It's curious here; histories of taste have been written in a slapdash way, but no one has tried to write what I suppose I would call an "anatomy of taste" as taste has operated for the largest art public since Corot's or Manet's time—the regularities in the way in which taste has operated. The best new art of a given moment is like a projectile whose speed is such that it generates—it meets—greater resistance than the less-than-best new art of that given moment. And this repeats itself so regularly, not only every generation or every dozen years, it repeats itself every two or three years. And we can see that right in front of us. Pick up any art magazine. Someone should try to do a history of taste that took account of the fact that Paul Albert Besnard, who came up in the 1880s, saw what the Impressionists were doing, made what they were doing more palatable, and immediately outsold Sisley and Pissaro, to their grief, and became better known too, in the short term. And he is not a despicable painter either, by the way. If someone wrote a history of taste—an anatomy of taste—taking account of facts like that, it would, I think, be very enlightening and would tell us ever so much about what goes on in what's called "the art scene" today. We would see recurrences, irregularities, that would be very enlightening and also very discomforting. . . .

QUESTION: You stated that only value judgments and esthetic verdicts can be non-tentative. I was wondering what qualifies those judgments as being non-tentative. Are there some rules that would give all judgments of quality the assurance of inductive statements like two and two equals four?

GREENBERG: There the question of direct insight comes in. It's almost the way Descartes put it: How do I know I exist? Well, I know, therefore I know I exist. Your reaction to a work of art is simply there—even though it may be one of inattention, indifference—it's there. Suffice it for the moment to say that you have this immediate take of your own take. And that's a question all in itself since people are in the habit of lying to themselves, under the influence of culture, about all sorts of things that happen to them. Now, esthetic verdicts are the warp and woof of

esthetic experience. You can't have esthetic experience without having a verdict. You can't avoid them. That's why I say they're not tentative anymore than the fact of your existence.

QUESTION: You mentioned tentativeness in another context; about what it was possible, and not possible, to say about art. What *is* within the realm of reasonable discourse about art? You mentioned physical properties and . . .

GREENBERG: When I used the word "tentative," I meant, for example, that in describing a work of art—any work of art—the description should know itself as tentative, not exhaustive. You can describe a painting by Titian and describe it relevantly, as I feel, in a dozen different ways—maybe in an infinite number of ways—and always with a certain tentativeness because we don't know whether we're actually describing the picture as a work of art or as something else. We may be describing it as a physical object, or as a document, or as a symptom of Titian's state of mind, and so on and so on. I'm approaching something I want to handle later; that is, why a work of art eludes discourse. But I'll anticipate myself and say—repeat what's been said by others, and quite rightly—that everything in a work of art becomes relational in that the work eludes each description or characterization you want to pin it down with. And when it comes to quality, this becomes more evident than ever.

GREENBERG: It may be hard to realize, but our immediate perceptions of things—"intuitions"—once your attention is directed somewhere, are not willed or chosen. We don't choose to see grass as green, or square things as square, or round things as round, or hear noises as loud or soft. We receive these impressions, as it were, without choosing them. Well, in an analogous way, we don't choose or decide our responses to art. We don't choose whether to like or dislike a given work of art. And this absence of volition and choice is another part of the intellectual impenetrability of esthetic experience. It is also why disagreements about art should never be taken personally. Of course, most often they are, and disagreements about art are a source of a lot of rancor. But when you can't help yourself, you can't be blamed. If you like something or don't like something, you're on the level; you haven't chosen to like or dislike something, and it shouldn't be held against you personally. Esthetic judgments are spontaneous, unwilled, undeliberate, because they are inseparable from immediate experience—immediate esthetic experience. Whether we like or dislike something is not arrived at by reflection after the fact, by revealing or weighing the evidence, or by reasoning, or by ratiocination. Whether we like or don't like something is given rather than decided—given right in the evidence— and the evidence is right in the experience and not separable from it. It is right inside the experience. It *is* the experience.

Kant actually says that an esthetic verdict, a verdict on whether you like or don't like a work of art, comes to you before you are able to have pleasure or to lack pleasure in the esthetic object. I think when he said "before," he may have said before

and logically before, psychologically before, maybe temporally be-
fore. The more you think about what he said, as paradoxical as
it may seem, the more reason he has on his side. But somehow,
exhilaration you get from a work of art seems to come along with
the insistence somewhere in you that this is good, I like it, and
that's why I am enjoying it, and not that I like it because I am
enjoying it. I like it, therefore I am enjoying it. If we knew more,
as I said last night, about what goes on inside the consciousness
when we are experiencing art, we might be able to unravel this.
But as it is, all we can do is say: I'm getting a big bang out of a
work of art to the extent that I like it. And it is just as easy to
say that, as to say I like this work of art to the extent that I get
a bang out of it. In the experience of art we are not always
conscious of the verdict that is implicit in that experience, that
is contained in that experience.

You can experience art in an intense way without vivid self-
awareness, without sharp awareness of exactly what is going on
in your consciousness as you experience it. And this is where
reflection comes in. It is sometimes only when looking back at
esthetic experience and remembering what it was like that we
realize that we enjoyed or didn't enjoy the specific experience.
But we recall, and in a sense recover, the experience. We most
definitely don't reason it out. We don't weigh evidence. We don't
balance arguments in trying to decide whether we like this and
that piece of music or this and that novel. Now, argument about
esthetic verdicts can help your memory, can sharpen remem-
brance. It may even make you aware of what you missed because
of faulty attention or distraction, wrong attitude, and so forth.
But argument about art—discussion about art—can't change
your verdict on a given work of art, it can't make you like what
you didn't like or dislike what you did like. Your experience of
art is something that you are stuck with for the time being—and
the verdicts contained in that experience. And you can change
these only by going back to the poem, the piece of music, the
painting, and so forth, and experiencing it all over again. That
is the only real way you can change your verdict. It is not only
the only legitimate way, it is the only honest way.

Too many people are cowed or argued into changing esthetic
verdicts without renewing, repeating the experience of the works

concerned, and the lie produced as a result of being argued into liking something you didn't like, or disliking something you did like, hurts you more than anyone else in the long run. You see that when people are ashamed to admit they like Norman Rockwell more than they do Raphael, or that they get more out of a calendar picture than they do from Picasso. If you are cultivated enough or move among certain people, you don't dare say that you really like this calendar picture more that you do a painting by Matisse or Picasso. You know you're not supposed to. And one of the things that keeps people from learning to see, and maybe learning to read and learning to listen, is this cultural shame—you won't confess that you actually do get more from looking at a painting by Norman Rockwell than you do from Rembrandt, from a good Rembrandt. And I think it is all to the good if you confess this to yourself because you might, in confessing it, recognize you are missing something in the way you look at pictures, and you might look again and do something about it. If you don't confess it to yourself, the chances are that you won't do anything about it.

Now, a lot of this kind of lying goes on, inadvertent lying, and it works to confuse the discussion of art. I call it sincere lying, because you are almost not aware that you are not telling the truth—and often you're not. I think of Picasso's *Guernica*, about which there seems to be an inadvertant conspiracy, a conspiracy to agree that it is one of the greatest paintings in the twentieth century. Now, don't think it is just my opinion, I challenge anyone to look at that picture and see it as satisfactory. I won't go into the reasons here, but I am using this as one of the screaming examples. It is a failure in Picasso's own time. And yet there seems to be this conspiracy to say *Guernica* is a great picture, and the same thing with *Night Watch*. And Picasso is one of the greatest painters in the Western tradition, and certainly Rembrandt was too. *Night Watch* doesn't come off, and yet, there it is, you are supposed to come and admire *Night Watch*. This sort of thing is what works to confuse and corrupt the discussion of art. This inadvertent insincerity.

The essence here is to pay attention to what actually happens to you as you are experiencing art. And this is something anyone can learn to do. Experience is the sole and only source of truth

about art *qua* art. There is no other truth. There is no other source of truth; not in the writing about art, not in the discussion about art, and so on. And it is of the essence, if you are interested in art, to report your experience of art to yourself as accurately as possible. And when I say accurately, I mean to report the color or tone or feel of your experience to yourself, to come clean with yourself as to what has happened to you when you looked at, listened to, read or watched something. It follows from the indescribability of esthetic experiences—their unanalyzability, and also their spontaneity, their unvolitional character—that esthetic judgments cannot be proven, demonstrated, or verified the way judgments of fact can be, or conclusions from nonesthetic experience can be—some kinds of non-esthetic experience.

As I said, disagreements about value or quality in art cannot be reasoned out or settled through discourse, and they cannot be worked out the way you can work out matters of scientific fact or matters of practical fact. It cannot be proven, it cannot be clinched, that Rembrandt is better than Norman Rockwell, or even that one painting by Rembrandt is necessarily better than another, or that Mozart is better than Irving Berlin, that Shakespeare is better than an advertising jingle. It simply cannot be proven in such a way that the assent of every sane person is compelled by the evidence. If you refuse to believe that two plus two equals four, there would be something wrong with you. But if you refuse to believe that Shakespeare was better than Ella Wheeler or Eddie Guest—I know these last two names don't mean anything to you—you couldn't be convicted of insanity. If you refused to believe that Michelangelo was better than a comic strip, you couldn't be convicted of insanity, and there are millions of people who happen to believe, actually in terms of their experience, that they do like comic strips more than they do Velazquez or Titian. And they are not insane, and we know they are not insane. But if they refuse to believe—once the points of the compass have been explained to them—that the sun sets in the west, they would be insane. Or if they refuse to believe that if you cut yourself you will bleed—everyone has to believe that. Here reasons have such a high degree of probability that we consider them to be invariables. But reasons in art are one-time

things dependent on context, dependent on relations. In a sense, all works of art boil down to relations.

As I have said, the work of art, the worst as well as the best, is unique because it dissolves under examination into a nexus or combination of relations that cannot be exhaustively analyzed or described. Let me give you a sample of how this works. I'm going to read two passages of poetry. They are both about the month of April. The first one goes:

> April, April
> Laugh thy girlish laughter;
> Then, the moment after,
> Weep thy girlish tears!

That is by William Watson, who was almost poet laureate of England. He was knighted, lived between 1858 and 1935, and when I was growing up he was a name well known to me. The second passage is from T. S. Eliot's *The Waste Land:*

> April is the cruelest month, breeding
> Lilacs out of the dead land, mixing
> Memory and desire, stirring
> Dull roots with spring rain.

Now, I'm not going to insult you by asking you which passage you prefer, but just try to prove that the passage from *The Waste Land* is better than the passage from Watson, just try to prove that and you find yourself going around in circles. You can say, maybe, that non-rhymed verse is better than rhymed verse—the Watson rhymes and the Eliot doesn't. And what you would immediately find out is that this doesn't hold. There are a lot of rhymed verses better than a lot of unrhymed verses, so you have to throw that reason out. Then you go to the meter, but you find that both are trochaic, so you can't make that the reason. And then you say, let's analyze the sounds. But you can't say there's anything inferior in the sound of "girlish" to the sound of "stirring," say. Well, maybe taking a dark outlook on a month is better than taking a cheery outlook. Maybe it is better artis-

tically to see April as a little threatening than to see it as girlish. And you say, okay, from now on all verse that sees something as threatening is better than verse that sees something as girlish. And that necessarily makes all verse that contains things that seem threatening better than hopeful, let's say optimistic, verse that sees things as girlish. Now, we know that that's manifestly impossible because if we could say that, and if we could say some of these other things, such as unrhymed verse being better than rhymed verse, invariably it would end up that we'd all be able to sit down and write first-rate poetry by rule.

You may think I'm stretching something here, or exaggerating something, but this follows in almost every comparison. In the case of painting and music you cannot isolate the factors or the set of factors that make one work of art necessarily always better than another—and I say, necessarily that is always better. The only way you can prove something is by showing that something always has to follow from something else, the way four follows from adding two and two, or the way water follows—once we accept the conventional symbols—from adding two atoms of hydrogen to one atom of oxygen. This is something that we all should know, we should all grow up knowing. And it is amazing how many people, especially literary people, refuse to believe it: that you cannot prove an esthetic judgment. They say it's preposterous. Anyone, of course, can tell that Shakespeare is better than Eddie Guest. But it is not so, and the argument is always kept relevant enough to the point that you end up by appealing to the person's taste. And when it comes to taste, there isn't any such thing as proving things. That is, every individual has to see for himself how good a good painting is, hear for himself how good a good piece of music is. This cannot be communicated. If you don't get the experience for yourself, you'll never know—you'll never know how good Mozart is until you hear him, and nobody can tell you how good he is. Neither can anybody communicate the kind of taste that will enable you to hear how good Mozart is. This is something you have to gain for yourself—something else that people buck at and won't face up to clearly enough. And so they go to art appreciation courses, read books about how to listen to music, and so forth. Not that there is anything necessarily wrong with this. They may be useful

in telling you how to direct your attention and not tamper with it and all that. But they are not going to tell you what is good about good music or show you how to find out without your finding out for yourself.

This is part of what makes art so wonderful, that it is not only the making of it, it is the experiencing of it that puts you on the spot all by yourself—all by yourself. You are all alone in the face of a work of art. You may be with a hundred other people whose taste cows you, and they say they like this, and you're scared. And you say, well, I like it too, and you're lying because you don't. You're all alone and you're faced with showing how uncouth you are by saying, well, I don't like it, I like rock better than I do Schubert. One of the encouraging things about culture today—but it's double-edged, both discouraging and encouraging—is that some people dare to say that rock is as good as Schubert, even better. At least they are being sincere. Sincerity in the truth is always a good place to start from. I say it's double-edged because it is often used as an excuse for not trying to find out why Schubert is so good. It becomes an excuse for not going back and trying to find out why, let's say, medieval sculpture was no good or why it was so good, and so on. It becomes an excuse for copping out on the effort of going back to works of art of the past. Maybe you are right, but find out what you're dismissing first. You have no right to talk about the past unless you've gotten it. Unless you have been able to see it.

Well, so how do you tell the difference between good and bad art? I come up with the word "taste," and taste cannot be defined or analyzed or described either. We can maybe watch its operation and say, well, it seems to do this this time, and that in that situation, and so forth, but we know taste mostly by "it works"—its results. Just as taste itself knows art itself only by "it works," or results. Now, tomorrow night I will go into the question of taste at greater length. For the moment I'll leave it here. And now it's your turn....

QUESTION: Given and taken that you can't prove critical judgments conclusively, we do also know that some critics are better than others. Some people's judgments are more right than others are. What I am curious about is how you would arrive at the

rightness of some critic's judgment over others, given that we can't prove it. You once said, praising Eliot as a critic, that it was both his taste and his insight into his own taste that gave him quality as a major critic. Is it simply that we know that Eliot is a great critic—over and above a reviewer for the *TLS* as a bad critic—because he simply has insights into his own taste; that he doesn't convince us but he can evince his own taste more conclusively? Is that the reason why we think he is better?

GREENBERG: No. By the time you come to appreciate a truly good critic as a good critic you have enough experience behind you—enough experience in literature—to recognize that his judgments, his verdicts, coincide in some part with yours and in other part, as I said, begin to disturb you when they don't coincide with yours. He has already given you enough evidence to show, on the basis of your own experience, that he reads well, or expands his literature sharply. And then beyond a certain point, say, the disagreements come in, but you're disturbed by the disagreements on the basis of sufficient agreement. That sounds like a circular answer, doesn't it? Well, let me give you one example. I knew of Julius Meier-Graefe's name as a somewhat popular art critic in the late twenties and thirties and then he fell out of fashion. Then he was republished in German and a book of his essays was sent to me. In one of them, I read about a visit he paid to Padua sometime before the First World War, and the first time he went into the Eremitani Chapel where the Giotto frescoes are. And he said, what an awful room, what an awful job of decoration. Well, I'd been to Padua in 1954 and that had been my reaction too, and I had been very scared about it. And I had been to Assisi and seen the Giotto-esque frescoes in the upper church and I thought they were awful pictures as well as awful decoration, and I was saying, what is this about Giotto? And I'd met Ben Nicholson, the British painter, who said to me, Giotto's not so hot, you know, he's overrated. And I could see why he said that. He was thinking of the upper church and the Eremitani Chapel as a room. But then Meier-Graefe goes on to say, well, when I got in the room and I started narrowing my focus to each picture box—and that's what they are—something else began to happen, I began to see some great art. And that

had been my experience too. And I said, this guy knows what he is talking about. You see? He saw how bad the room was as a room, but it didn't get in the way of his seeing how good each little box was. And I had a feeling, well, this guy really looks. I went on reading and I disagreed here, and agreed there, and so forth. But you could tell, not so much by just the evidence of his taste but by the evidence of the way he looked, that he was really looking. Well, similarly with Eliot, you can tell Eliot is really reading. And I've disagreed with ever so much in Eliot, and the older I get, the more I disagree with, but it doesn't lessen my admiration for him as a literary critic. Don't we have the same experience with Samuel Johnson? His verdicts are couched in what we think is an old-fashioned or excessively dogmatic way. And then he tings you and you recognize that he has seen something that you have seen and hadn't been aware that you had seen, and he makes you aware of the fact that you have seen it— in reading Milton, say, or someone else. And I should include that the good critic reminds you of something in your own experience that you have blanked on, and sends you back to the work with sharpened attention. . . .

QUESTION: You said earlier that all art is relations. I was wondering what sort of relations you meant.

GREENBERG: Well, almost all art. I should qualify that.

QUESTION: And if it's relation of elements within a work of art and how they relate to each other, how do you view the so-called "non-relational" art?

GREENBERG: Well, when I say art boils down to a question of relations, I mean that within this qualification: Art has to have some medium, that is, sound, or visibility, or imaginability, that has to be that—a question of relations. And that's not just a question of pure relations, but let's say from that basis. You know those two passages of poetry I compared? I wanted to not show, but imply, that almost any given thing you can isolate in either passage depended for its effect on a relation to something else, and then in turn in relation to something else. And then

you've got groups of relations—relations of sound, relations of rhythm, relations of medium—and then, in the case of poetry, they're related in turn to meaning, and you go around and nothing boils down quite to the heart of the poem—nothing statable. All we can do is say poems tend to be rhythmically rhythmic words, intelligible, and maybe not intelligible. See, we get down to that, and that's a statement of relations once we are given words. And the same with music, and the same with painting. You can say paintings consist of colors put in a certain order on a flat surface, and about all you have said then is that you have sketched out a whole system of relations. And you talk about a specific picture, and you find yourself asking the same thing as you do with a passage of a poem—what is the heart of the picture, and we never find it. Now, I don't expect you to understand what I mean right off, but try it sometime. Try to describe a work of art—the simplest work of art—satisfactorily.

As far as "non-relational" art—that's one of these camp avant-gardist words—someone makes a box and he thinks because it's just a cube he has eliminated all relations. Or say he lays down a flat sheet of steel; he lays it down on the floor, and he says there are no relations, there it is, that's the simplest element you can possibly choose with which to make a work of sculpture, a work of art. Well actually, there are a lot of relations there: There's the relation of the thickness to the length; there's the relation of the length to the width; and you've also got the color of the sheet of steel. You've got three or four sets of relations. And similar to the box, there's height, width, length, and also you can bring volume in, I suppose. So when people say non-relational in art, they haven't thought in this particular area, and they don't even understand what words mean in this particular area.

QUESTION: So, you think all works of art are relational. All the relations are intrinsic to all artistic experience.

GREENBERG: Right. Intrinsic to all experience, I would say.

QUESTION: Isn't it possible to see a whole without dividing it into parts and setting up relationships?

GREENBERG: Well, that's the way you can experience a painting—say, *The Last Judgment* by Tintoretto. You see it as a whole without seeing any of its parts—or a Bosch. You see them, but here we come again to the fact that we don't know what goes on in the mind when we are experiencing art. You can see a Bosch that's wriggling all over with human figures and animals and monsters. And as a matter of fact, the first way to see it is to see it as a whole. If you hang up on a part of it, you're not seeing the picture properly, in my opinion. But then you may feel you won't see any relations there because you're not looking at it—intellectually anyhow—you're not looking at it part by part. That happens to be something almost peculiar to visual art. But you can't just discount the parts and say, because I don't feel it as a congress of parts, therefore it has no parts. The parts are necessary to the whole.

QUESTION: These relations, aren't they analysis?

GREENBERG: Physical analysis, not esthetic analysis, necessarily. I can't analyze the quality.

QUESTION: You assert quality. You . . .

GREENBERG: You "get it," you "intuit" quality. But you can't analyze it. As I said last night, you can make a stab at what you think might be some of the reasons, but you're never sure. So, let's take a box. I can say that I don't like most of Donald Judd's closed boxes, or the open-ended boxes, and I wonder why I don't and I say, well, I feel that he hasn't borne down hard enough on the proportions; I think that must be the reason, I'm not sure. But I can imagine seeing a box that might hit me. I can't predict what it might look like. I can say, well, it might be a box, and an inspired artist would . . . and so on. And all the while I'm just stabbing. I know it's near-hits all the time. I'm not putting my finger right on what is responsible for the quality or lack of quality.

QUESTION: Yes, but you're stabbing with words like "proportion," and you're stabbing with words like "volume."

GREENBERG: I'm describing the box, I'm not analyzing it. Really, I can't analyze the quality, but I can try, make a stab at finding out what I think is responsible for the quality. Suppose there is a box that I find is a great work of art. And suppose the proportion is two high and three across and then five long. I can't be sure that that's the reason why it works. You know, because somebody else may make another box with the same proportions and it might not work. So, I can't say it's because of that, I make a stab and I say I think the proportions are felt, and are really felt

QUESTION: How do you feel about familiarity affecting the esthetic judgment of art?

GREENBERG: I think it has a lot to do with it.

QUESTION: Can't it affect it in a negative way too? Like when you hear an advertising jingle over and over?

GREENBERG: That's ticklish. I think there is some kind of esthetic verdict there, I'm not sure what kind it is. A jingle, maybe that has something to do with your nervous system and not properly to do with esthetic take. In some part it has to be an esthetic take, but I'm not sure the reason it gets inside you is just because you like it.

QUESTION: Another thing, you were saying that you liked Norman Rockwell better at one time. Didn't that have to do with the fact that you were seeing more of his work then?

GREENBERG: No, I don't think so. At sixteen I wasn't up to seeing anything "better" as better. I hadn't looked at pictures enough.

QUESTION: You looked at the Old Masters so much after that that you learned to like them, but if you had looked at Norman Rockwell as much after that, would you have . . . ?

GREENBERG: Repetition doesn't mean that you're bound to like something. It can mean that it wears out. If the advertising jingle keeps ringing in your head, you begin to hate it the way you don't quite hate a Schubert tune. Anything can wear out. *The Trout* may haunt you, but it won't annoy you the way "Winston tastes good" will. And it doesn't mean that by dint of familiarity that you're going to like something. And again, it may. The first time you see abstract painting, only if you see enough different kinds of abstract pictures do you begin to make discriminations. You won't be as puzzled as the first time. In my experience, that's worked out. You take people into a room full of abstract paintings and challenge them to pick the one they like the most, and they'll end up picking one. They may pick, you think, the wrong one, and you bring them back in, say, the next day and the next day. That kind of familiarity has amazing effect, I found. I think it works the same way with certain modern music that seems to make no sense at first.

QUESTION: You're saying that in the end, the quality will come through?

GREENBERG: The discriminations come through. You begin to become aware of differences that you weren't aware of at first because everything looked like a puzzle. Go and find out for yourself, as with everything of real value connected with art. . . .

QUESTION: You have been very careful to allow for eventualities of quality at all times, even in cases where I have reason to believe you do not care for a certain genre in general. What I feel is that there is a disparity between your modesty in the face of quality that might appear where you least expect it and your awareness that the history of quality shows that there's very little quality being produced by very few artists. The chances of being surprised are not there every day when we go to see a show in New York. What has been bothering me is this constant reiteration of fallibility as if we might be surprised at any moment by something that would be totally new, when our chances are almost prescribed historically.

GREENBERG: Yes, probability agrees with you, but I think that the safest attitude to have in the face of art is to be ready to be surprised.

QUESTION: But is it human nature to be constantly . . . ?

GREENBERG: Well, I think this is where human nature has to be controlled and suppressed—or restrained—so as to be ready every moment to like something that you may happen to like, because you're not going to choose. See, that's the catch here. You go through twenty galleries in New York on a given day and you know the probability is that most of the shows are going to be, by and large, duds. But if you're really looking, you don't go on that assumption. Each show you walk into, you're ready to like something if it happens. And also you don't walk into a show of paintings and recognize certain things all of the paintings have in common and say, well, I know this kind of painting and I know it's usually bad. You have to give yourself and the art a better break than that. You look at every painting one by one; don't ever let a work of art get swallowed up in its category. And then you have to be ready. Because you can't choose to like something you don't want to like, you'll find yourself liking works of art that you don't want to like for whatever reason. And there you are, you like it. Now you've got to admit that to yourself. Most people I know in art life don't allow enough of that. They aren't open enough, and I feel that this openness is necessary, not for the sake of the artist, but for your own sake as an art lover because some of the pleasure of art is intrinsically connected with surprise. And on top of that, you get shaken up in an edifying way that I can't describe here, it's beyond me, when you are forced to like something you don't want to like. It sort of shakes you and it improves your eye too.

NIGHT THREE
April 8, 1971

GREENBERG: I have said several times in the past two evenings that "taste" was a word that was in bad odor nowadays, and that it is compromised by its association with, and connotation of, things like tastefulness, fashion, politeness, and so forth. But still, there is no better term for what it means. The word "taste" came into the discussion of art in the late seventeenth century and it was much used in the eighteenth century, a century that we can see, the further it recedes in time, was signally a tough-minded period. And the use of the word "taste" met head-on certain crucial questions about art that have tended to be dodged more or less since then; questions about what is most pertinent to art experience, what is decisive in art experience, who is entitled to express an opinion on art, what to make of disagreements about value in art. And above all is the fact that taste is indispensable— an eye, an ear, a nose—indispensable in dealing with art, whether as a maker of it or as a receiver of it. There is no getting around what taste means, whatever other word you might choose to use in place of it. But somehow, since the eighteenth century, it is not considered proper to go on about taste in public, nor about the necessity of having an eye, an ear, a nose, or about the im-plicit necessity of being able to see before you sound off on art, being able to hear before you sound off on music.

Grant Allen, a fairly well-known British philosopher of es-thetics of the late nineteenth century said he felt it was an ad-vantage not to have taste in writing about art because then you didn't get distracted by your likes and dislikes. It is a fact that treatises on esthetics since the early nineteenth century have tended to dodge the question and to dodge even more the question about disagreements of taste. Even Croce, who is the

only writer on esthetics I really respect after Kant, uses double-talk when it comes to the question of taste and disagreements about taste. And it is typical that someone as intelligent, knowing, and alert in the best sense as Susanne Langer leaves the question entirely unmentioned in the three books she devotes in large part to art. And somehow you recognize that Dr. Langer isn't big league for that reason. As bright and smart and as articulate as she is, she dodges this big question of disagreements of taste and who acquires taste. It is a measure of how much better Kant was that he runs into it and won't dodge it. It bothers him. He comes back to it again and again in *The Critique of Aesthetic Judgment*—how the devil is it that we agree about taste, and why is it that taste is so necessary, and so forth. There is a pretty good survey of esthetics, Gilbert and Kuhn's *A History of Aesthetics*, where the whole question of taste—the sensibility, discrimination—disappears from the last two hundred pages of this six-hundred-page book. That is, it disappears after the name Kant is discussed.

And yet, the question of taste remains, and remains as crucial as it ever was, and the informal talk among artists, art lovers, and art buffs revolves around it. If anything, it revolves around this question even more than before. But still there is a great deal of fear, a great deal of coyness about putting on the line the question of who has taste and who hasn't, and how indispensable it is. A symptom of this is that over the last fifty years—not just over the last twenty years as some of us might think—it has become taken as a matter of course not to expect art critics to be able to see. They are expected to be commentators, idea men, sloganeers, phrase-makers, ideologues, but not connoisseurs. When an art critic explicitly discriminates quality and, above all, when he goes into detail about quality with a specific work of art—that is, when he exerts his taste—he is taken to be old-fashioned. One eminent American art critic has said that telling the difference between good and bad in art is the business of reviewers, that the art critic proper deals with the connection between art and culture—which is a really serious question compared to, let's say, discriminating between Picasso and, I have to use and name again, Norman Rockwell, poor Norman Rockwell.

Now a lot of the nonsense and the muddlement in art writ-

ing—and I'm sure everyone here who has read an art magazine must know what I mean when I talk about the muddlement, the inflated rhetoric, the incoherence of art writing—much of this stems from the feeling on the part of the writer, and sometimes on the part of too many readers, that you don't have to tie yourself to an esthetic judgment, that you can vapor on, that you can write with greater freedom if you don't have taste, if you don't commit yourself to value judgment. The way Apollinaire felt. Guillaume Apollinaire was by way of being a great poet, and he became celebrated in retrospect as an art critic championing the Cubists. But he started the tradition of aggressively bad art writing that afflicts us today. He couldn't see very well. But the tradition of rhetoric that he founded is the dominant tradition in art writing today. I won't say it is the exclusive one, but it is the dominant one. And it depends above all on the fact that the connection of taste is considered too trivial to be admitted.

And yet, the questions come back in. Value judgments sneak back in, unacknowledged, surreptitiously, inadvertently. The art writer, the art lecturer, intends to leave them out, but he is too confused to know when they come in. And at the same time he goes on writing and talking as if the question of comparative value judgments was indecent. This reproduces the confusion of the art writer's mind. The normal art writer isn't good in our time. The fact is that most art writers are cold; they're usually people who wouldn't be able to survive writing about anything else. I mean that in all seriousness. It is not my opinion alone, I want to insist on that. And all the same, the main question in art—the first question in art—is which are the works of art that we are to pay the most attention to and continue paying the most attention to, and which are the works of art that in a showdown we're to pay less attention to. And this is the main question—the main practical question—and this question is decided by taste, just as it always has been. It is decided by mistaken taste or it is decided by correct taste, but it is decided by taste.

And it is taste that the conversation—the shoptalk of artists—continues to revolve around as much as ever. It is taste that the talk of art lovers, art critics, and art buffs revolves around—the real talk about art, the informal talk, the talk that, alas, doesn't reach print very often. And it remains that without the

application of taste, there is no talking about art as art. You can talk about art without the application of taste, but when you do that you are talking about art as a document or a record, as evidence, historical, psychological, or moral evidence; as philosophical, sociological, or political evidence; as a clue to states of mind, to the ethos of a people, to the mood of a culture, of a civilization. But you are not talking about art *qua* art. And in so far as you are talking about art as a document or a record, bad art, in most cases, serves just as well as—and in some cases even better than—good art. That is, a bad Italian picture of the sixteenth century probably tells you more about culture in North and Central Italy than a Michelangelo or a Titian does. And at the same time, other things in art provide you with evidence about culture. Art becomes one piece of evidence among others; it doesn't function in its uniqueness when we use it as evidence.

Quality—and I don't think right now I have to specify what I mean by it—quality is what gives art its unique value. It is what makes art irreplaceable. And taste is the only thing that gives us access to art, the irreplaceability of art. Quality is constituted by the pleasure, joy, exhilaration, delight, elation, affect, the satisfaction gotten from art. And quality in its turn constitutes art, makes art art—the poorest as well as the best art. Everything that is in art; the content, the import, the tenor, the drift, the meaning, the significance—all of which words are stabs—all these things are carried by quality. And the more taste you possess, the more quality you recognize, the more satisfaction you get from art, the more strictly and sharply you are able to discriminate quality, the more, even, you get out of bad art.

Since Kant, the philosophers of esthetics have tended to get rid of the question of bad art by saying, well, bad art is not really art. That's what Croce says and many other philosophers of esthetics. It is commonly said. Even Coleridge—and even Kant, who knew how important the question was—somehow felt, I guess, unable to deal with it in his time. Well, that's a cop-out. All too often people enjoy bad art. And then we have to ask what the quality is that they get from it. I know part of the answer—not the whole answer—lies in the fact that they are discriminating quality that often belongs to a different medium. Storytelling pictorial art is a beautiful example of that. It is not

necessarily bad art, some of the greatest paintings—not only in the West but elsewhere—are great by virtue of their literary, as well as their strictly pictorial, quality. But all the same, people will enjoy a bad picture that tells a story because they tune in, as it were, to the literary quality of the picture. And at the same time, the literary quality will tend to be inferior as literary quality. Or they will enjoy bad art because they confuse the esthetic satisfactions one can get from the experience at large with the art immediately under focus. That is, they will associate a poem, a picture, a piece of music, with esthetic satisfactions that don't belong to any of these mediums. Well, that's a question I want to take up at greater length later on. It's where I'll be treading on shaky ground because I'll have no one to guide me.

But for the time being, let me get back to taste. As I said last night, taste isn't subjective. And curiously enough, I can't prove that any more than I can prove what I think in good art is good. But if you assume that taste is subjective, you'll find yourself running into absurdities. We have a sort of negative evidence that taste has to be objective. And as I said too, the past shows that there has been a consensus of taste over the ages—that those who spend the most effort, the most time, attending to a given art usually end up by agreeing in the main and disagreeing only at the fringes. And those who attend most to art, try hardest, tend in the main to be people who, whether they know it or not, cultivate their taste. People who cultivate their taste point themselves where they are least distracted, least blocked—in looking, listening, reading—by irrelevancies.

Everything I've said to you this evening seems to me so obvious, so self-evident, something that we should all have known was to be taken for granted before we came here. And yet, I bother to labor the obvious because my experience has been, as I said at the outset, that the question of being able to discriminate quality in art seems to be one that is improper to touch on in public nowadays. And at the same time, I still feel apologetic for bringing it up, as if I were insulting your intelligence. Yet it is also as though, if you want to make any general point about art in this time, you have to bring this elementary question up and go into it in an elementary way as a preliminary to the discussion itself. After all, there are artists today, and have been for

the past fifty or sixty years, who say that they are not interested in the question of good and bad in art, or as far as they are concerned, they have never seen any bad art or heard any bad music or read any bad literature or seen any bad buildings. And so, it is as though there is a point-blank challenge to come out and state this rather elementary truth—if just once—as I have tonight

QUESTION: It seems to me that at the beginning—in childhood, say—taste is really subjective and only over a period of time, after cultivation, does it become objective.

GREENBERG: I would tend to agree with that.

QUESTION: Okay, but I thought you were saying it can only be objective.

GREENBERG: Very good. At what point does taste become objective? Right! I have never thought about that. Nobody I've read has ever thought about that either. And that, I suppose, comes under the heading of what makes bad art bad and what makes bad taste bad, see? And you can cop out by saying, well, undeveloped taste is bad taste. And this, I now begin to see, is what caused so much confusion to estheticians. They recognized that people in the course of developing their taste, or at the point where they start developing their taste, have really bad taste, and then the estheticians say, well, what has that got to do with taste, and they get confused and throw the thing out. And then at that point they say taste is subjective. And I tended to just point to the record and say, well, the way art—formalized art—actually gets handled by society shows that good taste is decisive by and large. And I've just been watching that and that the life of art itself, even in the most decadent period, is governed by the operation of the best taste going.

QUESTION: Perhaps you could tell us when taste became objective for you.

GREENBERG: I think it began at a point where I stopped being afraid to say what I thought about anything. You know, being afraid to report my reactions to anything. When I reached that point of honesty—that new point of honesty, I'd say—my taste was now exposed for correction by further experience and by disagreement with other people who said, well, I disagree with you, and I was sent back to look at the work of art that was the object of disagreement. Something like that. But I'd tend to answer that question on the basis of the record, the results. And I would say that for me, my taste became objective—it will become objective—long after I die. Actually, if some of my judgments survive, and posterity goes back to the works of art I like and goes back to the works of art I don't like and agrees with me— and when I say posterity, I mean the people who try hardest when it comes to art in the future, you know, the people who look longest, and so forth, and are most on the level—if they, let's say, in succeeding time agree with me, that will show my taste to have been objective. Again, I go by the record. We can say that there are people who know, people like Pope Julius the Second who in Rome decided that Leonardo and young Michelangelo were the best artists in the neighborhood in the early sixteenth century, at a time when there was some reluctance in Florence to give these artists commissions—Michelangelo and Raphael. Julius the Second showed no reluctance at all. He immediately saw they were the best artists around at that time and brought them to Rome. Well, Julius the Second's taste has turned out to be objective in times since.

QUESTION: I think there is a distinction involved in that, or at least I would like to make a distinction, between showing something to be objective—time showing something to be objective— and time making something objective. I think that when posterity returns to what you said about art, that won't so much prove that your taste has been objective, but that will objectify your taste.

GREENBERG: I disagree with you point-blank there. You make it a matter of opinion. Taste in art, value judgments in art, es-

thetic verdicts, are not matters of opinion. That's exactly what I mean when I say objective.

QUESTION: I know. That's exactly why I disagree with you.

GREENBERG: About tide and fashion, and so forth, Raphael wasn't thought so much of, say, thirty years ago by a lot of people who should have known better. But they were wrong at the time. And there were people who knew they were wrong. And you realize that these people were not exerting their taste sufficiently to achieve objectivity.

QUESTION: I think it has something more to do with the uses our culture makes, or not so much our culture but the civilization makes, of certain ideas.

GREENBERG: What you say may be true, but in this connection it's a superficial truth and it doesn't really affect the case that much. If you read Greek, you have no right not to like Homer. Experience, which is the only court in this matter, the only court of appeals, the only Supreme Court, bears this out all the time. If you read enough English verse, if you read it with the proper attention—and you say, what is the proper attention, and that's borne out in experience too—you end up by concluding Shakespeare is the greatest English poet. If you don't, the conclusion drawn is you really can't read poetry beyond a certain point. And that's how we find out that taste is objective. Because the opposite of saying it is objective turns out to be absurd.

QUESTION: I think you are very close, but I think it is a really significant misuse of the word objective.

GREENBERG: It's not scientific objectivity, it's not probative objectivity as I said last night, but it's not subjective. And here we're caught between two terms. Objective is much closer to the truth than subjective. When you bring subjectivity in, then there are no barriers. If I, in my bad taste, decide I like a certain piece of music by Joe Smith better than I do anything by Mozart, I can say, well, that's my subjective opinion. And then if there's no

objectivity involved, I can go along safely believing that Joe Smith is a better composer than Mozart. And we know that isn't the way it works out. Experience—the whole past—shows that this isn't the way it works out. I'm not trying to legislate something. I'm trying to point to the way art has been dealt with in the past. And the way art has worked itself out.

QUESTION: If you say that taste is objective, doesn't that go against the idea of the gut reaction as you were describing it— you're alone with the work and you look at it, and you can't decide, do I like it or don't I? It just exists whether you like it or not. In terms of objective, over the long run, yes, it is objective—connoisseurship and so on. But at the moment when you're judging it, is it objective? How does that coincide with the idea of . . .?

GREENBERG: A gut reaction being an objective one? Well, why shouldn't it be?

QUESTION: Well, it's coming out of you.

GREENBERG: That's true, but you are, as Kant says, "in accord with humanity." What he meant was, we are made pretty much alike along general lines. And it is the general lines that come in play when we're developing our taste. The more you develop your taste, the more impersonal you become. Not the less individual.

QUESTION: When an appreciation of something can make it objectively good, that's not objectivity.

GREENBERG: I grant you that. In the strict sense, no. But it's worked out objectively. And that's the peculiarity of art, that you have what seems opinion, but isn't opinion—that has all the traits of, let's say, subjective opinion and yet is not. And you say that's a paradox. I'd call it antinomy. And it is one of the reasons nobody can define art, nobody can describe the experience of art or the making of art. There it is, this area where we recognize things, we see things, we react to things, and we can't straighten

anything out with logic. We can't straighten anything out by saying A can't be both A and non-A. You know, where the laws of contradiction don't apply. In one way, you can say in a sense, that's the main reason art is there. In one sense.

QUESTION: I can't tell whether you feel the terms are absolute.

GREENBERG: It's like leaving Aristotelian logic and going over to some other kind where opposites are not mutually exclusive but fade into one another. In the given individual, taste is never entirely objective. It's somewhat objective depending on the extent to which he has developed his taste, and we never find out until afterwards. I think in our time we have seen that taste comes closer to objectivity the more catholic it becomes. Now that seems a contradiction—it becomes more catholic and at the same time more discriminating. But when I say catholic, I mean you're able to like African art, Oriental art, pre-Columbian art. You're no longer confined to Renaissance and post-Renaissance art. . . .

QUESTION: If you find yourself really disliking a work of art that the educated consensus maintains is great, what do you do with that feeling?

GREENBERG: That too is where you have to dare to be on the level in reporting your reactions. That happens to all of us and it happens all the time. Here's an example. In my case it's Michelangelo's sculptures. Now, I was brought up to think of Michelangelo as one of the greatest, if not the greatest sculptor in Post-Medieval Western tradition. And I didn't like it, and I looked, and I looked, and the more I looked, the less I liked Michelangelo as a sculptor, and I find myself stuck with that. And I looked again because I think Wyndham Lewis and I can't be right and everybody else wrong. But the more I looked the more things I saw wrong with it, quite unlike looking at his painting. I think he was an infinitely better painter than he was a sculptor. So, there it is. Anyone who disagrees with the whole weight of authority is likely to feel nervous about reactions they

can't help having. But the fun is knowing that this is your experience and nobody else's. You aren't getting anything secondhand, it's all firsthand. . . .

QUESTION: You said before that we're all made pretty much alike when it comes to our reaction to art. It's not unlike chickens pecking kernels of grain, the light ones and not the dark ones. But when someone mentioned the apparatus of seeing, you backed off very hard. Why, when it seems to me that's where the objectivity comes in?

GREENBERG: I objected to the connotations of the word "apparatus," as though the seeing were done through something other than yourself.

QUESTION: But the self *is* an apparatus; it's equipment which is all pretty much alike.

GREENBERG: That's true, but I object to behavioristic terms. Now, I don't object to behaviorism, but to these terms. In any case, it's a question-begging phrase, that people are made pretty much alike. And yet again, they do come together, they show their likeness, in the course of time, in their reaction to art. I think one of the ways in which you can stab at saying what art does to you is that it puts you in a state of heightened cognitiveness. Not cognition, but cognitiveness. It's somehow as though you've risen above impediments to knowledge or awareness, but not on the basis of anything specific, that you are specifically aware of. Now, I come back to good old Kant who said that the pleasure of art consists in the free play of reason together with intuition or imagination. These faculties are stimulated at the same time: there's nothing there for you to know, there's just something there to intuit, and there's nothing there for the understanding to really absorb as information. The pleasure doesn't come from the fact that you're getting information, it comes from the fact that you're in a state of "exalted informedness." I flatter myself that I think I know what Kant means when he says that. But the elation you get from art is an elation of all the faculties

with which you are aware of things—not sensuous faculties; a heightened sense of, let's say, mental, which is too narrow a word, and not spiritual which is too compromised a word, so let's say cognitive faculties that are being exercised in a way that seems to transcend all the impediments of cognition. That kind of definition is a stab. Even in Kant, it comes down to a metaphor, but it's a vivid one. But then we always come back to the fact that we don't know what goes on inside us when we make art or experience art. We can recognize it but we don't know verbally. And discussions of art come around to that again and again. The impenetrability of discursive reason of art by analytical, intellectual reasons, intellect, and so forth. There it is. And yes, I object to behavioristic terms to explain reactions to art. . . .

QUESTION: As a critic, are you interested in settling recent disputes of taste? And if you are, how would you propose resolving these?

GREENBERG: Let me say first, you only resolve disputes of taste for yourself, not for other people. There's no arguing other people into agreement with verdicts of taste. All you can do is, in effect, urge them to look at the work of art you disagree about, take another look at it, look at it again, repeatedly. Contemporary art challenges taste more than any other kind, as we know. There hasn't been time for people to look, re-look, look again, and look again, and so the frequency of error is much higher. Again, I'm stating something very obvious. That's precisely the fun about contemporary art, and this is a little off the subject. The fun of it is matching your taste against new art and taking a chance. It's easy to go into a museum where everything is certified and say, well, all right, I like this Rembrandt, but I don't like that Rembrandt. Relatively easy. And it's easy to see a Titian or a Veronese and find out for yourself how good it is and feel safe in enjoying it without any qualms.

But when the new stuff comes up, there you take a chance. And I find it's exhilarating to take that chance—go out on a limb, feel creepy. I can't see how any self-respecting art critic can resist that kind of fun. But I can see at the same time why it scares you. The fright is part of the fun. With contemporary art

you are so alone. You don't have any books to help you. You don't have any print to help you. You are all alone with it, and you might come to certain examples of contemporary art that have already been denounced in the art magazines and newspapers, and you find you go for it very much and all the print is against you, and maybe all the talk is against you, and yet you're stuck with your reaction if you're on the level with yourself. You can't change it just because everybody disagrees with you. You have qualms, and you go back and look at the given work of art, and you still find that you like it, and everybody that you know doesn't like it, and you go back again and you like it, maybe you like it even more, and people keep on saying it's no good. You get scared, but it's some fun. It is.

NIGHT FOUR
April 13, 1971

GREENBERG: As expectations and on the basis of expectations—for the most part unconscious, not subconscious, expectations—art can be described rather unsatisfactorily as an interplay of expectation and satisfaction. I am not by any means the first to say this. Nor am I the first to say that surprise is intrinsic to esthetic satisfaction, but I hope that maybe I'm emphasizing it in a new way. I would say flatly on the basis of my experience that newness, surprise, has always been an ingredient of artistic quality—the presence of newness or the absence of newness, whether it is plus quality or whether it is minus quality. And the surprise inside the given work of art—in music and in fiction we have the most obvious example of it—operates in the visual arts too, though not on a temporal scheme. I think it can also be said that the more surprisingly satisfying and satisfyingly surprising the work of art, the better it is. These are definitions that won't help you very much—no definitions help in art—but at least they will help, if only to the extent of getting irrelevant things out of the way.

Major art—superior art in the fullest sense, the best new art—surprises not only internally within the given work and not only in its own intrinsic terms but also externally, extrinsically, in relation to the terms of expectations established by previous—and especially the immediately previous—best new art. And this, to repeat myself in different words, is why advancedness, innovation, is always an ingredient of the best new art and of major art. And major art also signalizes itself by the experience—the fact of its surprise—remaining and renewing itself within the work and without the work. The surprise becomes permanently

renewable. Why this should be so and how it is so—why Masaccio when he is good stays surprising—I can't explain. I have never heard anyone explain it quite satisfactorily.

The best taste of any given moment with respect to the art of that moment has assimilated the surprises of the best new art of the moment before and has had its expectations expanded and revised by these surprises. After Rembrandt, you could say, you had to want something from art, from pictorial art, you hadn't wanted before. And after Rembrandt you had to stop wanting some things, maybe, as much as you had wanted them before. I don't think you stop wanting anything, but maybe you have stopped wanting some things as much as before and have begun wanting new things more. This doesn't mean that art gets better. Perish the thought. It has nothing to do with art's getting better. It just means that art is moving—staying alive.

Taste travels through the artist too. And sometimes it travels through him alone. The ambitious artist—I mean the seriously ambitious artist, not the worldly ambitious artist—has to assimilate the best new art of the moment, or the moments, just before his own. I say this as though I were legislating, but the fact is that this is what the record shows. It doesn't show it with complete consistency. If you think of Rembrandt and then you jump to Watteau, you'll see that Watteau assimilated Rubens, not Rembrandt so much, as an immediate predecessor. But Rubens was part of the very best new art of the mid-seventeenth century just as Rembrandt was. And then you have cases where, let's say, Joshua Reynolds, who is a much underrated painter, assimilated Rembrandt without even advertising the fact. In a sense, Rembrandt was an immediate predecessor, given that the only other predecessor Reynolds was aware of was the school of Rubens. Anyhow, the revised and expanded expectations created by the best new art of a given moment work in the artist too, in the process of creation as well as in that of appreciation, and they work as pressure—they may work as other things but especially as pressure. And without pressure there is no superior art—the pressure of high, up-to-date expectations. And when I say up-to-date, immediately there is a connotation of fashion, and that is not what is involved here. The best up-to-date taste discards fashion—recognizes fashion and eliminates it. Bad art can be said

to be—and this is another provisional definition—that which disappoints expectations. And that is so flat and obvious I'm almost ashamed to say it.

But then there is academic art, which is not necessarily bad art. It may be inferior to the very best art, it may be inferior to less than the very best art, but academic art is not always, or necessarily always, bad by virtue of its being academic. And here comes another definition. Academic art succumbs to the tendency to satisfy expectations too patly, too neatly, without enough surprise, without testing your taste, without challenging your taste, without challenging your expectations or demands. But academic art can also satisfy without necessarily letting you down. I don't think the word "academic" should be used altogether in a pejorative sense.

But it remains in any case that the less surprise you receive from art the less you are moved, the less you are affected. And that is what art is about—to move and affect you. Academic art—safe art—comes in all varieties, that which satisfies the latest best expectations patly, or that which satisfies older expectations. There are infinite varieties of academic art. The deceptive kind of academic artist has appeared only in the last fifty years: Surrealists, Neo-Romantics, Pop Art, and since then, Magic Realists, and so forth. I'm confining myself here to representational artists who satisfy older expectations as filtered through later ones and who rely on what I call "twists," usually, not always, literary twists and sometimes twists involving a sharper focus, or twists involving a parody of painterly painting.

In any case, a tradition of art is built on an accumulation of expectation. And a tradition remains alive and moving as long as the expectations keep on being expanded and revived and keep on being demanding. A tradition of art, according to the record, dies when the relations between expectation and satisfaction freeze. You see that in late Egyptian and late Roman sculpture, you see that in Ming Chinese painting, you can even see that in Fauve painting in France today. It is as though expectation—taste—said we don't ask for anything to argue with anymore. It is as though the last tough connoisseur had died out, the last connoisseur to say, well, this stuff is all right, but it is not as good as it used to be, I'm not getting moved enough.

I happen to think that avant-garde modernist art arose in our culture a hundred years ago, as if in awareness that the demands of taste might slacken. And curiously enough, as far as the record shows us, it may have been the first time when artists themselves took entire charge of taste. Manet, the Impressionists, and in writing, Baudelaire, Flaubert, asked art to answer their own professional expectations—no longer just the expectations of connoisseurs—as though the only way you could maintain the expectations of taste at a high enough level was by professionalizing it. Now, I'm begging a lot of questions when I say all this, but I happen to think that this is one of the reasons why a hundred years ago the best new art began to supply new surprises—new, satisfying surprises—that were at first sight much more difficult than the new surprises provided by Western art hitherto. As the best new art didn't deliver satisfaction at first or second sight, the challenge seemed to be so high that you—the connoisseur, the art lover, and so forth—had to work as art lovers never worked before in order to get it. And for many people—not uncultivated people—the best new art after Manet, Baudelaire, Debussy, seemed to be all surprise without satisfaction, as if the question of satisfaction had been dropped in order to enhance the fact of surprise. And the avant-garde became identified in many minds with surprise as such, but not necessarily with satisfaction. And I think the Futurists were the first to draw the conclusion from this misconception—and after the Futurists, Duchamp, and then a whole side of Dada, a side of Surrealism, and now the "far-out" artists of the sixties—the conclusion that the best new art was surprise in absolute terms and the devil with satisfaction.

There is another way of explaining why the best new art after the mid-nineteenth century seemed at first so difficult, so mystifying, so disconcerting, and hardly anything else. It can be said—and these are tentative explanations, and I wouldn't say any one of them is satisfactory—that maybe taste in the visual arts, outside architecture, had depended on, had anchored itself in, verisimilitude realism. In literature taste anchored itself to explicitness and in music to tonality, and when these anchorages began to be abandoned, art had to become more difficult, more difficult in order to save high satisfaction. That kind of expla-

nation might help, but I find that kind of explanation a little too glib. It also can be said that in the nineteenth century high art was thrown on the open market for the first time. No longer subject to authority, no longer subject to connoisseurship, the new power was the middle classes and the new middle classes, and there is the fact that newcomers to a respectable culture and a high culture are always a threat to its standards. That seems to be a historical fact, and it probably worked in the nineteenth century to make the best new art more difficult, as though to take it off the market, as though to make it unmarketable. I used to go in for that kind of explanation myself years ago, but the older I get, the more empirical I get; and the older I get, the more concrete I want to be; and the older I get, I guess, the more willing I am to let certain things remain unexplained. Until someone comes along, I'm comfortable enough without the explanation.

What I notice concretely is simply a tendency, an enduring one—and whether it belongs to our society, our culture, or not, I don't know—to say: Let's accept the less than best, don't hold out for the best, don't make demands on art, don't make new demands on art. This is something I have noticed in my immediate firsthand experience, and it is the way I would explain, let's say, the endurance of academic art. I would also, by the same token, explain the defiance—the defiantness—of the best new artists of the last hundred years in those terms, saying almost explicitly to themselves: We're being asked to put up with less, we absolutely refuse to. Being asked, I think, in a way I don't think previous artists had felt this demand—to put up with less than the best. I think it is something artists have begun to feel in an acute way only in the last hundred years—don't expect too much to be expected. And then there are the handful of troublemakers in every generation who say: No, we're going to ask the most of ourselves regardless of the audience, regardless of the public. I'm describing something as more conscious than I think it ever was, but it was nonetheless real, however unconscious.

And in our time, the insistence on the best—now that the whole notion of avant-garde and what is advanced and what is not advanced has become so confusing—has become, as it feels to me, more difficult than ever before. Now, that may just be

the illusion one always has—that your own time is the most difficult—especially since the present generation of artists, let's say younger than fifty, has become so damned knowing. It is as though in the last ten years all the conclusions have been drawn from the way in which the best new art has appeared in the last hundred years, and young artists are able to go right to those conclusions. It is known, for instance, that expertness belongs to academic art—I'm giving you one example, there are many others. And there is an expert look of inexpertness, and it is a look that only experts are capable of—it having been noticed that Cézanne looked as if he couldn't draw, and so on. And the handful, as it seems to me, of people who hold out, as I said before, seem to hold out under more difficult conditions than ever before. I hope that's not true, but that's the illusion that I have. . . .

QUESTION: Do you think there's a correlation between the rapid increase in the expectation of surprise since 1850 and the rapid changes in the consciousness of modern man brought about by industrialization?

GREENBERG: Can I answer that in two parts? I don't think there is a rapid increase in the expectation of surprise. I won't even say there's an increase. I said there is an emphasis lately, which will wear off. No matter what happens to art, that emphasis is going to wear off.

QUESTION: Surprise is fashion, then? The expectation of surprise is fashion?

GREENBERG: Well, I'll allow the word "fashion" right now. People were baffled by, say, James Joyce—not just by *Finnegan's Wake*, but by *Ulysses*—but we all know *Ulysses* is by way of being a great novel. In the state of bafflement, there's a tendency to attribute everything to the surprise—the fact that Joyce is so innovative, and that's what makes it great—and the devil with enjoyment. That's why Andy Warhol can say: I like boringness. Which is a contradiction in terms. The devil with liking anything, the idea is to be thrown. I'm trying to say something very simple, but I'm afraid I'm not saying it simply. The first

Impressionist pictures, the full-blown Impressionist pictures done in 1873–1874, looked like a mess to a lot of people—just a confusion of paint. In a sense, they continued looking that way to a whole generation of people. And finally the Impressionists became consecrated and accepted and so forth, and a whole generation of people still thought this stuff—compared, let's say, to pictures out of the school of Ingres—was a mess. Well then, insensitively you draw the conclusion that the idea is to make art that confuses you. You don't have to like it, the main thing is to confuse you.

QUESTION: People who think that the essence of Joyce's quality is bafflement are misreading Joyce.

GREENBERG: Of course. Just like Duchamp misread Cubism when he saw Picasso's first collage-constructions and thought this was a joke and came up with his bicycle wheel.

QUESTION: Nevertheless, there's an increase in surprise in works of genuine quality in the last hundred and twenty years. It's not merely fashionable.

GREENBERG: No, not an increase in surprise. As I have said, nobody can explain why the public wasn't baffled by Michelangelo. That's the issue, the open question. Why they weren't baffled by Watteau or Velazquez.

QUESTION: Then getting back to my original question . . .

GREENBERG: . . . about the changing of consciousness. I don't believe that until it's shown to me. I call that jargon "hyperjournalism." Journalism is always saying things are changing fast. Journalism is futurist, and journalism started being that way a hundred and fifty years ago. Maybe I'm wrong, but I don't see this great change in consciousness. As a matter of fact, I don't see people living that differently—in spite of airplanes, in spite of all sorts of mechanical advances—from the way they did when I was a boy forty years ago. So I'm going to challenge that received idea right off.

QUESTION: Well, you have accepted that the art has changed, but you haven't accepted that there is a correlation.

GREENBERG: Well, I said there's change. As long as a tradition of art stays alive, it changes. As long as a civilization stays alive. I'm talking in Spenglerian terms now, in Toynbeean terms. It changes. There is no question about that. And like Spengler or Toynbee, I'd point to China in the last three hundred years as an example of how things don't change that much. But when you talk about a radical change in consciousness—and that's what you're talking about—I don't see it.

QUESTION: I do notice that since the turn of the century there has been a definite reorientation that consists of an examination of the form rather than the content. And this formalism that has occurred in philosophy is kind of a reflective act of saying let's examine the way we go about examining the world. I think that that is reflected very much in art, beginning with Cubism and saying, let's examine the picture plane, or let's see how we go about making art.

GREENBERG: Yes, I grant you all that, and maybe I was a little too flat in challenging the statement about changing consciousness because there is an evolution of awareness, I'd say. Now I'll have to hedge. Yes, there is an evolution of awareness, and it makes itself felt in science and philosophy and art, and so forth. The implication is that there has been such a change in consciousness that we don't take art any longer the way we used to, or we don't live our daily lives any longer the way we used to, and I suppose, of course, the nineteenth-century mind was different from the eighteenth-century mind. But all the same, I don't think it was all that different, and I don't think the twentieth-century mind is all that different from the nineteenth-century mind. And I don't think that certain phenomena need to be explained by a change in consciousness. I would say that there are also certain constant tendencies that work in an urban society. These constant tendencies will make themselves felt in a variety of ways depending on the circumstances. That, let's say, a lot of philistinism today vents itself in revolutionary politics,

that doesn't make itself any less philistine. The academic spirit now in art goes to the furthest out things that can be invented, but that doesn't make it any less academic. I don't think that the art critics or museum curators who go in so much for "far-out" stuff right now are any different in the quality of their sensibilities than the juries of the Salons in Paris in the nineteenth century who kept Courbet and Manet out of the annual exhibitions. I want to throw the emphasis that way. I don't want to say there is no change. That's preposterous. But I'm so sick of hearing everything explained by the accelerating rate by which things change in this day and have changed in the last, say, two hundred years. I feel that sort of explanation begs a question.

QUESTION: I think that the problem lies in the fact that we're only halfway into this kind of change period, and we can't put our finger on the actual changes that are occurring. Our knowledge of the world has increased so much in new areas and disciplines—social sciences, ethnography, linguistics. Art is very much language, and there are a lot of parallels between new linguistic ideas . . .

GREENBERG: So far we haven't new linguistic ideas, from what I can tell. With all their claims and so forth, they haven't added a thing in esthetics. I'm waiting, but until the returns come in you can't say anything. There is a tendency to flatten everything out. When I tell you that William of Aachen anticipated the language philosophers and the logical empiricists in outline in almost a miraculous way in the fourteenth century, you'd say, well, you mean nothing has changed since then in the consciousness of far-out philosophers. No, I don't mean that. But don't exaggerate the change, that's all. That's the journalistic tendency, to think that Wittgenstein has discovered more than he actually has. And probably Wittgenstein is great, but to think that de Saussure or Noam Chomsky has come up with a revolution, I call that the millennial fallacy.

QUESTION: I think that the point I was trying to make is that the revolution is nowhere near finished.

GREENBERG: I have been living with unfinished revolutions since I can remember. So let's not call it a revolution because there was no period and therefore nothing can start over again—in the West anyhow. . . .

QUESTION: Why is it that there is such a vast change in space? For four hundred years the same illusionist space was used—whatever happened within it, whatever difference in style. Isn't that an academic formula, and presumably now another academic formula . . . ?

GREENBERG: It took Manet and the Impressionists and the Neo-Impressionists and the Post-Impressionists something like seventy-five years to dismantle the illusionist tradition. But in doing so, they kept within the tradition of easel painting. And they stayed within the tradition of easel painting in the very specifically Western tradition. And as time goes on, the differences between Cézanne and Velazquez don't seem to me as conspicuous as they used to. They're there, they're important, they're essential, but they don't seem as spectacular as they used to. And I say the same for the Cubists' pictures too. You can say that's my opinion, and here I have nothing to back my opinion up with except my eye. I think that there was evolution and the devolution of illusion art did start with Manet, but it is continued within the framework of easel painting—within the limits of easel painting.

QUESTION: Well, I could go on and say that I see the destruction of painting as an art, but I don't want to go that far.

GREENBERG: Well, it's quite possible that painting will die out—that easel painting will die out any minute. You can't exclude that. I'm resisting the exaggeration of the break, that's all, because I don't think it was as revolutionary as what Giotto started in the fourteenth century. I think Western painting holds pretty much together from Giotto right on up to Pollock and beyond. I'll repeat something that I have written. In a sense modernist art can be taken as making explicit ever so much that the Old

Masters left implicit. Take the flat plane. The Old Masters knew very well, very well, that they were painting on a flat surface, and they knew without spelling it out, without verbalizing it but showing it in their practice, that the flatness had to be acknowledged, no matter how much, how vivid an illusion of depth they might have aimed for. And there were other such things that the Old Masters took into account implicitly in their practice, like determining the inside of a picture by enclosing shape. The fact that it has a certain shape—a certain frame—had to be acknowledged inside the picture, and someone like Cézanne made a great point, without knowing it, without ever spelling it out himself, of calling attention to the fact that pictures tended to be rectangular in shape. And then the Cubists pointed out that the illusion of relief and of depth depended much more importantly on shading than it did on perspective—differences of dark and light. And Analytic Cubism was one kind of orgy of shading, as it were, for its own sake. You look at the Picassos and Braques of 1910 and 1911 and so on.

There are other aspects I haven't discovered, and I'm sure other people will: making explicit in the practice of Chinese masters or the Persian miniatures what was implicit in the practice of the Western Old Masters. And that's very important, because shading never counted for much in any other tradition. And for that matter, it's important that the Western conception of the easel picture with the influence of the enclosing shape—the determining influence—never counted for that much in Chinese scroll painting, or even in the silk in their hanging paintings. If it counted, it counted in a different way. That's how I explain to myself the fact that contemporary abstract painting—whether good or bad—doesn't look all that different to me from Corot, not all that different. My eye can organize a painting by Pollock far more easily than it can organize a Japanese screen. I found I had to look—learn to look—at Japanese paintings in a way I didn't have to learn to look at Pollock, in spite of the difficulties I had with him initially. Well, maybe I was lucky, I was there on the spot. It was taking place right in front of me, that's all.

QUESTION: Comparing a Pollock with a Raphael, there are huge differences.

GREENBERG: Of course. But I want to place the emphasis some-where else, if only to restore perspective in these matters. I can only come back to what I said. Changes are the essence of life, but the exaggeration of change, that's culture journalism of the last hundred years.

QUESTION: To extend this a bit, the next major artist is going to have to assimilate at least what Pollock has done.

GREENBERG: The next major painter, anyhow. I feel that the highest probability goes that way. You can't be absolutely certain of this. I have been talking just on the basis of the record. There may be a revolution and things may change tomorrow. You al-ways have to be ready for that. I'm driving toward something that maybe I should have put in the statement I started with. When you look at art and the life of art, you recognize suddenly that it's a rather tragic cause. People go to art school and say that they are not going in order to be high school teachers, but they are going because they want to be great painters. And they go so merrily without recognizing that many are called and so few are chosen. The art world is not most conspicuously, but I'd say most densely, populated by embittered veteran artists. That's the standard citizen of the art world. You may not find him at Max's or Remington's—I mean the fellows who used to be at the Cedar Street Tavern are scattered. You'll find them in col-leges teaching, or uptown, or downtown.

Take this into consideration, and then you say, well, is talent scarce? I don't happen to think so. And I think that there are many things you could call luck; where you happen to grow up, where you happen to live, who you happen to know in your youth—I don't mean in the way of being helped by somebody's influence. But having watched three generations of artists, I'd also say that it's not the scarcity of talent, it's the inability to bear down. And one of the ways in which this inability—and this common human failing is not confined to artists—shows itself is precisely this: if you're an ambitious artist, not to realize that you have to assimilate and find the best new art—not only assimilate but find out where the best new art just before you is. It seems to me that it should be just a matter of course, but

artists, being like other human beings, are misled by what they see, what they are seeing in art magazines, what they see going over, and so forth. The record shows you have to disregard the "scene" and bear down and find out for yourself. I suppose it sounds like I'm making a lot out of a small point, but actually in experience—I just discovered it in the 1950s—it's not. I never thought I could size up an artist whose work I didn't know by his taste. I felt artists were entitled to gaps in their taste—distortions—they needed them for their own purposes. And it's still true. You have a certain right to underrate somebody and to overrate somebody else for your own purposes. But still, I haven't met an artist yet who admired de Kooning in the 1950s who came to anything in his art, and there are some prominent artists around now who admired de Kooning. But, as far as I'm concerned, they haven't come to much in their art, I don't care how well known they are. There are other examples. I think Ingres was a very great painter, but I think a young artist in the 1840s in Paris should have been able to see that he didn't have that much more to learn from Ingres. And you know, Ingres was like the Pied Piper of Hamelin: He sent two generations of academic painters—three generations—to their doom in France, just as de Kooning led a generation lost to New York to their doom. . . .

QUESTION: I wanted you to explicate a little more about how certain academic artists, or "safe artists" as you called them, rely on a new twist to give you the idea that there is something more than is actually there. Would you back that up by, say, the Pop artists?

GREENBERG: Well, let's take Lichtenstein. It's curious how much he relies on Léger—that doesn't take anything away from him necessarily—to center the picture. If he can't center the picture, he's helpless, the picture falls to pieces, but when he does center it, it's very pat and satisfying. The twist is simply in his imagery. If you get away from the literary fact in Lichtenstein, usually it's pretty small-time painting. Or Warhol, who I like more, some of the work depends pretty much on "all-overness," on Pollock and Tobey. And Jasper Johns who has depended pretty much on "all-overness" too, in a somewhat academic way.

The up-to-date aspect has to do with context. You take a certain context, say, that belongs to abstract painting and put representational elements in it. Rosenquist does that. He takes part of 10th Street Abstract Expressionism and uses it to paint the front of an automobile. That's a context twist. Duchamp originated that too, I think. But the Neo-Romantics—artists like Christian Bérard and Eugene Berman—I think are better painters, more interesting, because they went and plucked Le Nain out of the past. You know the frontal figures of Le Nain? They aren't in seventeenth-century dress and they are flattened in a very funny, modern way. Bérard and Berman pushed that aspect very hard. And they were decent painters, fundamentally academic because they gave a twist to something quite familiar. Even though Le Nain's reputation had to be revived somewhat, Neo-Romantic painting had already been assimilated via taste. How quickly recent art history gets forgotten, when you consider that Neo-Romantic painting was very much on the up at the end of the 1930s and the end of the 1940s.

GREENBERG: Tonight I talk about how taste could be said to be constituted by expectations, and how art could be said to be constituted by the satisfaction of expectations. Now, the satisfactions delivered by art—the satisfactions delivered to expectations in and through art—require decisions, whether the artist himself makes them or whether he lets them be made for him. It can also be said that the excitement of art—the quality of art, the value of art—derives not only from the satisfaction of expectation, but also from an awareness in and through these satisfactions that decisions—human decisions—are behind them. And it can be said still further that the interest of human activity—as we watch it or contemplate it—is, in general, the interest of decision. It is not just that we learn lessons from watching or reading or hearing about decisions that have been made by people, but there is a certain intrinsic interest in decision-making that we identify, consciously or unconsciously, with the human being in the situation of making decisions.

As we all know, decisions and choices are very important in the structuring of life. And quality in art which is felt as satisfaction—and the satisfaction which is felt, as I said, as maybe an enhancing of our cognitive faculties, as an excited awareness, an awareness of nothing in particular and yet, as it were, of everything—maybe this quality is also felt as the effect of triumphant decisions or choices. And maybe that is the great difference with which the philosophies of esthetics have struggled: the great difference between man-made and natural or accidental beauty. I think quality in art is felt as having been produced by decisions, not so much by a multiplicity or quantity of decisions, as by a weight of decision, a kind of density, a kind of completeness of

decision within given terms. And I would say that this density of decision can be felt just as much in a work of sculpture that consists of a box as in the figure of a human being—that you can bring a weight of decision to bear on the proportions of the box, as I said last week; the size, the material, the color, and perhaps other factors depending on how inspired the artist is. The weight of decision could make itself felt in terms of a dot on a monochrome canvas. I bring in the question-begging word: decision. Decision can discover what was hitherto undiscoverable, and it can make room—in principle it can make infinite room—for decisions and choices.

Last night I spoke about academic art and attempted a kind of partial definition. Now, a further partial definition of academic art is not only that it provides neat, tidy satisfactions in a more or less unsettling way, but it can be said, I think, that academic art tends to scant decisions, to eschew them, almost quantitatively. In academic art the artist tends to receive his decisions, not to take them—almost to be given them, to receive them in advance. Example: you start out by committing yourself to a given style, say, as the leading French academic artists of the nineteenth century did by committing themselves to the school of Ingres—hard-edged, smooth, accurate kind of sculpture modeling, suppression of color. You accept all that in advance and, in accepting this in advance, many, many decisions are taken out of your hands, they have already been made by Ingres and by Ingres's success. And that would be true for the school of Monet, Sargent, Boldini—and be true in later times in the case of Cubism, and later yet in the case of Abstract Expressionism—where you, in effect, accepted ready-made decisions in your work, accepted them in a wholesale way and almost automatically. And having accepted all these decisions instead of taking them yourself, the working out of the work of art became more a question of crafting than of creating. And just as making a good chair is a question of crafting—if you're not an inspired furniture maker—so it is with much of academic art.

Now, the essence of a decision lies in the fact that it involves a risk. There are no surprises—surprising satisfactions—without risk. In going against expectations, in order to provide surprise, you must take a risk. Now, it is true that the risk is determined—

the limits of the risk are determined—by the expectations of the very best taste in the given time. These limits also constitute pressure, that necessary pressure I talked about last night. They don't guarantee anything. It could almost be said that they increase the element of risk. Academic art—and this is a truism—is defined everywhere and always by the dodging of risks. One initial decision—like the commitment to Ingres's style in the nineteenth century, or to Picasso's in the thirties, or to de Kooning's in the fifties—one initial decision is expected to take care of everything and, as it were, to guarantee everything automatically. And, of course, you commit yourself in this way to past success and, as a matter of course, to past satisfactions.

Today, the academic spirit commits itself in the same way as before, but instead of committing itself to a style—and whether you commit yourself to a style or to something else doesn't matter; what matters is that you let the decision be taken by someone else, that the decision is there ready-made for you—today the commitment is to a category or a classification, namely the "far-out." The category supplies a risk, as such. The artist is committing himself to the category of risk, but he is not taking the risk because he signals the entrance of his art into the category of the far-out by very recognizable and familiar signs. I talked about context-mixing last night. There is also medium-scrambling. You signal that you have gone far-out by introducing three-dimensional elements in a two-dimensional context, in a two-dimensional work, or vice versa; the literary in a pictorial context, or the pictorial in a literary context; concrete poetry, poetry that makes a pictorial pattern on the page; noises in the context of sound; light in the context of sound; sound in the context of visual art, and so forth.

There is nothing wrong in any of these things, by the way. There is nothing that says that great art cannot be produced by medium-scrambling, by mixing contexts. Nothing says that in advance, and in some cases great art has been produced that way I am sure, even if I don't know the examples. But the overriding fact seems to be that the far-out art of our time, most of it, breathes off this academic spirit because it is an art that takes refuge in a category. The artist commits himself to the notion

of far-out and then makes no further decisions—Duchamp and Picabia making fun of the Old Masters fifty years ago, that one-time thing of painting a mustache on a reproduction of the Mona Lisa, or Picabia's writing something about Cézanne on the pictures. A joke is a one-time decision and it is a one-time event too. You can't hear a joke more than once if your memory is any good.

If you look at the show over in the Carriage Barn, there is a beautiful example of the difference between far-out art as non-decision-making and far-out art as decision-making. And both examples were produced by the same artist, Alan Shields. I think his octagon painting is a pretty good painting, and you can see, you can feel it—you don't have to examine it, you feel it—being decided on all the way through. I won't go into detail. But his lattice is a one-time decision. It is "idea art." There the lattice is, and it is as though the artist, once he had this idea and got the pieces of cloth and made the lattice, said the rest of it didn't matter, because the color is perfunctory and you're disappointed once you get inside the room, turn around and look at it. You're disappointed with the lattice and I would say one of the reasons is a relative absence of decision. To repeat, there is a decision to make a lattice and then to let the color go, the devil with the rest of it, and almost too, there was a decision to let the proportions go. As though the artist had said, all right, we'll use the modular sticks, which was a decision too, but you feel that that was a perfunctory decision; it was just an idea. And idea art is the quintessential form of academic art. You have an idea, let's say, to dig a ditch from here to San Francisco and nothing says that can't be a great work of art, but you've got to take care about the proportions of that ditch. It is not enough to surprise your daily mind, your ordinary mind, and just think of a ditch from here to San Francisco running along for three thousand miles or even a ditch from here to Philadelphia. You have to take care of everything. And I don't have to give you other examples. I assume you all see art magazines and know what I mean.

I talked last night about surprise as being taken to exhaust the whole meaning of avant-garde art. Now, it is the idea of

surprise. It is not essential surprise, it is the idea of surprise. And this has been worked out quite consistently. When Yves Klein had a show in Paris some ten years ago, there was nothing in it, and he was expressing his academicism in such an exquisite way. He was saying, all right, there is nothing but an idea—to me, or to me as art, or to my art. And you walk into the gallery expecting to see something, and there is nothing in it. He beat so many other artists to the punch, beautifully. He beat the people at the Dwan Gallery to the punch. In that line you can't beat Yves Klein. If you put a little dot on the wall and make the point of the show finding that dot, which is off in a badly lit corner, Yves Klein still has you beat at that. He is better at that if only because he is more logical.

The reason it is all so academic, another reason, is that we recognize this as surprising to start with. We don't even have to visit the gallery, we don't have to look at the ditch, we don't have to read what the Conceptual Artist puts on the walls or writes in art magazines. The surprise is already there as recognizable, unsurprising surprise when someone tells us about what they read in an art magazine and you've gotten it all. It is surprise as we are used to being surprised. And I say that the essence of the best new art is consistent in providing satisfactions in surprising ways—meaning, in new ways of surprising—and far-out art seems to consist in the opposite. Far-out art surprises you in a way that you expect to be surprised. It is surprising in advance and, as I said before, it is purely surprise. It is as though the purity of surprise was in being opposed to the so-called "purity" of art. And Duchamp encapsulated the whole business fifty years ago, which is another reason why it is so unsurprising. Anything and everything can be institutionalized, rendered into a category. And along with the idea of surprise as a category—recognizable-in-advance surprise—the idea of risk, adventure, daring, is categorized and academicized. Here again, you are warned in advance. Works of art—unless they are copies—whether good or bad or unique, the essential of their uniqueness is the element of risk, surprise, as I said, within limits. And I will go into the question of limits another night.

The academic intention, always and everywhere, is to elimi-

nate uniqueness, whether it knows it or not, because uniqueness involves risk. The academic intention is to generalize, formulize, guarantee by means of relieving you of, let's say, the anxieties, the nervousness of decision-making by letting you relax into crafting; in the case of painting, into what the French call "cuisine"—good painting, good workmanship. And art made in terms of classifications and categories is also art that signals in advance to the connoisseur who is spectator and tells him how to react. And that is part of the essence of inferior art, not only academic art but kitsch and sub-academic art. It is as though surprise were to be stabilized, surprise were to be assimilated, tamed, domesticated, in order not to be too surprising. And this applies as much to far-out art as it did to any previous species of academic art. And here, in this respect, certain kinds of far-out art join hands with bad movies, dime novels, bad TV, Tin Pan Alley music, and so on, where all that is involved is a matter of ingenuity, not inspiration, and above all, no risk on the part of the artist and also no risk for the spectator. The anxieties of taste put to rest, you walk into a show at the Dwan Gallery and you feel safe, you are with the most advanced stuff. It is not a picture on the wall, it is not a sculpture on a pedestal. You feel safe, you are with the future now, and you don't have to react in terms of good or bad, and some of the artists are smart enough to have drawn that conclusion.

To drive this home, the essence of it all is not to take a chance. No one would have expected that chance-taking, risk-taking, would be institutionalized, but just as Marx said that capitalism can assimilate anything, academic art can assimilate anything. The main thing is that the experience of the artist in his art is not his own. It is what used to be fashionably called "inauthentic experience." Robert Morris lettering a floor, or riding a horse back and forth between two posts—the experience isn't his own, it is his idea of something, which is not one's own experience. And the people who in their boredom with this sort of thing pretend to themselves—they're saying a new era of art is opening up, big doors into the future, and so forth—these people who see this and don't confess to themselves that they are bored are inauthentic too. . . .

QUESTION: On that last point of boredom, it's almost as if someone like Warhol, picking up on how academic art could make a thing of boredom, went ahead and made a movie . . .

GREENBERG: Well, there again the idea of surprise comes in. If you say, "I like being bored," as Warhol has said, you're not talking about real experience, you're saying something that gets put in the category of the surprising because it's a contradiction in terms. It's all very well to say these things, but the inauthenticity I talk about is to see people putting up with boredom for fear that they may be thought not to be "with it."

QUESTION: I just want to say that Pop Art did bring back some kind of awareness we didn't have before, and it did add some kind of a sense of humor to art.

GREENBERG: I want to say something about amusement and visual art. I think that amusement and literature—humor in literature—does work, obviously it works. I've never seen humor work in visual art except on a one-time basis, whether in Miró or in Hogarth or in anyone else. I've never seen it decide an experience of visual art, let me put it that way. Why humor is so secondary, tertiary, less than that, in visual art, I can't say. But when people say to me, look at the humor in Miró, I feel they're talking about something that's beside the point. When we look back, when we look at the past, can we think of any Old Master who was really humorous—including Hogarth, who was a good painter for other reasons? Let me qualify that. I think George Grosz is a great draftsman and the humor carries that. So I can think of exceptions, but I can't think of high painting that rests on humor.

QUESTION: Painting probably functions at its best visually. It's stated visually and received visually. Wouldn't it follow that to add anything, to impose anything on it, would be a mistake?

GREENBERG: Leave the word "impose" out. Artists will often need a literary impulse in order to get started on a painting or a

piece of sculpture and will incorporate whatever the pretext is in the work and it may be implicit, but it's not imposed. I think Grosz had to make some of his great drawings because what charged him was something he saw as funny, but in the end the drawing seems to swallow a good deal of the humor. Now I can't explain more than that, but it's not imposed. Just as the literature in the Old Masters is not imposed and it's not extraneous, I'd say it happens to be great visual literature too. Rembrandt is a signal example of that. Rembrandt not only makes great paintings, but the stories somehow of great literature too as he sees them. Or Titian, for that matter, in his own literary paintings. And the same applies to Giotto. Now, I know there's been a tendency to overrate Giotto, but I still think he's a great painter. Those stories have a hell of a lot to do with the way the pictures work. I can't explain why, but the stories are great literature too. And nobody's been able to satisfactorily explain just how literature comes into painting and works well. And just what happens when it doesn't—well, we know better what happens when it doesn't work well.

QUESTION: But if it doesn't function ultimately as a visual operation, it fails.

GREENBERG: I would tend to say that, although I can think of exceptions, but not in the line of high art, high painting. I think of photography. I consider that a high art and I can think of no great photograph that wasn't essentially literary. I don't know how to explain this. I know a lot of people don't agree with me about this. I'm saying it on the basis of my experience.

QUESTION: Following your train of thought up to that remark, one would probably have guessed you wouldn't think of photography as high art because it can function other than visually.

GREENBERG: Well, what I love is the inconsistency of these things—that's just it. Then you get surprised and you find out you can't make any safe generalizations. That's part of the fun of art. . . .

QUESTION: Do you agree with Michael Fried's theory of theatrical as far-out, as political, art?

GREENBERG: You mean art as theater? No, I don't, and let me tell you fast why. Fried took these artists up on the basis of what they said, and that is no legitimate grounds for approaching their art. I think he made a very serious error there. You don't judge art by what its creators say about it, that's all. You just look at the art.

QUESTION: I assume, then, you do make distinctions within the field of the far-out.

GREENBERG: The last thing I'd want to do is condemn a species of art as a species. So that even, as in these talks, when I keep on pointing at far-out art as deceptive, and by way of being fraudulent when it is really being academic, that doesn't mean I take everything I consider far-out art and consign it to the same low level. I'd still want to go and see each work for itself, and I'm still talking only about the far-out art I've seen, and I'd still insist on value discriminations, even there.

QUESTION: When Michael Fried gave a lecture here on theatricality, I understood it to be something other than dealing with merely the artists' works. He showed us a slide of an Andre piece which went right through the door so that people had to step over it or around it in order to see it. In other words, it seemed that theatricality had to do with imposing either a way of appreciating the art or looking at the art.

GREENBERG: He had something of a point. But I haven't found it that helpful myself, that's all.

QUESTION: Well, it helped me in terms of seeing the difference between art being left alone to be appreciated and art that has to have an environment in order to be appreciated.

GREENBERG: That's not illegitimate, necessarily, that in itself. You can still make great art with the aid of an environment. I

haven't seen it much yet, but that's not pinpointing enough why the stuff is bad. I think Andre could have paid more attention to the proportions of his plates and the colors. And I noticed when he uses copper he's better than when he uses steel, things like that. I think that's what you would get at first. . . .

QUESTION: You said something about an academic artist very often relaxing into the crafting. Isn't it possible that some artists revel in their craft and that that becomes a primary carrier that makes it something greater? I'm thinking now of a great printmaker like Charles Méryon in the nineteenth century, or maybe Canaletto, the painter and printmaker.

GREENBERG: I admire Méryon very much. In order to be a good printmaker you do have to get involved in crafting, in a sense. But I don't think that's the main emphasis in his art, any more than it is in Flemish primitive painting where crafting . . .

QUESTION: That's not what I mean. I mean as a very primary ingredient which somehow draws you to the painting.

GREENBERG: Well, then it's not crafting, it's art. It's like when the Adams brothers designed a new chair, or something like that. It wasn't just crafting, you know. They were being creative. Maybe it wasn't on a very high level when they were doing their furniture-making and interior decorating, but they were creating. What I mean by crafting is when you make no more decisions, they're all given. And in Méryon's case he made decisions right along, or the prints wouldn't have come out as good as they did. Méryon's not imitating other people that much, he's making his own decisions. I mean, take the Méryon that was in the Stein collection at the Museum of Modern Art. That wasn't as well made as it was just as a print; there was inspiration and risk-taking that went into the well-madeness of that print—as in Rembrandt's etchings, or Dürer's engravings. But, you might say, look at the way Van Eyck or the other Flemish painters fill up their pictures, how carefully. And you'd add, well, the care was more like the care with which you make an object than make a work of art. Now, I don't believe in that distinction. Their care

was inspired care too. Putting on the tempera, and then their glazing and then the re-glazing and all that—it was inspired. That's why it came out so well. See? Because you only judge by the results. One artist will go about making art, and to watch him, he might be making a bookcase. Nevertheless, there might be a great piece of sculpture or a great painting that comes out of that. And that's all that counts. That shows he wasn't crafting. And another artist will paint the way Abstract Expressionists are supposed to paint—you know, this and that—and it comes out inert and dead and contains everything that the artist saw in de Kooning or Kline and it's almost crafting. . . .

QUESTION: Would you comment on this apparent revival of people like Meissonier, Alma-Tadema, Gérôme? In an age where modernism is dominated—if not esthetically, at least public relations-wise—by far-out bad art, why would there now be an interest in this other kind of bad art? Do you think modernism is relaxing in its maturity and accepting more?

GREENBERG: Well, I share that interest. And I think the effect of modernist art has been to make tastes in general more catholic. It has helped open up exotic art, and now we see archaic art and primitive art thanks to modernism's taking the exclusive rights away from Renaissance traditions. I think that's part of it. And also, I think, there's a shortage of old art. I know you don't see enough of it. Years ago, I wanted to see Bastien-Lepage and people like that, and I had to wait until six, seven years ago for the Met to bring their big Lépage art out of the basement. And then I wanted to see Moreau and I had to wait for the Museum of Modern Art to put on a Moreau show. I'm curious about it and I know there are certain pleasures to be gotten from it, satisfactions. I'd like to see more Eugène Carrière and on and on. . . .

QUESTION: You talked before about taking the literary idea and expressing it visually. In contemporary art it seems that the only way to take a literary idea or a human being as subject matter to painting is, as in Pop Art, as a sort of parody. Why isn't it possible to express direct literary ideas in art now?

GREENBERG: The obvious answer—the popular answer, and one I will agree to in large part—is there's a way of using things up in art. We've seen that in other traditions. And why things should be used up, I don't know, but that's it. Somehow you can't send a picture over today by painting it the way Titian did. And you could no longer do it in the seventeenth century. Let's say the means to pictorial illusion as they've been developed in the West seem to have been used up.

QUESTION: I don't want to call it subject matter, but in abstract art, do you feel that that can ever be used up?

GREENBERG: Sure. Good God, everything passes.

QUESTION: Some things don't.

GREENBERG: All right. Let me say I would hail the return of great representational art because if I have a prejudice, it's for photographic realism in art, in painting as well as in photography. If I had my way, the best painting of this time would be close-focus realism. It would fulfill the dreams of the pre-Raphaelites. But you don't have your own way in art, you can't choose what to like and, alas, the best painting of our time isn't like that. Alas, I say. I mean it. And you do have biases and all that in art. You know they're there, but if you let them influence you in any way in your experience of art, you're missing out. It isn't that you're doing violence to the art, you're doing violence to yourself. I think Gerhard Marcks is one of the greatest sculptors of our time. Most people here haven't even heard his name. He's a representational artist and he's been considered a naturalistic one too, in any sensible use of the word "naturalistic." And there it is. I mean there's a paradox about the stuff and it doesn't quite work the same way as in painting. There is Maillol and there are others. But why certain means of making art, stylistic means, get used up, I don't know. It's as though they lose their capacity for producing satisfying surprises, let's put it that way, and that's begging the question. And it's happened before. It happened to the old Late Roman Empire. Sculpture got worse

and worse and the whole naturalistic tradition of sculpture died, sculpture in the round practically died in the West. . . .

QUESTION: The odd thing, and it's almost self-evident, is that anything can be expressed as long as it's expressed visually. And for all we know all manner of things could be being expressed—mysticism, literature, tragedy, humor, or whatever—in any type of art, only we wouldn't know it for what it is because it's visual, and so it's not coming across as what it originated as.

GREENBERG: You touched on something here. Nobody knows what a work of art means, by the way—the worst as well as the best. Dr. Langer goes into that very well. You can't say what the content of a Rembrandt is. You can't say what the content of Goya's *Third of May* is. It's not about shooting men—that's a pretext. We don't know what, as a work of art, it's about and we can't say what's being expressed. It can't even be said that emotion is expressed in art. And I think Dr. Langer, when she says "feeling," is a little sloppy, though I guess it's the closest thing. We actually don't know what the hell gets put into art. We can recognize, but we can't define—can't put into words—any more than we can put into words what we get out of art. And the content of the *Divine Comedy* is just as "ineffable," to use Dr. Langer's word, as the content of a Jackson Pollock—the tenor, or the drift, or the import. Bunyan's *Pilgrim's Progress* has its meaning written all over it supposedly, but the satisfaction that we get from reading it doesn't derive from that meaning. We don't know what it comes from.

QUESTION: But I would add one distinction and it's one of yours. All that pertains to high art.

GREENBERG: And the worst art too. No matter how explicit poor art makes itself, I maintain that we can't say what it's about. You take the most wretched comic strip and you can't say, well, what's this about? We know it's bad, it's dull, it's hardly worth looking at, but we can't say what it's about. In poetry, George Herbert may say, I'm writing this poem for the glory of God. And there's no question but that George Herbert's religion was

crucial to his poetry. But when we start to look hard we find out that the religion becomes a means, an esthetic means that enters the poem. And yet what makes the poem triumph isn't the religious feeling as such—it's something that the religious feeling has contributed. And that's why I think this question can't be answered, at least not here, tonight.

NIGHT SIX
April 15, 1971

GREENBERG: I very much want to take up where we left off last night, especially on my use of the word "academic." I should have made the distinction between academic in the pejorative sense and academic in, let's say, the historical sense. There is no hard-and-fast line between academic art in the pejorative sense—or even merely expert art—and good minor art, any more than there is a hard-and-fast line between major and minor art. God knows, a lot of academic art, like a lot of minor art, is precious. A lot of provincial, a lot of art that might be called retarded, shouldn't be overlooked, and shouldn't be overlooked, either, just because there is relatively a lot of it. Much of it does offer distinctive, if not large or searching, satisfactions. But minor art does not keep art going. Minor art in an urban culture feeds off major art, and without major art, minor art thins out with repetition and becomes academic in the worst sense. Major art— the all-out try—opens the future to the continuing production of high art. And it is the sense of the try—the all-out try in the sense of high seriousness that the new critics used to talk about in literature—that seems to be a necessity. You could say that the best new art of this time, the only major art we have, does not—may not, we can't be sure, but let's suppose—reach the level of the best new art of the past four or five hundred years. But there is still a sense, in the best new art of our time, of a try at that level. A sense of the courage and a sense of the ambition necessary to try for that level. And, as I see it, regardless of how the best new art of our time shapes up against the best of the past, art is moving nonetheless. And, by the same token, taste keeps on moving.

Sir Kenneth Clark says this is not a good time for painting. He doesn't mention sculpture. And he says that the last forty or fifty years have not been a good time for painting. He may be right. At the same time, I don't think he is in a position to tell because his taste has not kept up with the best new painting of our time, certainly not with the best new sculpture. But even if he were right, it doesn't necessarily mean that painting or sculpture in this time is in a period of decadence. There has probably always been an effort, at least since the Renaissance, to palm off good minor art, some good minor art, as big and major art. And usually the attempt hasn't succeeded because of what I can only call the vigilance of taste, which is not a purposive vigilance. It is not that connoisseurs—art buffs—have stood off and said, well, this isn't major art and found themselves, let's say, not satisfied enough. And I feel this is still true in our day, even though the expression of dissatisfaction with minor art that pretends to be major comes mostly from artists themselves and not so much from any part of the art public. As I said the other night, it is the taste of artists themselves that has kept high art going in painting and, as I think, in literature too, and in music over the last seventy or eighty to a hundred years.

I've been accused of making too much of the difference between major and minor, and I've been teased about it. Now, I don't bring myself into this to draw attention to myself. It's something of significance that I watch. People will say, oh, Greenberg—major and minor! as if that were my King Charles's head. How many here know what King Charles's head means? Mr. Malamud. Who else? You mean to say no one else knows what a King Charles's head is? That's a symptom of the decline of culture. David Copperfield, remember? When he comes to this old, amiable man who's always going on about King Charles's head? He brings it into every conversation. King Charles the First who had his head cut off. Well, anyhow, people have teased me as though this were my King Charles's head because I keep saying, well, it's not big art or it's not major art. In the beginning I don't think I knew my own motives in the case. I will say I didn't know how to do otherwise. The implication here is that I'm part of the best new taste of our time,

but I don't mean that. But there was a sense of not wanting to settle—like in the late thirties and early forties—not wanting to settle for anything less than what, say, the French were doing or supposed to be doing at that time. And at the same time, I came into an art world where, to my gradual surprise, I noticed that most people were scared by hard demands. It's not that different today. I remember artists getting nervous when you began to talk about good and bad. Not just good and bad pictures, but good and bad art, good and bad artists.

I feel that every self-respecting artist should be eager for the hard demands. He should have an appetite for them. He should search them out in entire readiness to accept the certain discomfort that is imposed. But most artists are like most human beings and it is hard, in the first place, to look for where the pressure is and, in the second place, hard to expose yourself to the pressure, submit yourself to it. The demands are there for an art writer too. He is supposed to develop his taste and ask hard things of himself as well as of art. It's not that much different. I think the vigilance with respect to the difference between major and minor art is particularly needed nowadays because of the kind of art that usurps the role of high new art. Innovative art does so nowadays—gives itself out as big art and claims to be revolutionary art that would change the whole future of art.

The way in which the claims of minor art, or less than minor art, are advanced today—the aggressiveness—is a new kind of aggressiveness. And the minor artists or the academic artists concerned show a new kind of self-confidence. That is my impression. That may be, again, the effect of foreshortening. I don't remember, nor does there seem to be any record of minor artists or academic artists or inferior artists in the past showing, not bitterness or anger or outrage, but self-confidence and aggressiveness such as they show today. And that is one of the new phenomena, let's say, in the art scene today. Again, pick up any art magazine—especially *Artforum*, I think—and this is the kind of aggressiveness with which some of the artists write about themselves and the way they see art going. It's not the way Bouguereau talked in his time, or a French salonier of 1910. Someone like Henri Martin, looking at Matisse, may have said, well, that's not art because that's an outrage or that's an insult, and so forth.

But he didn't say, my kind of art is the only really new art of our time and it is going to change art from now on and it is going to make five thousand or twenty thousand years of past art look obsolete. Henri Martin or Bouguereau or Carrière or Salvador Dali even—who is a minor artist, though not as bad as some people think, and is certainly someone who made a profession of not being modest—they didn't talk that way. And these revolutionary claims fill the foreground of the current art scene. When I say that, I mean you can look at *Time* or *Newsweek* or *Life*, not only the art magazines, and you can see by the references that people who know very little about painting or sculpture make. Or Susan Sontag, for example—how sold she is on the fact that the latest jazzy art is the very latest, most advanced, most significant art of our time. And the assumption is made that this art is what is continuing Cézanne and Manet, Picasso and Matisse, Miró and Pollock as if there were no alternative. And it comes down to the critic of contemporary art to hit harder, maybe, in a condemnatory way here than he has had to in a long time.

The fate of art is not in doubt—not yet—but it is as though the fate of taste were. There has always been this willingness to settle for less than the best, and it is a willingness that doesn't know itself, even as the unwillingness to settle for less than the best doesn't know itself. There is nothing programmatic about real taste. Real taste is never programmatic and its demands are always implicit demands, not explicit ones. They are not programmatic demands. They are not prescriptive demands saying, you have to do this. Real taste, in effect, just says, I'm not satisfied. And it holds out and doesn't say, well, this is the best we can do in our time. It doesn't say, as Sir Kenneth Clark might say, this isn't a good age for painting; let's put up with the best there is. It says, it's not good enough.

There is plenty to like in contemporary art. There is a lot more than you might think at first. But there is not plenty to be exhilarated by, elated by, or deeply moved by. And you don't want to be confined to museums for that kind of art. Of course you go to museums. You revisit the past, you keep in touch. But you don't want to be confined just to museums. There is something that says you want high art to come from the world as it

is in your own time, the world you live in. Some people insist on up-to-date major art. You insist on high art in terms of experience more "topically" like your own. I put topically between quotes. The great art of the past isn't enough to keep yourself going. I think, as an art lover in the best sense, I was always somewhat puzzled by Berenson—who had one of the best eyes on any record—by the complacency with which he would say contemporary art is not good since Cézanne; it's nowhere. I would have understood his saying Picasso and Matisse, whom he once admired, are not, maybe, as good as Titian or Raphael or Giorgione. But I couldn't understand his dismissing contemporary art and also his lack of curiosity about it. I met him once and it was one of the things I asked him about. He turned me off rather facetiously—I mean not in a bad way. On the other hand, I can understand why Sydney Freedberg over at Harvard, who I think is the best living art historian—and I advise you all to read his "Painting of the High Renaissance in Florence and Rome"—can't keep as much in touch with contemporary art as he might want to. I can understand his feeling uneasy about the fact that he doesn't see enough of it and, therefore, doesn't get enough from it. I understand his interest is the past but, in my eyes, he is a truer art lover than Berenson was, disciple of Berenson though he himself is. He wants the best art possible to come out of his own time too. Not for social reasons, not because he wants to be optimistic about our times and thinks it is good for society or good for education, but for himself. And that is what a real art lover is like, in my opinion: for himself, not for any ulterior purpose. That is why I think the difference between major and minor should keep on being hammered at, even though it may sound like an obsession

QUESTION: Is it possible that some of this lack of humility in today's artists that you referred to is due to a reaction against the kind of elitism . . . ?

GREENBERG: I agree that it's part of a desire to throw off culture as elitist. I do think in our time the awareness of certain things that have happened in the recent past, within the last century, has become diffused in an extraordinary way. Extraordinary at

least to me, who is a good deal older. I said that when it came to art everybody toward the end of the fifties and the beginning of the sixties really woke up to the fact that the way art has gone over in the last hundred years was by being innovative. And it seems to me that it took them a hell of a long time to find out, for that to become popularly seen. I'm surprised it wasn't seen much earlier on this broad basis. That is to say, we've never had an educated middle class of the size we have now in this country or even in Western Europe. I think it's also been seen—what I think Marx was the first to see—that most of mankind in urban civilization in the past five thousand years has been excluded from high culture. High culture and cultivation was the exclusive province of people who had enough money to enjoy comfortable and dignified leisure. The injustice of that has come home to many people quite recently, and people who unfortunately are callow enough and haven't read Marx well enough to know that you can't change the situation by fear, by wishing to change it. You don't change that, as the vulgar Marxists and Stalinists felt, by bringing culture down to the masses. Both Hitler and Stalin were one in that desire. You can bring it down to the masses, but it's no longer high culture. There's no getting around that. It isn't because the poor are born with worse taste than the rich. Taste is something you cultivate, it's not something you're born with.

This unjust arrangement is still with us and probably will stay with us in the lifetimes of everyone here. It's not a state of affairs that gets radically changed in one or two generations, not even in the most advanced country in the world where most people are still poor. The cry about elitism is one of these over-simplifications or illusions that quick solutions are possible in this area. And also there's a lot of juvenile self-righteousness involved here in the sense that elitist culture is now thought to have been a conspiracy. I just read a piece in Sartre's magazine *Les Temps Modernes* written by a very literate man who's a Marxist—and I guess if Marx were to read him he would revolve in his grave—but the implication throughout is that the upper classes ever since art appeared—he doesn't make an historical statement, he im-plies it—have conspired to erect an established thing called "taste" and that the conspiracy became most nefarious over the

last hundred years when the notion of pure art emerged; pure art and autonomous art being something that the ruling classes have put up to emphasize their difference from the masses. I don't believe in pure art, but the idea is there in the history of art over the last hundred years. I don't think there's any such thing as pure art, but the notion was there and to explain why it arose requires something more complicated than a class analysis. It wasn't just a conspiracy, and in every culture, urban culture has always been in the lead. Alas, but there it is

QUESTION: I link your preference, all other things being equal, for a photographic naturalism with a somewhat cautious attitude toward the ultimate staying power of the quality of modernist art when compared to Old Master art. I seem to remember your having written something about it not yet being proved that modernist art is a necessary episode in the history of art. And I have to find some relationship between that attitude and the attack on recent art. I wonder how you respond to my putting these things together.

GREENBERG: It's possible that I say this because of the limitations of my taste. That's the possibility. There's no question in my mind but that Goya's *Third of May* is better than anything Pollock could paint. And I think that Pollock's a great artist. I find myself comparing all kinds of art. I think that's the only way. I hope I'm wrong, by the way. I hope Pollock's *One* of 1948 or *Lavender Mist* does hold up and get its chance to be hung in the Prado next to the *Third of May*. I wrote a piece for the *Saturday Evening Post*—I don't like the piece particularly, but I said I thought that Cubist painting between 1910 and 1914 could stand up with anything of the Old Masters, and some of Matisse could. I was very cautious about the rest. But cautious because I think it's politic to be cautious here. I haven't had a chance to see enough of the best modern art up against the best of the Old Masters. There are bad Titians and bad Goyas that Pollock comes up to. But I'm talking about the top two Titian pictures— the *Worship of Venus* and the *Andrians*. I'd like to see the best of contemporary art against those two paintings. It's strange that I don't feel that unsure about contemporary sculpture, though

there's so little good contemporary sculpture. But I know that David Smith could stand in Donatello's company—a good David Smith—or that Picasso's sculpture in the late twenties could. And I know Maillol and Gerhard Marcks at their best could stand next to Donatello. And Rodin, of course. And some of Matisse's bronzes and Degas'. This is the first time I've thought of that.

There happens to be further irony. I remember Gorky saying in 1938 or 1939, if only I could get a bit of Picasso's quality. Somebody was saying Picasso had sort of fallen down in the last ten years—as indeed I believe—and my thinking at the time was that this was laudable humility but if I were Gorky and an ambitious artist, I wouldn't feel that way. And then about five years after that Arnold Friedman—I think he was one of the best painters this country turned out before the Abstract Expressionist era—I remember his saying to me after he had painted some pictures that I thought better than middle-run Bonnard or Vuillard: Well, we can't compete with those French boys, that's the big league, we're only Americans. And this was the attitude in New York art circles when I came around. . . . And then with Pollock, he was impatient with that kind of talk. He never came out and said it explicitly but you knew he was there for the big leagues. He was the very first to my knowledge who had this attitude. But in a while many other American artists began to share that attitude. . . . Now, of course, it's overdone. We're not only chauvinists here, we're parochial too. It's not only shocking, it's appalling how little attention foreign artists get when they're shown in New York today. . . .

QUESTION: The other night you said that Stella and de Kooning were examples of artists who were accepted by the cognoscenti and yet there was a discrepancy when you looked at their works. I didn't understand what you meant by "discrepancy." That they didn't hold up?

GREENBERG: Yes. Both these artists come as close to being noncontroversial as contemporary artists can be. De Kooning in the fifties and now Stella in the sixties. And they may be better than I think they are, but they're still not that good. And I didn't say

"cognoscenti," I said the art public, the "with-it" art public. We don't know who the cognoscenti are today. In Michelangelo's time we knew. They were all gathered around Pope Julius the Second and his successor—real highbrows, ferocious ones. Today we don't know when it comes to painting and sculpture. That's a curious thing. There are a lot of people who sound, when they talk and write about art, as if they know, and you test their eye and you find out they don't. As far as I can tell, it's been that way for the last fifty years and maybe it was even that way in Paris, though I don't know. As you go around New York or as you went around Paris, you met very few people whose eye you respected. And you can say, well naturally, that's because they didn't agree with you. I'd say that I didn't find enough people to disagree with relevantly. In New York today it's damn hard to find somebody—outside of a few art historians—who can tell the difference between the good and bad Rembrandts in the Met.

The de Goncourt brothers said that taste is harder to acquire in painting and sculpture than in any of the other arts—what they should have said was in Western civilization; that is, I don't think this is true in Japan or China. In any case, I think there are certain reasons for this difficulty, at least in the West and Near East. Aristotle said the eye was the most important of the senses, or he said the most intellectual of the senses, and by that he meant that the eye automatically associates a concept, a class, with what it sees—does so automatically, quicker than the ear or the senses of smell, taste, touch. It's very hard for us to see anything without automatically attaching a name to it. That means a concept, a general notion, or what they used to call a universal classification. We can hear things without insisting on recognizing their source and without insisting on naming anything in connection with the noise. Actually, we're not made as uncomfortable by noises or sounds whose source we don't know as we are by visible things that we can't identify. The result of this is that in looking at paintings and sculpture we tend immediately—or, let's say, by the time we're able to talk—to see everything there as standing for something, as not being there in its own right. Let's leave abstract art out, here.

And the process of learning to see painting and sculpture is a process of developing a certain innocence in your eye so you

see representations—two- or three-dimensional representations, real things—you see the representations for themselves and not because it's a representation of a beautiful girl or a cute baby. You see it as a picture. You see it not as a symbol either—though some people would quarrel with me about that. You look at painting and sculpture for itself and not for what it represents. Though, as I said the other night, what it represents will play a part, and nobody has been able to exactly discriminate what that part is. At any rate, the greatest literary painters, Goya or Giotto, have stood as painters—people who knew how to put paint together on a flat surface—before they stood as anything else. This is why Clive Bell and, to some extent, Roger Fry could say with some plausibility not to pay any attention to what a painting shows. I think that was a salutary overemphasis in its time. It is an overemphasis. I actually think that abstract art has taught people—some people, more people—to see painting for what it is than anything hitherto. I surmise that anyhow. I'm not sure. And there is taste in painting and sculpture today that is more widely diffused than I can remember its being, though there have been liabilities in that connection. As I said, it tends to be blunted taste, taste that will settle for pat satisfactions. . . .

QUESTION: The artist's assimilation of the best art of his time, what is added to that? You said that character gets into this. What do you mean by character?

GREENBERG: Well, it's my stab at naming something, though when I say character I feel sure. And it's connected with inspiration. What is inspiration? I can't define it. We don't know what's going on in the human consciousness when art's made. It's the x-factor that's always there and is indispensable. Taste without inspiration is helpless, largely helpless.

QUESTION: You don't talk too much about feeling.

GREENBERG: Oh, it's there. I said the other night that feeling is something I shy away from as a word because it lends itself to misunderstanding. I think it does so when Dr. Langer uses it. Taste is something I can talk about. But I said to start with that

without inspiration you don't make significant art. Don't misunderstand me as saying that if you assimilate the best new art in the time just before your own and in your own, then you're all set to make art. I said that was a necessary, but not a sufficient condition. Inspiration is next. You. You yourself. That's indispensable, that's all there is to it. I mean, it's not as simple as that but that's what I can do with it in verbal terms. . . .

QUESTION: Would you talk further about why you think photography is a major art?

GREENBERG: A lot of people—most people today—don't think photography is capable of matching painting or sculpture or poetry or music in their highest flights. I don't agree because some photographs I have seen are among the most beautiful pictures I've ever seen.

QUESTION: You're referring to old photographs?

GREENBERG: Well, mainly old ones. If we get into the esthetics of photography, we have to allow for period flavor, and that's tough to separate out. But there's great photography made in our own time—Walker Evans, I think. I'll match him against Atget, a great photographer who benefits from period flavor. And I think Evans is just as good and, maybe, better. The question of period flavor is damned interesting because painting, on its higher levels, doesn't benefit from it. It's just on the lower levels that a painting will chance to benefit, to disarm your eye a little, just a little. But take a daguerreotype, it seems to have an infallible quality; all the mid-nineteenth century portraits have it, not in the original metal but when they're printed. And I think Stieglitz in the late 1890s made some great photographs. I think he became too arty, he got misled by painting as so many photographers did from 1910 on. For me to say all I have to say on this would take hours. There are difficulties, like the question of period and why the best photography is literary, story-telling, anecdotal; anecdotal in the sense that Atget can take a photograph of a hitching post and the curves in the cobbles on a Paris street and somehow or other, it's got a whole story in it. He, like Evans,

happens to tell a better story when he's photographing man-made objects than when he's photographing human beings, which is unlike some other great photographers.

But about abstract photography, I happen to think it's almost always bad because an abstract photographer fools himself. I think what he's doing is painting with light on a light-sensitive surface, and that's a kind of fooling. He has to be as good as a painter, whether they're as good photographers as Aaron Sisskind or Man Ray—who is a damned good straight photographer, by the way. But when they go abstract, they have to be just as good as a painter. I don't say they can't be—you can make an abstract photograph that's just as good as an abstract painting—but so far I haven't seen that happen.

NIGHT SEVEN
April 20, 1971

GREENBERG: I've already spoken about the new awareness that came over many people about sixty years ago of what, up to then, had been fifty years of success on the part of the avant-garde and how, for the first time, the avant-garde began to be looked to by many people as a source of safety rather than occasions for risk. There had already been plenty of academic spirits who wanted to join the avant-garde but had been unable to find it. It wasn't there steadily enough to join. And all they could do was tag along stylistically after poets like Baudelaire and Rimbaud, painters like Manet and the Impressionists.

There had also always been aggressively academic and academically aggressive artists. But now, for the first time, aggressively academic artists aspired to avant-garde prestige, wanted to share in what they thought were the guarantees of the avant-garde, as shown by successes of the previous fifty years. The trouble was that, being people of academic sensibility, they couldn't keep up. And this was the case of the Futurists, with respect to Cubism, and it was also the case of Marcel Duchamp with respect to Cubism. You can see it in the paintings of the Cubists and you can see it in Duchamp's famous paintings—which are not bad, by the way. They're not. They're not great pictures but some of them are quite good ones. The Futurists decided—I'm simplifying; this was by no means all there was to Futurism—that the safe thing was to be new. They made the mistake everybody makes when they decide to be something of that sort because the new is something you discover, you just don't decide to be new. You discover the new, and particularly in art, though also in other fields of endeavor. Duchamp de-

cided—it seemed this way—that the secret of the success of the avant-garde had been that it had been startling and shocking with each new move it made. And it is as though he equated originality and avant-garde art with surprise, with the disconcerting and, as I've said before, with surprise purely as surprise, if need be, without art. And as I've said, his first important move that sprang from this conclusion was to offer ordinary objects like a bicycle wheel turned upside down on a stool or, better yet, a bottle rack as works of art. He offered these ordinary things in an artistic context. And part of his intention was not only to shock and startle but, apparently, it was also—not apparently, even more it was explicitly, and this you can gather from his own words—to escape the jurisdiction of taste.

The refrain I've harped on throughout these seminars is, more or less, that taste pursues, and taste is inexorable and implacable. All the same, Duchamp, in his effort to escape from art through art, inadvertently demonstrated something that, I think, had already been suspected for a while, namely that anything and everything could be experienced and treated esthetically. No matter what you decided to put in an art gallery or in a studio or in a museum—whether it was a green pea or an elephant's leg or a colander or a vacuum cleaner or a simple brick—anything could be focused on esthetically and experienced esthetically. All that was necessary was an act of mental distancing, and this act could be performed outside an art context and has been an infinite number of times—for the most part inadvertently, for the most part with the person who was having the experience being unaware of what he was doing.

To experience something esthetically is, in effect, to experience something, other than the human being, as an end in itself—a certain kind of end in itself that you were satisfied merely to contemplate, look at, smell, touch, taste, hear, see—and all that was required was a mere flick of the mind. And you can also experience ideas esthetically. You can experience anything that crosses your mind esthetically as something regarded for itself alone—savored, you could say, for itself alone. It is not too unlike the religious experience that some mystics have reported. It is not too unlike what William Blake wrote about. If he could see all of heaven in a wildflower, he could also see all of

heaven in a little petal or in two people passing one another on the street.

Since Duchamp's time it has also become apparent that there is no hard-and-fast line to be drawn between esthetic and artistic experience. Actually, they don't just overlap, they coincide. Croce already, I think, had some notion of this, a notion he didn't follow through on. I don't think he could have until it had been demonstrated. Croce said that the work of art, in being experienced, is reproduced. It is not simply that you receive art from its maker or that you receive esthetic experience from whatever its source in nature and in man-made environment, you also reproduce it. Now, anything experienced esthetically, as far as I can make out, is reproduced artistically: anything esthetic is also artistic. I can't demonstrate this. I just appeal to my experience and I appeal to the experience reported by other people. And it is one of the achievements of recent avant-garde art. Now mind me, I distinguish between avant-garde and avant-gardist—when I say "ist" I mean something different than the authentic avant-garde or the classic one.

It is the achievement of avant-garde art, especially in recent times, to have demonstrated that the notion of art as an entity is not confined to the notion of art as a work—as a self-contained object or script or pattern—but that art can be a mere occurrence, an act, a moment. And for that reason, art is ubiquitous. Art is virtually universal. All reality, all possibility is virtually art, not necessarily realized as art, but virtual as art. In other words, we live in an ocean of art or of the possibility of art. An infinity already there. And art is not an honorific status. The condition of being art does not necessarily confer honor or more than minimal value on anything or any event or any act or any moment. It was Croce's big mistake, and others', to say that if art is bad, it is not art, and then to leave it undecided as to what bad art was, what order of experience it belonged to. That left a whole huge area of human experience unaccounted for; not bad art, non-art. And introspection, I think, shows that this isn't so, that it is the very nature of art to contain infinite degrees of value, quality, and so forth.

It is significant, I think, that it is inferior art that has demonstrated this, that has made this theoretical point. And it is

inferior art that hoped, as it were, to make the judgments of taste irrelevant by force of demonstration, by force of the theoretical demonstration. And it is inferior art that hoped, in making judgments of taste beside the point, also to make its own qualitative inferiority beside the point. And the kind of art that did this—the avant-gardist art—also proceeded on the assumption that the main thing, anyhow, was to advance the frontiers of art, supposedly, as classic avant-garde art had done. From Manet on, new areas of experience had been won for art, areas hitherto intractable to art. But taste still pursued and taste still pursues.

Ubiquitous art—this rudimentary, universal art or virtual art that avant-gardist far-out art sets in an artistic situation, that is, formalizes—says: This is art as art is recognized to be. This stuff that was art all along but wasn't socially established as art, almost all this art—the art of a moment; the art of daydreams, though daydreams are not really art; the art that overtakes you when you're looking out of the window or when you smell something or when you hear something or, even, when you taste something—almost all this art is inferior, low-grade, rudimentary art, literally minimal art—no reflection on what is known as Minimal Art intended at this point. And formalizing it, doing what Duchamp did, doing what has been done so often in the latter sixties, doesn't make this kind of art any better. Presenting it in an unmanipulated state doesn't make it any better. And demonstrating that it can be done is no longer significant. Once one or two demonstrations to this effect have been made, all further demonstrations are redundant and pointless because the force of a demonstration is a one-time force. Like the force of a joke, as I mentioned some evenings ago, it is unlike artistic force which has nothing to do with demonstration. And anyhow, it turns out that the authentic avant-garde, the classic avant-garde, advanced the frontiers, not of art as such, but the frontiers of superior art. Art as such had infinite limits to begin with, and has infinite limits. There is no point to advancing its limits. There is no point to taking a speck of sand and setting it in the middle of the floor in an art gallery. It's art anyhow. As William Blake said, "It's religion anyhow."

Hence, the boringness of the kind of art that, as so much far-out art does today, sets things hitherto considered non-art in

a situation or context or setting in which they have to be approached as art and nothing else. This is the boringness of art by fiat. It is true that anything we choose to call art is art, but that doesn't make it good art. And boredom, as I've said several times before, the boringness of this constitutes an esthetic judgment—you don't escape from the difference between good and bad. And it doesn't affect the case too much when you take supposed non-art and you set it in an academic context as, say, a painter like Rauschenberg does. If he fastens a stuffed bird to a canvas or creates a bas-relief out of a plot of grass, as he did at one Stable annual, it doesn't make this supposed non-art any the less academic. And the thing that would always get you about Rauschenberg was that no matter what he touched, it fell into art school Cubism. And the plot of grass was the clinching thing. I don't know who else remembers seeing that. I know that Rauschenberg had to come in every day to water it. It was a part of his delightfulness. Incidentally, he is a delightful human being.

Another example in a related line was when Jasper Johns cast flashlights or beer cans or coffee cans filled with brushes in bronze and then would paint them in the exact same colors as the originals so you couldn't tell whether it was really a coffee can filled with brushes or not. The point was, he said, well, this is art because I've put it in bronze and cast it. Well, it was art anyhow, but it wasn't very good art, that's all. What might be crucial here, and I'm not sure, is that most of this supposed non-art that is put in a situation of art isn't even academic art, isn't even as good as academic art. It is sub-academic. It isn't even as good as cheap commercial art. It is sub-kitsch too. It is some of the worst art that has ever been formalized as art. And this might be significant, I don't know: In the fifties I thought Abstract Expressionism and Art Informel, as carried on by literally thousands of artists all over the world, had a chance of being the worst art ever beheld under the name of art. (*laughter*) I know this sounds funny, and of course you're going to laugh, but literally it was so. Now I think some of what you see at, let's say, the present Guggenheim International Exhibition or at the big recent show in Boston is possibly some of the worst formalized art ever experienced under the name of art. I won't say it is the

worst art ever experienced as art, but possibly the worst ever socially experienced as art.

In any case, the good and bad come right back in. Taste doesn't get evaded that easily. And if taste were to get evaded, it wouldn't be evaded by tens of thousands of artists. It would take an exceptional few. And taste comes in more emphatically than ever. And I feel that there is some realization of this that helps explain the rapid evolution of avant-gardist far-out art in the latter sixties. As though each move is recognized as a one-time move that has to be trumped. Each move somehow betrays, in spite of the claims made by the makers of this art, its lack of endurance, lack of artistic substance in its results, and lack of artistic endurance.

I haven't finished with the latter sixties. There are still other stratagems left in the way of being far-out. But let it suffice for this evening, because I think the notion I advance of ubiquitous art shouldn't be accepted just like that. I expect pressing questions on that score from here on in. . . .

QUESTION: I'd like to clarify something. Has the achievement of inferior art been to demonstrate this ubiquity of art?

GREENBERG: I'd say there's a demonstration of something, but something that's been here all the time.

QUESTION: Are you also saying that as yet no one has been able to use this ubiquity in a way that transcends what you call the infinite limits of art? Because then you seem to be giving with one hand and taking away with the other.

GREENBERG: No. I'm saying that the limits of art are infinite. They can't be advanced since everything we can possibly experience—perceptually or mentally—is already virtually art. There are no limits to art. It was thought of the early Impressionists, Cubists, Abstracts Expressionists: This is conquering a new area for art; what we never thought before could possibly be art is now art. Well, that proved not to be the case. These areas were conquered for superior art, not for art as such. There's a differ-

ence. It's low-grade art that is virtually universal. Who knows if in some future civilization or some future state of consciousness we might not realize Mondrian's dream, which was to convert everything into art. That's really wonderful. The whole environment would be art and, he didn't go on, but then everything we did would be art. With a flick of the mind you could stand off and watch what's going on here in art in this room. If you practice enough introspection you'll often inadvertently, unconsciously, involuntarily experience things esthetically and not even notice it, not even be surprised by it. Now, following Croce, you're producing a work of art in your mind. It's solipsistic art, autistic art, but that doesn't make it any the less art.

QUESTION: There seem to be two universal, antithetical notions playing around inside what you're talking about. The first one is completely nonjudgmental, which is the ubiquitousness of art, and the other one is totally judgmental, which is the taste you talked about.

GREENBERG: That's right. I divide it very much.

QUESTION: Then you talked about art not being an honorific term. We discovered the fact that it really is when we talked about it. This shouldn't be.

GREENBERG: That's right. And actually it isn't when we talk about it. Even in Croce's own case, when he says, well, is it good enough to be art? That was like a rhetorical flourish. He was saying, in effect, that's bad art.

QUESTION: But there are other cultures that avoid these problems, if they want to be seen as problems. In Japan I think they have a word or a phrase to describe some of these states of mind, which can be thought about as that kind of art. You know, when you watch geese fly or see a sailboat go out to the islands and disappear. We don't have a word to describe this. So the moment you begin to say that that's possibly art you're confusing it in our minds perhaps with notions we've always been trained to apply elsewhere.

GREENBERG: To apply to formalized art. What I'm talking about when I talk about ubiquitous art is unformalized art. I'm glad you brought up the Japanese because the Chinese and the Japanese have a much greater vocabulary than we in the West have for the states induced by art or by natural beauty and so forth. And it's curious that the Japanese are on the *qui vive* for esthetic experience all the time.

QUESTION: Anthropologists would say that that's a dead give-away that we are not a particularly artistic culture because when something is important to you you get a lot of descriptive names for it.

GREENBERG: Yes. And I think it's quite true that, compared to the Chinese and Japanese, we're not consciously on the alert artistically. Which, in a way—and I hadn't thought of this until you brought it up—bears out my point that the Japanese tend to be less as artists, except for their medieval sculpture. They're too esthetic to be good artists. Now, this doesn't apply to the Chinese. The Chinese are grosser and cruder. The Chinese are not bad artists, in this sense. But Japanese art is a disappointing thing. With all the exquisiteness, you go into one of the Imperial Gardens and there's an esthetic trap for you in every inch—they have it all set up. You have this experience at this half step and the next experience at this step, and so forth. And in the end it's all been mild. You haven't been really moved much by anything. It's like their pottery. Their pottery is there and it's got everything it's supposed to have, and somehow it lets you down.

QUESTION: That might be because we walk in expecting more of a certain kind of surprise. A Japanese might walk into that garden and get a certain kind of experience because he knows that his response is what it's supposed to be. Millions of people have reacted the same way to that little trap that was set and that, in itself, is a peculiar kind of esthetic experience. It might be a very powerful one if you were trained for it.

GREENBERG: That is always one of the big problems. Except I found, looking at Japanese painting and sculpture and pottery

and architecture, that my taste pretty much matched theirs. It's how somehow we agree with the ancient Egyptians about what was best in their art. We agree that the Old Kingdom sculpture was the best. And obviously the Egyptians must have thought so because they kept harking back to it for two thousand years. You find when you go to India that if you bear down it doesn't take so long to get with it and match your eye against the indigenous eye. And you'll find the judgments of your own taste aren't that discrepant from theirs. This is one of the things that convinced me of how fallacious historicism can be in part, and relativism can be in part, when it comes to artistic matters. Here again Croce made a big mistake when he said you had to put yourself in a state of mind, say, of a fourteenth-century Italian in order to squeeze the juice out of the *Divine Comedy*. I tend to doubt that. If anything, I think we see, let's say, Piero di Cosimo better than he was seen at the turn of the sixteenth century in Florence. I happen to think too, the pictures are extraordinarily well preserved and maybe other pictures of that time are not. I think there's an element of the absolute in the esthetic experience. I hate to admit that, but I'm forced to.

QUESTION: At the same time did you want to concede that anything might be art?

GREENBERG: Yes, that doesn't contradict. . . .

QUESTION: How happy are you wanting to talk about art which somehow adds to the tradition of Western art as the decisive and discriminating means of separating out sheep from goats among our contemporaries?

GREENBERG: Why shouldn't I be happy? Tradition belongs to formalized art. And the point I tried to make was that a lot of inferior art is now being formalized as art. That is, it's presented in terms that society recognizes consciously as art instead of experiencing unconsciously as art. Now, that distinction is of the essence. I said we live in an ocean of possible virtual esthetic experience, a lot of it realized unconsciously, inadvertently. Some small part of it may be even of superior value, though the fact

that so much of this experience is solipsistic, and I said autistic, makes it very hard to find out. But you can get maybe a very intense and genuine artistic feeling from watching a car go down a road. That can't be excluded. What I should have gone on to say was that in formalizing art you make it communicable. You grab that experience, try to fix it so that it's communicable—which has, I suppose, been the endeavor of formalized art. And in doing so—I'm not being abstruse, I'm appealing to your introspective and imaginative powers—usually you're formalizing it. I think the pressure of making esthetic experience communicable is what has created superior art and traditions of art. You could say, possibly, of buildings too. I mean, that's one theory, one hypothesis: that the formalization of art began with the first man-made shelter. I don't know. But I feel that man was having artistic experience before he fixed it, say, in a shelter, before he fixed it, let's say, by outlining his hand on the wall with a rock. I know I'm stretching something very far. I don't have any precedents for saying this, that's why I'm stretching it far.

I want to go on to say—I'm postulating now—that in order to make your esthetic, your artistic experience, the art you've received—you "receive" art, you're inspired—communicable you have to do some manipulations. And the necessity of manipulating is the pressure. The wondrous thing about far-out art today is—though there's some consciousness of the fact—that it's just the necessity of manipulating that exposes you most to the judgments of taste. So maybe if you haven't manipulated, if you throw something down at random, you might be exempt from the judgment of taste. People won't say it's good or bad, they'll say, look, it's art. Maybe they will be so taken aback by this and the realization it's art, formally art, that judgment will be averted, and art will be taken into another realm where good and bad, differences of quality, don't obtain. And so the artist goes out into this infinite ocean of virtual art and says, look what I'm doing, I'm capturing this for social art, not just for art at large. And that's the feat. But as I said before, one time is enough. . . .

QUESTION: Would you say there's a difference between having an esthetic response to something, anything, and having that same thing presented as serious art in a museum? What I'm

getting at is that sense of pretentious gesture one gets which has something to do with an artist's intention. You don't see the same intention if you look at something in the environment and see it as art and say, that's kind of nice. Is this enough of a distinction, in your experience, to reintroduce the distinction between artistic and esthetic response?

GREENBERG: If you're not alert enough, it might. But you're supposed to be working on your taste to eliminate things like intention. I mean that. If you see a hoist, say, on a roof and it looks better as sculpture than most of what you've seen in the Whitney Annual—which is not saying much, by the way—well, you're stuck with that. There it is, this hoist made of wood, and you're stuck with it. There have been cases like that in my experience when I saw something that wasn't intended as art and it looked better than a lot of formalized art or formal art.

QUESTION: If you saw that hoist in a museum . . .

GREENBERG: Would I think it better still? The chances are I might, but I'd have to work on myself not to consider that.

QUESTION: You see, there's something about a lot of this far-out art where you get a feeling of the gesture behind it, a sort of obviousness which is, after all, an obviousness of someone's choice, and that's artistic, specifically artistic. And all I want to know is can we reintroduce these terms?

GREENBERG: I don't think they belong logically. Empirically, it could happen. If you don't see something in an art context, you might not be as alert, but that's an empirical, psychological question. It's not, strictly speaking, an esthetic one. You can reverse that. I might not like the hoist that much had I seen it in the Whitney. I'd have seen everything that was academic about it. There's that possibility. That's empirical, now. You've got to keep that out of the question of the principles of taste because that relates to attention, which I haven't gone into. Attention plays such a role in the question of taste. And you can generalize that really; in the end, developed taste *is* developed attention. But I

don't feel competent to get there. Nobody has written about this, and I'm afraid of getting in over my head. I do think, ultimately, taste is a question of directed and developed attention. I do. I think familiarity sharpens your attention and it happens un-awares. . . .

QUESTION: We've been using logic to show the futility of logic.

GREENBERG: We've been using experience and conclusions from experience to show that verdicts of taste and that which goes on in art are not capable of being put into rational discourse. That's a matter of experience, not a matter of logic. Presumably, I'm trying to give you my version of information and also trying to point out that a lot of things that are commonly thought to be known about art are not known. And to show you that practice and the record and experience demonstrate that they're not known. And I'm willing to say that most of the people who have attended these seminars have felt that I'm telling them things they know already and they've known for a long time, so what's all the fuss about? If I were a more practiced dialectician I would try to show you that you think you know this, but you don't proceed as if you do. Yes, you proceed otherwise. I said at the outset that one of the issues was maybe to find out—you know, I think I already know—what can legitimately be said about art and what can't be in a discussion of art. And I felt that was a useful thing to do for people interested in art, in view of what you read about art in art magazines and art books, which is for the most part so irrelevant or so useless or so incoherent. . . .

QUESTION: Tonight you mentioned an idea that I was aware you thought had some controversy—the idea that everything has the potential of being art. I think it's happened in every culture where an expression reaches a characteristic degree of cultivation. You said that you can't imagine anything that you have not seen before, and by definition, therefore, if anything has a potential of art and you pick it up, it would follow that someplace you had seen it before. About fifteen minutes ago, looking up I saw all-over painting in the grill. Every place I looked, I looked with a model in mind, which means that everything does not have the

potential of being art but rather that when taste reaches a certain degree of refinement, we look at everything with some received form of prototypes and we are at a late stage.

GREENBERG: But I maintain that before this conscious esthetic experience, there are a multitude of experiences one has that are esthetic, though you're not aware of it, you're not conscious that it's esthetic experience. As I said before, it's unconscious, or inadvertent, esthetic experience. And I know that's a risky notion. I'm foundering on introspection just like Kant. And I can remember states of mind in which I looked at things esthetically—long before I could appreciate abstract art—and in an esthetic mode, and that was one of the points that struck me. Or hearing noises and getting a pattern sometimes out of the same sound. It's easier with sounds, I think, or noises, than it is with seeing.

QUESTION: When we reach the point where we can look around and see a building as sculpture and not as a building, culture has reached the end of something. That's what I think the implication is here.

GREENBERG: It's a connected point but it's a different point. I didn't say everything has been realized as esthetic—we'd be barbarians. I said everything is virtual, or potential. That's all. It's already there to be realized as art without any manipulations. With only a mental flick. It's unnecessary to my argument to ask how much of an esthetic experience you have had in the past. I maintain that people in different cultures—let's say, less advanced stages in terms of urban civilization—have inadvertent esthetic experiences too. I'm sure every human being has had some. And that's the point I want to make.

QUESTION: I wish you could point to one object that would be free of associations, that was not in the category of a Dadaistic act.

GREENBERG: Well, it is a Dadaistic act. This is what Dada inadvertently picked up on. Duchamp and Dada wanted to present objects or entities or events devoid of any artistic interest. Du-

champ didn't mean he wanted you to look at the bottle rack as a piece of sculpture. His intention, and the bang of the whole thing, was a cultural blank. Yet insofar as those entities or objects have persisted, taste got in there anyhow. Duchamp didn't get away with it esthetically. This was an historical event; a one-time demonstration. He said, I can call anything formalized art. He didn't put it that way. What he said was: Anything I choose to present as art is art. And he was right. If someone had done that fifty years before, he would have been right. But no one did until Duchamp. So now I can take any part of this room and contemplate it artistically, like that beam up there, and I might do it inadvertently. The fact is that art as it goes along—not as it progresses, it doesn't progress—makes us more consciously aware of possibilities of conscious esthetic experience. This is something I don't gainsay, it's a fact, a tested fact. At the same time, I bring this other aspect of unformalized artistic experience in. In some ways it's the only way I can account for the utter deadness of far-out art. But there are other ways too; the fact that this art is not controlled by expectations, as all good art has been hitherto.

NIGHT EIGHT
April 21, 1971

GREENBERG: Last night I said that there are other ways in which the flight from taste was carried on—in the mere matter of context-juggling, and so forth—and there are different paths, as we have seen them in the latter sixties especially, but they are also in large part, paths that intertwine. Now, desire to be far out is almost by definition a confused and ambiguous desire. That is the way we have seen it. The discriminations of taste are resented and, at the same time, the artist who resents these discriminations wants the kind of approval that can only be delivered through judgments of taste. In his aggressiveness, the far-out artist denounces other kinds of art, other artists, in terms of taste while at the same time professing to transcend these terms. He says he is above good and bad, and at the same time he says so-and-so is bad, that's why by implication he is better. When he says that so-and-so is obsolete, he doesn't just mean that he is not up-to-date, he means that he is less as art, and he is making a judgment of taste—a poor would-be judgment of taste. And he says, well, as for me and my art, good and bad, well, that's old-fashioned.

One of the ways I have already mentioned in which this confusion works itself out in an, I'd say, purposeful way is what I call "medium-scrambling." And there is nothing necessarily wrong with medium-scrambling. There is nothing again that says you can't produce great art this way, except that the tendency has been over the latter ten years to jump from one medium to another, or appeal to one medium in the context of another, in order to appeal to a lower pressure of taste in the one medium against a higher pressure of taste in a given one.

Pop Art is an example. Pop Art pictorially was self-evidentially academic—Cubist grid and so forth, the art school Cubist grid. And the appeal to literature—the archness of the appeal, the acuteness of the appeal—was to take your eye's pressure off the given item as pictorial art. It would have been fine had Pop Art appealed to a high order of literary taste because there is nothing wrong with literature in a pictorial context. Well, Pop Art appealed to a lower, obvious order of literary taste—like making fun of advertising, making fun of pinup girls, making fun of labels on cans, and so forth—which is so easy to make fun of and we are all in on it anyhow. I don't say this deprives Pop Art of all value. I think some of Pop Art is respectable academic art. It will probably last the way the small pictures of Gérôme or Bouguereau—and probably not as well as some of the small pictures of Meissonier—have lasted. I'm not kidding here. They will probably last, some examples will probably last, as well as the small pictures of Lawrence Alma-Tadema. That's not big art. I know there are paintings of Warhol's that I enjoy. The soup cans I think are especially good on account of the color and when he groups them. But it is nice small art and it is respectable, but it is not good enough to keep high art going. It is not an all-out try, and the mechanism is still one in which the highest expectations of taste in a given medium are kept off balance, as it were. And this is true—seems to be true anyhow—of far-out art in music, in literature too.

There is a kind of dodging among the media, or mediums, in the effort to evade the most stringent demands of taste—the heaviest pressure—and you see that in the shaped canvas, say, when it comes to painting. The shaped canvas has turned out to be so disappointing—as I found it to be—because it really appeals to bas-relief, and it appeals, it presents itself, in the showdown as a flat cutout shape, a silhouette which seems, as it were, to hark back to something which Western art went through and exhausted a long time ago. I can't put my finger on it, but I know that to blank out what is inside a shaped canvas and to see it as monochrome often will tell you why the picture is so dull, why the shaping is irrelevant as in so many, say, of Stella's paintings. The shaping itself, the flat silhouette, turns into dull bas-relief. And that is one, I think, notable example. Another is

often the attaching of three-dimensional objects to the surface of the canvas. It's as if the three-dimensionality gets the artist off the hook because he can't quite accommodate what he is doing to the flat plane.

Last night I spoke about demonstration art. That too gets mixed up with medium-scrambling. The general tendency of medium-scrambling in the visual arts has been away from the two and toward the three-dimensional, and Duchamp's ready-mades already showed some awareness of that—the awareness of the fact that taste was less immediately implacable. It came down, but it didn't come down so fast or so hard in three dimensions, and the job was to find out where taste seemed to matter less. The job was, as it were, to get to the fringes of non-art where apparently taste wasn't right on top of you to say good and bad that fast. All this is seeming, of course. Well, as I said when it came to demonstration art—Duchamp's ready-mades—the point, once made, never had to be made again. That this point itself, once made, was redundant when made again took a long time to sink in. I think it did sink in unconsciously, and academic artists who wanted to be advanced in the latter sixties realized increasingly that a more positive area of escape from taste was needed. They realized this—let's say it was wanted urgently but, at the same time, vaguely. And that is where the three-dimensional came in—the three-dimensional where everything material that is supposedly non-art already exists. And where, since the advent of abstract sculpture, the line between art and non-art seems most blurred, where works of art apparently define themselves more uncertainly than in other mediums.

The attraction to the three-dimensional became all the greater as one—as you, as we all—became more and more aware that anything and everything two-dimensional or flat declared itself as pictorial automatically and thereby became immediately vulnerable to pictorial taste. A blank canvas declared itself as a picture, a blank wall declared itself as a picture. So it is as though in two dimensions, no matter what you did there, you were flat up against pictorial taste. And it is also as though pictorial taste were keener than taste in sculpture.

At the same time, the course of abstract sculpture, since it was born out of Cubism—out of the Cubist collage-

construction—has been highly uncertain, littered with disappointments and also defined almost by the difficulty of making good abstract sculpture. Simply put, it turned out it was harder to make a good abstract sculpture than it was to make a good abstract painting. Or it seemed that way. The fact is there have been so many disappointments in abstract sculpture. So many abstract sculptors have come up and then gone down so fast—and I don't have to mention names; go back and look through the art magazines in the last twenty years—and the turnover has been greater there proportionately than it has been in painting.

But for this and the other reasons I mentioned—there may be still others—something like a vacuum of taste seemed to open up in the area of the three-dimensional. A region where taste couldn't pursue, into which taste couldn't pursue you. And this was like a godsend for the academics who wanted to be in the forefront of art at the same time as being academic. In this area where distinctions between good and bad might not only seem tenuous, they might also seem misplaced. And thus the tropism, as it were, of far-out art was toward the three-dimensional, and that became, I think, evident with Minimal—what's called Minimal—Art. There it seemed that what I call a "postured idea" could make itself significant in terms of art history—put itself down in art history—and by putting itself down, it acquires a significance about which the artist himself might often be confused, as I said, to begin with, but at least it was there in art history.

But taste pursues, and taste when it comes to art is inexorable, implacable, merciless, ruthless. Its expectations are always there, or have been so far. Maybe the expectations will evaporate, and then we will really end up in the decadence of Western art, but so far that hasn't happened. Meanwhile, the expectations of taste catch up with everything and anything, and the vacuum of taste collapses. Boredom is one of the flattest, most self-evident, most self-justifying of all esthetic judgments. There is no appeal from boredom. Even when you tell yourself you like boredom, there the verdict is. And with this funky art—and I have gone through the list of labels before; Earth Art, Environmental Art, and so forth—boredom gets into all these things. And it is as if when these items of art collapse—and it is a mixed figure of

speech—they don't collapse under the weight of boredom, they collapse under their own weight. And then the curious thing is that good taste gets in this vacuum of taste. Abject good taste, good design—that gets in even sooner than the judgments of taste. The minute a far-out artist lets down his guard—and he always does—there comes good taste, good taste in the most conventional sense. Here is the only place in this seminar where I wish I had slides of actual works of art so that I could point out examples of good taste in Earth Art. The academic drawing, say, in someone like Michael Heizer, where the artist thinks that because he is drawing a great trench in the earth that can only be seen from an airplane, he is going to get away with it, that he is going to get away with his conventional drawing. Or in the case of someone, to mention Robert Morris's name again, who thinks litter is going to disguise his almost effete good taste. It is as if this artist can't even drop a bunch of feathers on the floor without its arranging itself in conventional good taste. And so on.

But again, everything is bet on the notion of surprise—pure surprise. But pure surprise, or surprise in general, is not really surprise: Surprise is surprise only in terms of expectation. If the sun were to rise in the west, or a dog were to talk, or a mountain were to float, well, we would feel a certain amount of surprise. It would be mixed with fear or amusement or scientific curiosity. And this is the kind of reaction elicited by most kinds of surprise. And these too are one-time effects. If the sun rose in the west two days in a row, we would begin to stop being surprised. If a dog were to talk for more than five minutes, the surprise would start to ebb. The surprise of Duchamp's ready-mades, the surprise of environmental art, or whatever, is essentially of this nature, a one-time surprise, a unique circumscribed surprise.

The surprises administered to taste are of a different and peculiar kind because they are not one-time—they are built-in. And this is because they satisfy in surprising. The expectations of taste are not routine, like the expectations to which the kinds of surprise other than the artistic minister. The expectations of taste are not expectations of repetition. Taste doesn't expect things to go on like before, and this is unique to esthetic expectation. It doesn't expect daily or scientific repetition—I say sci-

entific advisedly—it doesn't expect the repetition of habit. Expectations of taste are *sui generis* and, again, I say unique because they expect surprise—the highest expectations of taste, let me qualify. And they are only satisfied by a certain factor of surprise. And this is what taste at its best, when it is pitched high enough, when it is up-to-date in the fullest sense, this is what taste habitually expects: surprise.

Other kinds of surprise are surprise because unexpected even when desired. Esthetic, artistic surprise is peculiar insofar as it is not only desired but expected, or at least half-expected. And the surprise that satisfies it is controlled, you can say even confined, surprise both for the maker of art and the receiver of it. The best and highest expectations of taste are not the same as the expectations involved in the appetite for variety or mere newness, which is a lower order of esthetic expectation. What is also paradoxical about the expectations of high taste is the expectation of difficulty of a sort. High artistic surprise creates a certain resistance, and gratifications in the case of high new art come in some part from the sense of resistance overcome—overcome by yourself and maybe overcome by the artist himself. The attitude of the receiver of high new art can be more decisive for the artist himself. This is tangled here. I know what I mean, but I can't find the right words yet.

At any rate, far-out surprise, pure surprise, general surprise, is aimless surprise. It is targeted to expectation in too general a way, too uncontrolled, too accidental a way, like the surprises of nature or the surprises of history. And this is where art history comes in so importantly, so urgently for the academic spirit that wants to disguise itself and get into art history nevertheless, and Duchamp is the arch example of that: If you startle enough people you will be remembered. Who was it who set fire to some famous monument in ancient times and said his motive was to be remembered forever? Well, the latest spasms of far-out art seem to betray some recognition of the futility of all this. And so Duchamp anticipated everything. All they do is recapitulate and run variations on themes he has set. And I find Conceptual Art fascinating because of its desperation—and intriguing. It's as though Conceptual Art says, all right, we are going to turn around on you, we are not going to give you any surprises at all

and there won't be an expectation involved either. You are going to get boredom so undifferentiated as to constitute a surprise all in itself. This solid, monolithic, unadulterated, undifferentiated boredom will really stand you off and be our memorial. . . .

QUESTION: You mentioned that there was a seeming vacuum of taste which existed around three-dimensional art. Now is this simply the product of the fact that sculpture was the last of the major arts to arrive at its distinctive, plain, modernistic look?

GREENBERG: That has something to do with it, yes.

QUESTION: But you said that that no longer pertains, that now sculpture has come of age in modernist art.

GREENBERG: No, I don't say that. I say the cause may no longer pertain, but the difficulties of taste when it comes to abstract sculpture seem to me to be much greater than the difficulties of taste *vis-à-vis* painting or architecture, that's all. Which doesn't mean that taste doesn't obtain and doesn't get in there in abstract sculpture too, only it's as though we're less certain here, or less immediate. It's as though the difficulty makes itself felt by the fact that taste operates more slowly.

QUESTION: Do you think that is just with abstract sculpture? It has been said before about representational sculpture too. Baudelaire, if I'm not mistaken, makes that point about sculpture. Something about the physical presence, that authority which an object has, that puts you off somehow, makes it more difficult for you to distance it, let's say, than painting which is, after all, already abstract.

GREENBERG: Well, wax images when they are done exactly to scale, and done well enough, come closest to being non-art of anything that has ever been called art. There were a couple of pieces in the last Whitney Annual where in the dim light you might have taken the figures to have been real human beings.

QUESTION: On the other hand, in your wax museum, the better it is done, the better it is.

GREENBERG: No. The better it is done, the less artistic it is. That's the contradiction about representation.

QUESTION: Illusion, there is always illusion there.

GREENBERG: Yes, but the illusion inheres in the material, not in the spatial factor. And if we color the things skillfully enough, we may not be able to tell the difference.

QUESTION: As soon as you accepted this illusion, it had to be good.

GREENBERG: But it didn't have to be. No. It wasn't good. It was done damned skillfully. But just think, an inspired artist would come very close to reality and then, let's say, depart from reality and be still better. As Rodin was in *St. John the Baptist* when he was accused of casting that figure from life. Earlier I mentioned the seeming vacuum of taste in the three-dimensional, I should have added that opinion about sculpture since the advent of abstract sculpture has maybe stayed more confused for a longer time than opinion about painting. The most grossly inflated reputations in recent art are the reputations of sculptors, curiously enough, not of painters. Take Rouault, who I considered a vastly inflated reputation in the forties. Rouault had been a fair, pretty good painter before the First World War and then, as I think, gone downhill. Then somehow or other, taste overtook Rouault with what seems to me gratifying speed. Now Henry Moore, I won't say he is negligible but he is responsible for some of the worst stuff I have ever seen as well as some of the nicest—not nicest, but somewhat nice. And taste doesn't seem to run him down, and taste doesn't seem to run Calder down, and taste, maybe it's beginning to run the postwar Giacometti down, I don't know. But these balloons stay up there and that, to me, is one of the symptoms of the difficulties of taste in sculpture over the last thirty, forty, or fifty years, right around the same time that we crossed off the great sculptors like Gerhard Marcks or Despiau who don't receive their due recognition because they don't look modernistic enough. And I feel that in painting this misconception wouldn't have obtained as

long, that a painter of quality equivalent to Gerhard Marcks would have gotten his due all over the world by now

QUESTION: You mentioned something about shaped painting as a dodge and also that that had been exhausted in Western art before, and I am curious as to where.

GREENBERG: In decoration—rococco, baroque, or wall painting. It seems to me—and this is the sort of statement that can never be demonstrated clearly—the mere shaping of a two-dimensional surface doesn't seem to mean that much. The mere shaping of it. You have to shape it inspiredly. There it is, back to it. Recently it's as though inspiration is hard to find or get to in shaping a flat surface. It's as though—and it doesn't have to happen this way—it turns into a sort of attached decoration, as if somehow the challenges of that don't elicit inspiration. It is significant that the first shaped canvases were done ten years ago or more by academic abstract artists—by artists who showed academic sensibility in their painting—and their proceeding to shape the canvases didn't change that effect. It was as though this were a venture on the part of academic sensibility, not on the part of an original sensibility.

There's another aspect to it. When Gorky began getting his stretcher bars made two or three inches wide and then not stripping or framing these pictures—and God knows Gorky never talked about this as far as I know—there was that *tableau objet* idea that had come in. I know I was made aware of it in the early forties—that the picture is an object, it is a physical entity at the same time that it is a work of art—and one way you emphasized this was by showing the picture as a slab, as it were, on the wall, pointing to the fact that a picture is not just a paper-thin surface but a three-dimensional *objet enfin* when you come right down to it. And then that was taken up by Rothko, this three-dimensional thrust, and he likewise refused to have frames or strips put around his pictures, as though that frame or strip would flatten them out. There is a certain amount of self-deception here. The painting is virtually a two-dimensional object, and you can thrust it six feet out from the wall and it's still by its two-dimensionality that it works unless you paint around

the sides as Gorky, and as Rothko particularly, and then as Stella did and say, well, I want a little piece of sculpture in this too. And that may work. There is nothing necessarily wrong with this. But somehow or other when it came to the shaping, back you were to flat two-dimensionality silhouetted with what seemed to be a kind of drawing that had no real relation to, or somehow didn't complete what went on inside.

Now, again I say that this isn't necessarily wrong, it just worked out that way, and that's not to say that some painter won't come along tomorrow and make it work. It just happened that shaped canvas became a resort of academic sensibility. It was like the idea of the shaping was another example of a "postured idea"—this tells you something new is here, it is no longer a rectangle, it is no longer an oval, this is a signal you're seeing something new now. . . .

QUESTION: You worked over Duchamp and Robert Morris pretty hard a few times and I wonder, in giving this description of the exercise of your taste, why you took the low order of art to talk about.

GREENBERG: I think that this art exhibits and demonstrates a point with a kind of clarity that no previous art I am aware of has. How academic sensibility can mask itself, but even more important, how necessary taste is to the production of good art and how taste made it impossible to describe—as I fancy, to describe better—the operations of taste. I know that, as I have said, it became traditional to think that anything far-out in painting and sculpture was by its very far-outness a challenge and a warning, a warning that we might be in the presence of something so new and so good that you couldn't get it. This was something I accepted myself without realizing it—without fully realizing it—and I, like other people, identified phenomenal novelty with artistic novelty. Something looked so extravagantly new that it must be something really artistically new. And here in the sixties I saw these two aspects separate from one another. That is a new problem. Ever since modernist avant-garde art started, phenomenal newness coincided with artistic newness. When it came to Picasso's construction-collages and then Constructivism,

that seemed to be proof to the hilt. And it seemed to get proved in David Smith's case and by Pollock even more in his all-over painting, which looked so confusing to so many people. They were phenomenally new and they were artistically new. And then you became aware during the sixties that phenomenal newness was now being offered as artistic newness and somehow it wasn't coming through as artistic newness.

You know that Primary Structure show at the Jewish Museum in 1962? We got it full blast. All these odd objects; they were odd and they were new and presumably this represented the forefront of art—this was the newest and, by the same token, the best art of the moment. There was some discrepancy here. And you felt it and you came back to the stuff. You stayed open and here was this separation. And that is something. The separation was a real historical moment in art, though it had already started. The precedent was Duchamp, as I have said, with his ready-mades. And you couldn't just dismiss this by saying, well, it's really bad art, it's academic, sub-academic, sub-kitsch, you had to find out a little more. You had to find out where this negative judgment of taste came from. That's why I have been going on about this in these seminars

QUESTION: You talked about the attitude of the receiver toward the artist as being somehow decisive.

GREENBERG: I got a little entangled there. In my experience I have noticed often that the surprise—the success of the surprise almost—is something that the artist waits for the receiver to confirm.

QUESTION: What if there is no receiver to confirm it? Does it continue?

GREENBERG: Well then I would say the decadence of art begins, or there is some gap, there is an interruption. For the most part, as I have said, over the last hundred years the receiver—the keenest receiver—of new art is another artist. Taste keeps going through artists much more than it does through connoisseurs. It wasn't a connoisseur or a critic who got dissatisfied with the

soups and gravies—the darkening in painting—in the nineteenth century. It was artists. The Pre-Raphaelites, and maybe before them, the Nazarenes, and then Manet. It was no critic or connoisseur who said these paintings are getting too dark—too much shading, too much shadow. And there was a market that seemed to accept and want this muddying of paintings. And artists themselves had to say, painting is going to the dogs this way. Now, there are other explanations, I mean the explanations converge, but that's the way it looks to me.

You can see right from the beginning that it was Manet's impatience with the run of art around him that drove him to begin to paint as he did in the early 1860s. To some extent you see that as the first responsive echo from fellow painters. And it's even more so with the Impressionists who seemed to have been painting for one another for a while. Cézanne was liked by friends like Pissarro and Degas and Monet before anyone else liked him. But he also wanted to get into the Salon. He wanted to make it in the world. He wanted the same kind of reception that Bouguereau got. He said so.

QUESTION: Not enough to aim his art that way.

GREENBERG: No. But this is the dividing line almost all artists have. They want to be hailed by the world at large, but they might not respect the taste of the world at large. There were maybe only a few people whose judgment they would take seriously, but they wanted the rewards of acceptance by the whole world. When I say taste travels through artists, it's also along the line of something I said the other night. Cézanne's most ferocious opponents too were artists, not critics. You see, taste travels through some artists. The most ferocious opponents of the best new art in my time were artists, not art critics. No matter what critics may have written against, say, Newman or Pollock or Smith, still the bitterest opposition came from fellow artists. And sometimes that kind of opposition was more disheartening than anything else. I remember Pollock dismissing Smith's sculpture as folk sculpture. And Pollock, himself, knew that he wasn't considered a real painter at the Cedar Street Tavern, and that's where he wanted to score. He didn't want to go up to the *New*

York Times and say to Howard De Vries, look, I'm good and you'd better write it down. In any case, De Vries would have come around to seeing Pollock's art much sooner than most of the artists down at the Cedar Street Tavern. That's part of the irony of the situation.

There's a further irony. It's been noticed that when an artist begins to weaken, his popularity will increase very much. A recent example would be David Smith and his "Cubi." They went over but they are very uneven; most of them, I think, are actually failures. And Pollock started to really go over with his last show, his first and only bad show. People said to me, at last I see what you see in Pollock. And this was the first time I had seen Pollock paint uninspired pictures, not just bad, but dead, or hollow, pictures. This is one of a short-term collection of errors of taste. It's as if at that moment the artist has given you a conception that makes it possible for you to get with his art. De Kooning began to be a greater success when he began to paint soft pictures. A lot of people could get with these pictures more readily than they could before. There are many examples, and ironies, of this sort.

GREENBERG: The distinction between opinion and taste is that opinion tends, usually, to be conventional. Opinion usually fails to keep up with taste at its best. And opinion establishes its own order of expectations. And these expectations tend to weight art in the given moment more toward reputation and standing than to intrinsic quality—names rather than works, and recognition rather than merit. And as I said last night, since the triumph of the classic avant-garde, once the success of the classic avant-garde was registered—and this was some fifty years after it had been under way—opinion formed the resolve not to miss the next big new thing in art. And opinion grew, tending increasingly toward this, I call it, "apprehension" lest the next big new thing be missed—the fear of being left behind—and lest it cost opinion either money or the prestige of good taste.

Now, I think this was seen earlier in France than in this country—the formation of opinion with regard to avant-garde art as something distinct from, let's call it, avant-garde taste. In this country it is something that I, at least, have noticed only in the last twenty years. And this fear of being left behind—this anxiety to keep up, not for the sake of art so much as for other things—this too is part of what I call avant-gardism and it is part of the syndrome of avant-gardism. And I'm recapitulating here. Already with the Futurists and Duchamp the conclusion was drawn that the next new original, important, history-making, the best new art would come in more or less the same recognizably startling, disconcerting, and apparently disruptive way as Cubism had, and as had Cézanne, and Impressionism and Fauvism before Cubism. And in this country, after Pollock, this ex-

pectation—this categorical expectation—became almost a popular one among art-interested people. And by almost the same token, it became a safe expectation.

What seemed to be the malice of the best new art since Manet—and maybe since before Manet, since Corot—was that it set out deliberately to confound expectation and show up opinion. As though it set out never *not* to surprise opinion in this sense. And it is as though opinion cooperates by somehow always falling for the speciously new—the superficially surprising, the ultimately, or the basically, familiar and easy. And Pop Art, the welcome given to Pop Art in the early sixties, was an example of that. An opinion is more like fashion than it is like taste. And it was an assumption that belonged more to fashion than it did to taste that the best new art could be expected to react against, and even cancel out, the best new previous art by its sheer startlingness. And again, Pop Art, by reintroducing illustration, seemed to be trumping Abstract Expressionism and, given the context, it seemed to opinion and to the new middle-brow followers of modernist art that this was probably the most revolutionary thing you could expect of art in the given moment.

Well, the scene of art in the sixties—the so-called "avant-garde scene" of art, "the avant-gardist scene" of art—was then marked by quick conclusions and the rapid spread of these conclusions, as though a hundred years of previous art, the meaning of a hundred years of previous art, was finally sinking in and becoming accessible to a lot of people. I think that is what happened. And this, let's say, development of awareness brought with it rather quickly, I think, a realization of how frustrated opinion always was by every new move of serious art. And I think this realization set a new generation of academic artists into the all-out far-out as though it were a last resort—as though, if we could only get hold of something that seemed irrefutably new, we were safe. And it also seems as though in the last year or two that the awareness of the mirage quality of the all-out far-out has become diffuse too. So that Conceptual Art, which is like an attempt to make art vanish and stay at the same time, looks like a last despairing conclusion. And the fact that despair shows so exuberantly shouldn't deceive us about that. I think the mice

that followed the Pied Piper of Hamelin into the river probably were having a good time, until the last moment.

The best new art, the most serious art of our time, had some more malice up its sleeve. As though to compound the frustration and despair of opinion and the frustration and despair of middle-brows, of art lovers at large, it had decided to play still another trick, which was to mask itself as conservative. And so in this way the best new art was answering this new academic far-out art, which masked itself as aggressive and adventurous and which displayed the kind of self-confidence that used to be associated only with the avant-garde over the past one hundred years. It was as though the best new art came in diffidently now, in order to lay still another trap for opinion. The best new art surprises the expectations of high taste just as much as it ever did, but without the apparent disruptiveness of the past one hundred years, as though—and again I say, as though—to make the point that the disruptiveness of previous avant-garde art from Manet on, from Baudelaire on, from Rimbaud on, from Debussy on, had never been more than apparent. That it had never been really revolutionary. That there have been no breaks in the continuity of art, as even opinion could see in retrospect. That is, new eras of art hadn't been ushered in by Manet or the Impressionists or by Seurat or by Cézanne or by the Fauves or by the Cubists or by Pollock—there hadn't been, so far, any new beginnings in that sense. However disconcerting the best new art has been over that past century, it had never been revolutionary, not only because it maintained a continuity of standards, but also because it maintained a continuity of stylistic evolution which, let's say, was not apparent immediately in each case but in retrospect has become apparent.

Even as painting and then, later, sculpture devolved the tradition of naturalism, it did so without ever breaking that tradition. It did so in terms of that tradition. And as I said some nights back, a picture by Mondrian has more to do with a picture by Velazquez or Giotto than with a Chinese scroll painting or a Persian miniature. A picture by Mondrian or by Pollock belongs still to Western tradition and shows it. And it is also part of the malice of the best new art that it makes itself more difficult to

detect as new by divesting itself of all those emblems of inno-
vation and newness—spectacular novelty and disorienting sur-
prise—that by now, that in the last century, have become tra-
ditional. Though I would say the best new art still disorients.
But the best new art no longer seems mystifying as Cubism did
in its time, as Fauvism and Impressionism did. But these em-
blems of innovation or newness—the disconcerting, the disturb-
ing, the mystifying, the disorienting—have by now become com-
promised in any case because they have been institutionalized,
and that institutionalization started with the Futurists. And still,
the best new art is as innovative as the best new art has been in
the past. Were it not, it might be just the best new art for the
lack of any better. I think the best new art at this moment main-
tains the standards of the past, but in some sense it is all the
more disconcerting. It turns back, it circles back on itself, and is
more disconcerting than ever because it seems not to be discon-
certing. Another one of these tricks that seem to belong to hu-
man culture and not to nature. The best new art continues to
extract, I'd say, even disorienting surprise from aspects of art that
avant-gardism was premature in regarding as obsolete.

As I have said, the artists and the critics who hurried to say
that painting was finished, or that this and that were finished,
were in every case—with no exceptions, as far as I can tell, and
as far as the recent record shows—people who didn't know where
the best painting was anyhow at that moment or where the best
sculpture was at that moment. They were people who said that
painting was finished because they couldn't see painting anymore,
not because painting had finished; people who preferred Rausch-
enberg to Reinhardt, who thought painting was finished because
Reinhardt's pictures had turned so close to monochrome that
they couldn't see anything in the pictures, and from their failure
to see, they concluded that there was nothing more to be seen
in painting. And thus painting was finished off by middle-brows.
If painting is ever to be finished off, it won't be by middle-brows.

Michael Fried wrote a piece some years ago in which he
defined the common quality of avant-gardist art as theatrical.
And at that point it did seem as though a *coup de théâtre* was
being pulled off—especially in the case of Minimal Art with its

"postured ideas"—which was largely unfair, which in theatrical terms couldn't help but make any kind of new art that delivered quality seem tame. But tame only in terms of theater, in terms of *Time* and *Newsweek* and *Life* and the art magazines, all of which participated in this and all of which had an appetite for drama. An idea can get responses more immediately and more dramatically than a work or works of art ever could. The only trouble is that in the context of art, ideas are ephemeral. And in the context of art without any future, ideas collapse out of their own irrelevance.

One thing that has hardly ever been noticed about all the feats of the far-out—beginning with the Futurists, and especially with Duchamp, and with Dada and going on—is that far-out art could never do anything with color. Far-out art could make fun of drawing and it could make fun of three-dimensional volume, it could make fun of design—it could raise hell with design—it could get extravagant when it came to drawing, it could get seemingly audacious with design, drawing, and sculpture—let's say, in the sculpture abstracted from color—but it could never raise even the show of adventure with regard to color. The most the Surrealists could do was parody cheap reproductions of Victorian chromolithographs—some Surrealists painters did deliberately parody that kind of color. But now, and by now, there have been thousands if not tens of thousands of avant-garde artists, far-out artists, and none of these artists has tried anything with color. Not even Yves Klein, who might be said to have come closest to it. And Yves Klein's taste when he did a monochromatic picture, the point was thick paint—I liken it to stalagmites or to pastry. But he couldn't do anything with color as form—I hate to have to put it that way because form lends itself to misinterpretation.

And part, still another part, of the malice of the best new art, especially of painting, was to develop as nominally pretty iridescent color. Monet's lily pads were the first example of that. This is how Picasso and Matisse's generation missed the Orangerie pictures—because they saw them as categorically pretty. And it could be said, I think, that color is saving high pictorial art today. I have been charged with being too focused on color,

and I know when you say color, it sounds like a slogan, but it seems to be a fact nevertheless. I'm using the word color, I don't really believe I'm saying color in the sense of a slogan.

Still further malice on the part of the best new art is that drawing thrives in sculpture, in abstract sculpture. This too is supposed to be obsolete and was announced as obsolete by Minimal artists, though not as explicitly as in the case of painting. The best new sculpture confounds opinion by its drawing. Here opinion had decided in the mid-sixties that the logic of modernist art was further and further simplification, further and further bareness, further stripping down. That seemed to be the logic of avant-garde art to these middle-brows, and here it is as though that logic were being stood on its head. So opinion can't guide itself by logic either. And once again, taste is the only sure guide here, taste on the part of the artist as well as the art lover, taste without preconceptions. And that is the lesson of the worst as well as the best art of the time and, as I said last night, some of the formalized art of recent days is probably the worst formalized art ever produced.

The lesson is: When it comes to art, always be ready to be surprised by anything and to be satisfied and exhilarated by surprise. The lesson is to want unwelcome surprises. And I think this is the way in which to get the most from art, whether new or old. . . .

QUESTION: Could you describe what you mean by drawing? It seems like some artists would say that they're painting basically with color, that they aren't using drawing in their painting.

GREENBERG: Well, you can't separate the two. Drawing is not just a matter of linear delineation, the matter of linear separation of shapes or areas. There is as much drawing in Thomas Wilfred's "Clavalux" color machines as in a Picasso etching. I should have said that linear drawing thrives in abstract sculpture today as it doesn't, seemingly, in painting. That may be just a momentary phenomenon. What you see of the Minimal artists— and I think they present the most serious taste for avant-gardism, the all-out far-out, and also the most serious works of art in this connection—they did feel that one had to get rid of all the fin-

ickiness that had looked to them as having afflicted past art. And so, if you called the least possible attention to the physical attributes of a work of art, you were closest to the new artistic truth. With, say, straight lines or circles you seemed to call less attention to drawing than with irregular lines. Anonymous colors, like the earth colors, like the color of metal, and so forth, seemed to call less attention to color and surface than spectral colors. Now, I don't say that they reasoned this way consciously, but this seems to have been the immanent logic of what they did. It seemed that you brought art down to a minimum of visibility. Well, it turned out later that the minimum visibility wasn't enough. It wasn't enough for wanting escape from judgments of taste. And Conceptual Art, as I see it, has drawn the conclusion or carried this logic to a further extreme. And you know the claims that go along with this; someone like Judd says, well, European art is just art-art, and we have begun a new thing here in America. It was not only benighted, it was philistine, too. They said, it begins with us, and things like color and drawing belong not only to Europe, and therefore are obsolete, they belong also to the past, and as of this moment we're closing out the past.

It's as though the Minimal artists and their successors set themselves up to be confounded, which is the way conventional taste has seemed to have done consistently since Manet's time, if not before—set itself up in order to be confounded, in order to be refuted. Even in the way in which Impressionism was followed and finally assimilated by taste, by conventional taste, it was as though conventional taste set itself up again and again, found firm postulates, arrived at certain axioms, as though to make their confusion all the more embarrassing. You see that in even a great art critic like Roger Fry, who had a great eye, when he concluded from Cézanne's example that now quality was the illusion of volume in painting. And then Cubism came along, set out to hold onto the illusion of volume in painting, and that turned into the flattest painting Western art had seen since the time of the Byzantines. Well, I don't want to go into too much detail here, I would have to make too many qualifications. I can only repeat: Conventional taste keeps setting itself up again and again precisely in order to be confounded. And that's part of not

only the malice of the best new art, but I think it is the malice of a certain logic. . . .

QUESTION: Why was the artist stuck in a guerrilla warfare with conventional taste? It occurred to me in looking over some notes of Freedberg that in the Renaissance the notion was different. Raphael came out of Perugino and Piero della Francesca, he rose up and culminated, whereas we seem to be involved in a kind of constraint that reduces—that we assimilate what has been reduced from previous art—so that there is less and less. It seems a reaction rather than being involved in a vision.

GREENBERG: There is no good art without a vision.

QUESTION: But I don't hear that enough when you're talking.

GREENBERG: Well, it's so well known. It's a truism. Of course there is no good art without inspiration. There is no good art without this *je ne sais quoi*. We all know that, so why emphasize that? There's nothing to be said about inspiration—it's a mystery. . . .

QUESTION: In the past, the best art was a response to the knowledge that academic art was bad art. Is far-out art now a response to something about high art?

GREENBERG: Insofar as middle-brow culture has always been a response to high-brow culture, yes. And I hate to use these terms but there are not better terms than high-brow and middle-brow in this context. The way I see it, in oversimplified terms—crude terms—is that high culture is always threatened by new candidates for culture. And the greater the number of the new candidates, the more its standards are threatened. This seems to be a matter of record. The great increase in numbers of the middle classes since the onset of industrialism has constituted a steady threat to high culture, and the avant-garde is part of high culture's answer to that threat. This is only a partial explanation of this state of affairs. I don't say that modernist art went along

countering each move made by middle-brow or philistine art. No. I don't think the initiative lay with the opponent. As I said, in any case, good art depends on a certain factor of newness in all times, not just since the mid-nineteenth century. Newness, surprise, is an essential ingredient of superior art. Not newness for the sake of newness, but for the sake of satisfaction. I'd say that what keeps avant-garde art going is not simply the threat of a market or a horde of new aspirants to high culture. There's also some kind of immanent logic—autonomous logic, or autonomous dynamism—at work. That's a safer way of putting it. It's not excluded that high culture—high art—becomes decadent some time in the future. . . .

QUESTION: You said that however disconcerting the best new art has been during the last hundred years, it never broke a tradition. It was never revolutionary. It seems to me that a lot of the arguments you put up to support that would talk us out of considering, in political terms, that there was a French Revolution or a Russian Revolution. And of course you can make that case. But wasn't Cubism or, certainly, Impressionism just as valid a revolution in art?

GREENBERG: Well, we have a definition for revolution in the case of politics and social affairs when one class replaces another on top and there was an overturn. The literal meaning is a turning over, a revolving. That hasn't happened in Western art since Cavallini and Giotto. I said this before. I may be over insisting simply because the word "revolution" has been applied to the course of art too often in the past hundred years. First there was Manet's revolution, then the Impressionist revolution—Manet and the Impressionists were not the same thing by any means. And then there was Cézanne's revolution. And then there was the Cubist revolution. And then there was supposed to be a revolution of art with Abstract Expressionism. And today, there are revolutions every year. Art is not politics. It's a different discipline. Let's say, have there been revolutions in philosophy? Yes, you would say, since scholasticism faded at the beginning of the fifteenth century there was a gap until Descartes came along. You

might say that. All right. It depends on the definition of the word "revolution" here. But politics is not art. Politics is not culture.

In any case, there was a continuity of culture that ran through the French Revolution, through the Russian Revolution. As a matter of fact, culture in Stalinist Russia harked back to the past more than it did in the non-revolutionized countries of Western Europe, or here.

QUESTION: Wouldn't you call Picasso's collage-constructions revolutionary?

GREENBERG: "Revolutionary," yes. I would say that was a revolutionary time in sculpture, maybe the most revolutionary time in art in the twentieth century. But leave it to the *New York Times* to tell us, as they did a while ago when the Museum of Modern Art got their new Picasso, that there was a revolution in sculpture around 1912. If it was, it's the only revolution I've seen, or that I'm aware of, in the last six hundred years of Western art. But revolutionary, yes. . . .

QUESTION: How do connoisseurs and artists gather their taste?

GREENBERG: Taste is not voluntary. It discriminates, but it's forced to like and to dislike. There's no "authority," as it were, in the sense you imply.

QUESTION: But somehow what taste selects in a closed room, when the room is opened up, it filters out and becomes opinion. How do you see that process?

GREENBERG: Well, I should have defined opinion more. I would call opinion "congealed taste." Opinion runs through people who stop developing their taste. I don't want to make it too complicated. They stop, and taste freezes into opinion. It can happen in the same person. Some people never get beyond a certain point. Most people, I'd say. Most people expect things to repeat themselves. And you could say that's part of the definition of opinion. Just expectation that things will repeat themselves. It

turns out that their taste for the next new artist was because he reminds them enough of the last great new artist. It's not the real thing. . . .

QUESTION: About color being the means for high pictorial art at present, does this mean that the options for high pictorial art are now more limited than any previous stage of modernist art?

GREENBERG: Can't say. I think in the seventeenth century Rembrandt and Velazquez and Rubens might have felt—had they been that historically conscious—our options are limited too, we can't paint as flat as the Byzantine painters did or the Romanesque muralists did. I can't say.

QUESTION: Do you have a hunch?

GREENBERG: In the early forties in New York it looked to a lot of artists as if it would be just impossible to paint great pictures anymore. That feeling was wrong, it was a delusion, but it seemed then that the options were closed. And maybe once you begin asking about what options are open to art in any given moment—in this given moment—you run the danger of making predictions about art, and as I said, that's the one thing one should never do when it comes to art. Never predict. Don't legislate. In principle, anything can happen in art tomorrow—in principle. Now the probability is another thing, but personally I don't want to deal in probabilities. That's my self-indulgence, say. . . .

QUESTION: Do you see in avant-gardist art a kind of internal development no longer dependent on high art?

GREENBERG: Good point. Yes, I do. You see it especially in Duchamp. He runs through possible options, to use that word again, and as one comes out of the other, the endeavor, say, is to get away from good and bad. And yes, you see that being recapitulated in the sixties as different young artists go through the same options again and come out, in effect, where Duchamp did—logically, if not chronologically. It seems that

almost all human phenomena that stretch out over time work up a dynamic logic of their own. It does seem that way. There is no question but that in the sixties the academic attempt to look up-to-date had evolved from Assemblage and Pop Art and Op Art. It evolved rather rapidly, with the rapidity of not a serious style, but with the rapidity of something that has to do with fashion. Artistic styles are not ever turned over as fast as artistic fashions have been turning over the last eleven or twelve years.

I want to offer an apology to some of my questioners and also an excuse. I notice when people ask questions and say "You said so and so," often I have said just the opposite or something quite different. That's part of the sloppiness with words in art talk. One of the reasons I think I talk slowly is because I've learned to be so frightened of this—that any word will do for any other word. You use words to mean something and mean just that, not something else. As I said earlier, art talk—most art talk—is bad. Most art talk in public or in print is bad—a lot of gibberish, glibness, inflated rhetoric, and so forth. Now, some of the questions I have been asked invite an answer only in terms of bad art talk, which means no answer at all, with circumlocutions and double-talk. There are certain things—and some of the most important things—about art that are answered only by pointing to the works, pointing to things in the works, and not by a flow of talk. And as I said, there has grown up not only a tradition of avant-gardist and far-out art but also a tradition of far-out talk, and it fills art magazines and not just American art magazines.

QUESTION: Well, who will write something that will speak artistic sense rather than rhetoric? Why is it not appearing?

GREENBERG: Again, it's not well enough recognized that we don't know what goes on in human consciousness when art is made or when it is experienced. And we don't recognize sufficiently that you can't ever prove qualitative judgment, that you can't demonstrate it the way you can two plus two equals four. If you keep these two things in mind—remember them suffi-

ciently—and realize that much of what you say about art is a stab, an approximation, and that the main thing in art is quality, first of all—though it's not the only thing, it's not what we have to confine art talk, art rhetoric, to—then the writer or speaker will check himself or herself. I think, I hope. . . .

APPENDIX:
A Draft of Chapter One

The following, written in the early 1980s, is an incomplete draft of what was to be the first chapter of Greenberg's projected book, to be titled *Homemade Esthetics* (see Foreword).

Art can be neither defined nor described satisfactorily. We can recognize it, point to it, but we can't get hold of it with words or concepts. In order to do that, we would have to be able to observe much more than we've been able to of what goes on inside us when we experience or make art. But neither introspection nor experimental psychology has gotten close enough to the mental or psychic processes involved in the experiencing or making of art.

This imperviousness to words and concepts—to discourse—isn't particular to art; it belongs to all intuitive activity. Art, esthetic experience, makes itself evident solely as a matter of intuition, of direct, unmediated insight. So does ordinary sense perception, so does introspection. We can't reason or infer our way of seeing, hearing, smelling, touching, tasting, or sensing differences of temperature. Nor can we reason or infer our way to knowledge of what goes on inside our consciousness. In short, we haven't been able to get close enough to intuition by means other than itself to substitute anything else for it. We know intuition only through intuition itself. Which means that if you can't exercise intuition spontaneously nobody can teach or show you how to. It's up to you alone to see, hear, touch, smell, taste. Similarly, it's up to you alone to get art *as* art, esthetic experience *as* esthetic experience. That is the way it is with intuitive activity: The *how* of it can't be communicated, transmitted, or taught; and because the how, the means, of it can't be communicated or taught, neither can the *what*, the results, of it be.

There does happen, however, to be effective agreement about the results of sensory intuition and, to a certain useful extent, about those

of introspective intuition too. All passably sane and physically intact people *recognize* the same colors, noises, surfaces, tastes, and smells in much the same way, whether or not they react to them in the same way or apply exactly the same words to them. And they also agree that two plus two equals four, and that when they look into themselves they can remember certain things that other people in the position to decide will agree took place. On the basis of these kinds of agreement we are able to communicate with one another and embark confidently on chains of inference or reasoning. The results of *esthetic* intuition are not that universally agreed upon, not that self-evident, therefore cannot be reasoned from as confidently, and do not provide so reliable a basis for communication.

Sensory and introspective intuition—which I'll call intuition in the primary mode—is required for survival as well as for communication. Esthetic intuition is not. Intuition in the primary mode is instrumental; it's a means to ends other than itself, ends that include and go beyond survival, far beyond it, but which are still external ends. Esthetic intuition contains within itself its own ends and purposes, its own self-sufficing satisfactions. Primary intuition furnishes data for action and re-action, for identification and classification; it leads to possibilities and consequences; it founds useful knowledge. Esthetic intuition gives matter, substance, but not data; it stops with itself, hangs up on itself, rests in itself, and is valued for itself. Nor can its results, unlike those of primary intuition, be abstracted from itself. In esthetic intuition means and ends fuse indissolubly. Esthetic intuition is all that esthetic intuition is about. It's its own value. And all that esthetic intuition can intuit is value, just as all that primary intuition can intuit is properties (to adopt G. E. Moore's distinction).

The difference between primary and esthetic intuition is not blurred by the fact that the former is a necessary precondition to the latter: that you do have to be sentient in the primary mode in order to have experience in the esthetic mode. That is, that if you don't have use of your senses, or are incapable of registering what goes on inside you, you're not only unable to survive, but are also unable to have esthetic experience. It still remains that, in order to experience anything esthetically, you have to make a definite shift from the mode of primary intuition into that of esthetic intuition.

Yet any and everything that can be intuited in the primary mode can also be intuited, experienced, in the esthetic one. Which means that any and everything that enters perception and/or consciousness can be experienced esthetically. But even more: What consciousness itself

generates can be experienced esthetically; I mean mental processes like reasoning and generalizing, though these are not intuitive in themselves. In short, there's nothing that we can be aware of in any way that we can't also be aware of or intuit esthetically.

It also happens to be the case that what is called *art* cannot be definitely separated from esthetic experience in general. Anything said about the latter can also be said about the experience of art. Anything experienced in the esthetic mode can be said to be experienced as art too, art as such. The notion of art, put to the test, proves to depend not on skillful making (as the ancients held), but on an act of mental distancing: Art means simply, and not so simply, a turn of attitude toward something you perceive or introspect. I call this turn an "act of distancing" because it brings about a mind-set by which whatever it is that's perceived is accepted for its own experienced sake, and not for what it means in any other terms—not for what it may signify in terms other than itself, not for what it suggests in the way of consequences, not for what it means to you yourself as a particular person with particular personal or practical or theoretical interests. These interests and these terms are what you become "distanced" from by the turn of attitude involved in esthetic, and therefore artistic, experience.

Art, then, like the esthetic in general, can coincide with everything and anything conceivable. Anything and everything conceivable can be converted into something that takes effect as art. There turns out, accordingly, to be such a thing as universal art, art at large, art that is or can be realized anywhere and at any time—even if it is for the most part inadvertent, momentary, and solipsistic art: that is, private and unsuitable to being adequately communicated *as art* by the person who experiences it. The big difference between this art at large and what the world agrees to call art is between art that is not communicated to another person's attention and art that is. The one I call private and "raw" art and the other I call public and formalized art. They are different, but for present purposes I don't consider them radically different. They are both areas of experience constituted by a certain kind of end-value. And through their orientation to this kind of value both varieties of art shade into one another, the difference between them becoming a question of degrees of value more than anything else— more even than a question of communicability, or of the difference between private and public.

When we deal with esthetic experience or art *qua* esthetic experience or *qua* art—as nothing but esthetic experience or art—we deal with values and valuing. And as I've already said, the values here are

end-values, intrinsic or ultimate ones. Art isn't the domain of any such values. There are moral values that are ultimate, and these too are (as I think) accessible only to intuition, to direct insight. Yet not all moral or ethical values are intrinsic, ultimate ones; some of them are instrumental—that is, means to other, further moral values—and which, because they are instrumental, can be discovered through reasoning, not intuition. This is not true of any esthetic or artistic values: They are all final intrinsic values, none of them instrumental. It is in getting itself taken as final, intrinsic value that art, or esthetic experience, identifies and realizes itself, makes itself felt for what it uniquely is.

If art, or esthetic experience, has its essential reality as value, then esthetic intuition is essentially an affair of valuing, evaluating, judging. With the same immediacy with which primary intuition gets the properties of things—descriptive, identifying attributes (to use G. E. Moore's distinction)—esthetic intuition gets a certain kind of intrinsic value, and in getting this value appraises it. Esthetic intuition does this automatically, otherwise it's not esthetic intuition. In short, you don't, and can't, experience art as art without simultaneously judging it; to the extent that something is experienced esthetically, to that same extent is it evaluated and judged, whether consciously or unconsciously.

Esthetic judging, esthetic valuing means making distinctions of extent or degree, of more and less. There's no more separating this from esthetic judgment than there is separating the latter from esthetic experience as such. There's the kind of judgment that comes out as a flat either-or, yes or no, guilty or not guilty, but this isn't the usual esthetic kind. The latter means grading and shading, even measuring—though not with the quantitative exactness of what is ordinarily thought of as measuring. Esthetic judgment is more on the order of *evaluating* than of judging pure and simple. That it tends to go on without words or symbols or signs—without calculation or even meditation, if not quite unconsciously—this doesn't make it any the less an affair of evaluating. Esthetic intuition distinguishes and weighs values with the same immediacy as primary intuition does physical properties, and it operates just as "opaquely."

Esthetic evaluating has to do with liking more and less, and with not liking more and less. What is liked or not liked is *affect*. Esthetic experience, esthetic value or quality are affect, a certain way of being moved or stirred. (Affect is not to be equated here simply with emotion; affect can comprehend something more or other than emotion.) It's the degrees of liking or not liking that are affect, and these translate themselves into degrees of value. But all these "moments"—affect, liking,

value, quality, evaluating—are synonymous with one another and distinguishable only in discursive reflection on esthetic experience, and only for purposes of conceptualization. In actual esthetic experience they are one. Which doesn't mean at all that this "one" is simple; otherwise I wouldn't be using different words or "models" in the effort to isolate it

That esthetic judgment is not voluntary—not decided *by* you, but rather *for* you—should not need emphasizing. All you have to do is reflect for a moment on what happens when you listen to, look at, or read works of art. But people do behave as if you chose what to like or not like, and as though your choices betrayed good or bad intentions. This is why what's called *odium aestheticum* (literally, "esthetic hatefulness") abounds, why people invest disagreements about art with so much personal rancor. Yet it remains that you yourself no more choose to like or not like an artwork than you choose to see the sun as bright or the night as dark. All intuitive reactions, whether primary or esthetic, are involuntary (for that matter, so are all rational or intelligent ones). They are given, not taken. All that's taken or willed or decided when it comes to esthetic experience is the directing and focusing of attention (and about what happens with attention, no discipline of knowledge, whether psychological or philosophical, has yet been able to say much that's useful). To put it another way: Esthetic judgments, being indissoluble from, inseparable and indistinguishable from esthetic experience itself; being in fact constitutive of that kind of experience—esthetic judgments, being all that, are reflexive, automatic. They are not arrived at by being deliberately reflected upon, weighed, pondered, or decided; they are—once again—given, given because they are inherent in esthetic experience itself, because they *are* that experience. And because they are given, they are received.

(Of course, there is, and has been, much dishonesty on the reporting of esthetic reactions. There's no one, probably, who professes an interest in art who's not been guilty of this kind of dishonesty at one time or another. There's the person who looks at the nameplate on a painting before deciding how to look at the painting itself. There's the person who prefers the Beatles to Mozart but doesn't dare admit it, even to himself. It depends, of course, on what circles you frequent. There's also the person who lets nonesthetic interests or fixed ideas interfere with his reactions. Here it's less a question of dishonesty than of disloyalty—disloyalty to art. But whether it's one or the other, it's still bad faith in the context of the esthetic. And it may be the prevalence of bad faith that accounts for a lot of *odium aestheticum*. But it

has to be allowed at the same time that bad faith of this or any other kind is prevalent in society at large.)

Immanuel Kant (who had more insights into the nature of esthetic experience than anyone else I'm aware of) held that the "judgment of taste" always "precedes" the "pleasure" gained from the esthetic "object." It's not necessary here go into the reasons he gave for asserting this. I'd rather deal with the reasons my own experience provides for agreeing with it. His assertion in itself points up—once again—how integral the "moment" of judgment is to esthetic experience as such. My surmise is that the very involuntariness of the intuition which *is an esthetic judgment* enables you to *commit* yourself to the "pleasure"—or "dys-pleasure"—of the intuition itself. That the judgment is received rather than taken makes it a necessary one as it were, and its necessity frees you, surrenders you, to the commitment, to all its spontaneity and "purity." A judgment taken deliberately and consideredly would be a limiting and contingent rather than a liberating one; the "pleasure" or "dys-pleasure" would be infected with the possibility of qualifications and doubts; it would be a notion instead of an intuition—at least to start with. In short: If the "judgment of taste" "precedes" the "pleasure," it's in order to *give* the "pleasure." And the pleasure in turn gives the judgment.

Whether Kant's separation of the "judgment" from the "pleasure" is meant in a temporal or in a quasi-logical sense, I can't tell from what he says. My own experience insists on the latter sense. I find it impossible to separate the "moment" of judging from the "moment" of pleasure in any but a metaphorically logical sense, certainly not in a temporal one. The judging and the pleasure mean one another are synchronous and synonymous. The pleasure or dys-pleasure is *in* the judging; the latter gives the pleasure or dys-pleasure, and at the same time the pleasure or dys-pleasure gives the judgment. They fuse with one another. That one thing makes another possible does not have to mean that it precedes it in time. What is logically discrete does not have to be temporally discrete. Conceptual thought tries to wrestle experience into its own domain by spreading out in time or space things that exist instantaneously and, sometimes, in unspecifiable places. . . .

At the beginning I said that what goes on inside us when we experience art can't be adequately observed and therefore can't be adequately known. Then I went on to say that esthetic experience always identifies itself through, and as, a value judgment that consists in an affect, which consists, in turn, of liking or not liking. Saying all this still didn't mean saying anything really about what goes on inside you

when experiencing art. But now I will make a stab at suggesting—as best as I can make out through introspection—something of what goes on inside *me* when I experience art.

Again, I have to start from Kant. Not that he offered a clue in advance as to the results of my introspection, but he did anticipate some of the terms I have to use in describing those results. In *The Critique of Aesthetic Judgment* he speaks of esthetic "pleasure" as consisting in the "free play" and "harmony" of the "cognitive faculties," in their "harmonious activity," and in the easier play of both mental powers—imagination and reason—animated by their "mutual harmony." The "harmony," "free play," "animation," and "activity" are occasioned by the esthetic object, which is itself a "given representation" such as is "generally suitable for cognition." This, despite there being no cognition as such, no addition to knowledge—or food for knowledge—in esthetic experience as such (which doesn't mean that some sort of knowledge isn't usually a corollary of esthetic experience, even if it's only the knowledge of having had the experience).

I don't have to accept Kant's designation of the mental or cognitive faculties in order to find out that the gist of what he says about the role of cognitive activity in esthetic experience is confirmed by what I make of my own esthetic experience. As I see it, as I sense it, as I introspect it, the pleasure of art—when it does give pleasure—consists in a sensation of exalted cognitiveness that transcends cognition as such. It's as though for the time being I could command, by dint of transcendent knowing, everything that could possibly affect my consciousness and, with that, my existence. I *know*, and yet without having anything specific or definite to know. Definiteness or specificity in this respect would extinguish the sensation, the feeling, the state. For it's a question of "ness"-ness, not of what-ness; of a state of consciousness, not of a gain or addition to consciousness. The more diffuse or "general" the state or sensation of cognitiveness, the more embracing it is, and the more embracing, the more exalted and exalting. It is by its greater "generality" or diffuseness, which is also its elusiveness, that better art makes itself evident as better.

What is ordinarily meant by emotion or feeling is swallowed up in esthetic experience. It's as though the state or sensation of cognitiveness contained emotion, along with sensuousness and knowledge and intellection, as things transcended—contained and transcended—in a totality of sentience (to borrow Susanne Langer's term but to change its application somewhat). Emotion, like immediate sense perception and knowledge and rules of logic, becomes "known" and "felt" and "sensed"

from outside itself, from a vantage point that commands and controls it for the purposes of sheer consciousness. The "pleasure" of esthetic experience is the pleasure of consciousness; the pleasure that consciousness takes in possessing itself and its powers and the operation of those powers. In satisfactory esthetic experience consciousness revels as it were in the sense of itself (as theologians used to say that God did).

It's in this state of exalted, transcending cognitiveness that esthetic affect, esthetic quality or value, consists; rather, this state is that affect, that quality, that value. All three mean the same thing. The more and the less the degrees and differentiations of esthetic quality or value are, the more and the less the degrees and gradations of this state, of its intensity and scope. Inferior art or esthetic experience shows itself, precisely, in failing to bring about a state that is high enough—or intense enough or extensive enough. But all art, all esthetic experience, good and bad, superior and inferior, identifies itself by promising this state of transcending cognitiveness, or by intimating a promise of it. And it's only taste that can tell to what extent this promise is kept.

FURTHER READING

Works by Clement Greenberg

The four volumes of *Clement Greenberg: The Collected Essays and Criticism* edited by John O'Brian (Chicago: University of Chicago Press, 1986–1993) contain several essays relevant to *Homemade Esthetics*, including the following:

"Avant-Garde and Kitsch," 1939
"Towards a Newer Laocoon," 1940
"Irrelevance versus Irresponsibility," 1948
"The Plight of our Culture," 1953
"Abstract and Representational," 1954
"Modernist Painting," 1960
"After Abstract Expressionism," 1962
"Complaints of an Art Critic," 1967
"Avant-Garde Attitudes," 1969

The following articles, not included in the *Collected Essays and Criticism* also deal with the subject:

"Abstract, Representational and So Forth." *Arts Magazine.* v. 48, no. 7. April 1974.
"Detached Observations."*Arts Magazine.* v. 51, no. 4. December 1976.
"Looking for the Avant-Garde." *Arts Magazine.* v. 52, no. 3. November 1977.
"Modern and Post-Modern." *Arts Magazine.* v. 54, no. 6. February 1980.
"States of Criticism." *Partisan Review.* v. 48, no. 1. 1981.
"To Cope with Decadence." *Arts Magazine.* v. 56, no. 6. February 1982.
"Beginnings of Modernism." *Arts Magazine.* v. 57, no. 8. April 1983.

Works by Other Authors

*denotes works cited in text

Barzun, Jacques. *The House of Intellect.* New York: Harper Torchbooks, 1959.

Bell, Clive. *Art.* Oxford: Oxford University Press, 1987.

Bourdieu, Pierre. *Distinction: A Social Critique of the Judgement of Taste,* translated by Richard Nice. Cambridge, Mass.: Harvard University Press, 1987.

Buchloh, Benjamin, S. Gilbaut, and D. Solkin, eds. *Modernism and Modernity: The Vancouver Papers.* Halifax: The Press of Nova Scotia College of Art and Design, 1983.

Carrier, David. "Greenberg, Fried and Philosophy: American-type Formalism," in *Aesthetics,* edited by George Dickie and R. J. Sclafani. New York: St. Martin's Press, 1977.

Cassirer, Ernst. *Kant's Life and Thought.* New Haven: Yale University Press, 1981.

Clark, T. J. "Arguments about Modernism: A reply to Michael Fried," in W. J. T. Mitchell, ed., *The Politics of Interpretation.* Chicago: University of Chicago Press, 1983.

———. "Clement Greenberg's Theory of Art." *Critical Inquiry.* v. 9. September 1982.

Cohen, Ted, and Paul Guyer, eds. *Essays in Kant's Aesthetics.* Chicago: University of Chicago Press, 1982.

*Coleridge, Samuel Taylor. *The Philosophical Lectures.* London: Pilot Press, 1949.

*Croce, Benedetto. *Aesthetic.* New York: The Macmillan Company, 1970.

Crowther, Paul. "Greenberg's Kant and the Problem of Modernist Painting," *British Journal of Aesthetics.* v. 25, no. 4. Autumn 1985.

de Duve, Thierry. *Clement Greenberg Between the Lines: Including a Previously Unpublished Debate with Clement Greenberg,* translated by Brian Homes. Paris: Editions Dis Voir, 1996.

———. *Kant After Duchamp.* Cambridge, Mass.: MIT Press, 1996.

de Goncourt, Jules and Edmond. *Journals des Goncourts, 1851–1870.* Garden City, N.Y.: Doubleday, 1937.

Delacroix, Eugène. *The Journal of Eugène Delacroix,* translated by Walter Pach. Introduction by Robert Motherwell. New York: Viking Press, 1965.

Descartes, René. *A Discourse on Method, Meditations and Principles.* Rutland, Vt.: Charles Tuttle, 1986.

Eagleton, Terry. *The Ideology of the Aesthetic*. Oxford: Blackwell Publishers, 1990.

Ferry, Luc. *Homo Aestheticus: The Invention of Taste in the Democratic Age*. Chicago: University of Chicago Press, 1993.

Frascina, Francis, editor. *Pollock and After: The Critical Debate*. New York: Harper & Row, 1985.

*Freedberg, Sydney J. *Painting of the High Renaissance in Florence and Rome*. New York: Harper & Row, 1972.

*Fried, Michael. *Absorption and Theatricality: Painting and the Beholder in the Age of Diderot*. Berkeley: University of California Press, 1980.

——. *Art and Objecthood*. Chicago: University of Chicago Press, 1998.

——. "How Modernism Works: A Response to T. J. Clark," *Critical Inquiry*. v. 9, no. 1. September 1982.

*Fry, Roger. *Cézanne: A Study of His Development*. New York: Noonday Press, 1958.

——. *Last Lectures*. New York: Macmillan & Co. and Cambridge: University Press, 1939.

——. *Vision and Design*. Mineola, N.Y.: Dover Publications, 1998.

*Gilbert, Katherine, and Helmut Kuhn. *A History of Aesthetics*. New York: The Macmillan Company, 1939.

Guilbaut, Serge. *How New York Stole the Idea of Modern Art*. Chicago: University of Chicago Press, 1985.

Harrison, Charles. "Modernism," in *Critical Terms for Art History*, edited by Robert Nelson and Richard Shiff. Chicago: University of Chicago Press, 1996.

Harrison, Charles, and Paul Wood, editors. *Art in Theory 1900–1990: An Anthology of Changing Ideas*. Oxford and Cambridge, Mass.: Blackwell, 1992–93.

Haskell, Francis. *Past and Present in Art and Taste*. New Haven: Yale University Press, 1987.

Hegel, George Wilhelm Friedrich. *Introductory Lectures on Aesthetics*. London: Penguin Books, 1973.

Heidegger, Martin. *Kant and the Problem of Metaphysics*. Bloomington: Indiana University Press, 1990.

Herbert, James D. *Political Origins of Abstract-Expressionist Art Criticism: The Early Theoretical and Critical Writings of Clement Greenberg and Harold Rosenberg*. Stanford: Stanford University Press, 1986.

Hofstadter, Albert, and Richard Kuhns, editors. *Philosophies of Art and Beauty: Selected Readings in Aesthetics from Plato to Heidegger*. Chicago: University of Chicago Press, 1976.

Hume, David. *Of the Standard of Taste.* New York: Bobbs-Merrill, 1965.
———. *On Human Nature and Understanding.* New York: The Macmillan Company, 1971.
*Kant, Immanuel. *The Critique of Judgement,* translated by J. C. Meredith. Oxford: Oxford University Press, 1978.
———. *Logic.* Mineola, N.Y.: Dover Publications, 1994.
Kuspit, Donald. *Clement Greenberg, Art Critic.* Madison: University of Wisconsin Press, 1979.
*Langer, Susanne Katherine Knauth. *Feeling and Form: A Theory of Art.* New York: Scribner, 1953.
———. *Philosophy in a New Key.* Cambridge, Mass.: Harvard University Press, 1979.
Lynes, Russell. *The Tastemakers.* New York: Harper & Brothers, 1954.
*Meier-Graefe, Julius. *Modern Art: Being a Contribution to a New System of Esthetics,* translated by Florence Simmonds and George W. Chrystal. New York: G. P. Putnam's Sons, 1908.
*Osborne, Harold. *The Art of Appreciation.* Oxford: Oxford University Press, 1970.
*———. *Theory of Beauty: An Introduction to Aesthetics.* New York: Philosophical Library, 1953.
———. editor. *Aesthetics.* Oxford: Oxford University Press, 1972.
Peirce, Charles S. *Chance, Love and Logic.* Lincoln: University of Nebraska Press, 1998.
Reynolds, Sir Joshua. *Discourses on Art.* New Haven: Yale University Press, 1998.
Ross, Clifford, editor. *Abstract Expressionism: Creators and Critics: An Anthology.* New York: Harry N. Abrams, 1991.
Santayana, George. *The Sense of Beauty.* New York: Random House, 1955.
Sartre, Jean Paul. *L'Imagination.* Paris: F. Alcan, 1936.
*Schiller, Friedrich. *On the Aesthetic Education of Man in a Series of Letters,* edited and translated by E. M. Wilkinson and L. A. Willoughby. Oxford: Oxford University Press, 1982.
Tillim, Sidney. "Criticism and Culture, or Greenberg's Doubt." *Art in America.* v. 74, no. 5. May 1987.
Wellmer, Albrecht. *The Persistence of Modernity: Essays on Aesthetics, Ethics, and Postmodernism.* Cambridge, Mass.: MIT Press, 1993.
Wittgenstein, Ludwig. *The Blue and Brown Books.* New York: Harper Colophon Books, 1958.
Wölfflin, Heinrich. *Principles of Art History,* translated by M. D. Hottinger. New York: Dover Publications, 1950.

INDEX